RELIGIOUS FOLK ART IN AMERICA

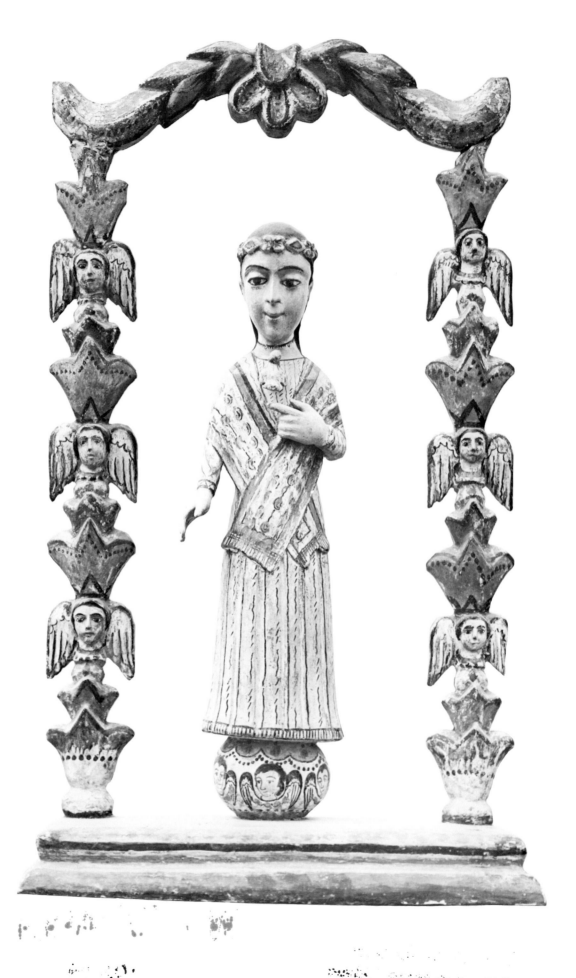

Religious
Folk Art
in America
REFLECTIONS OF FAITH

C. KURT DEWHURST

BETTY MACDOWELL

MARSHA MACDOWELL

E. P. DUTTON, INC. NEW YORK
In association with the
MUSEUM OF AMERICAN FOLK ART NEW YORK

Published in the United States by E.P. Dutton, Inc.,
2 Park Avenue, New York, N.Y. 10016

Library of Congress Catalog Card Number: 83-71103

Design by Marilyn Rey

ISBN: 0-525-93300-X (cloth) 0-525-48071-4 (DP)

Published simultaneously in Canada by Fitzhenry & Whiteside Limited, Toronto

W
10 9 8 7 6 5 4 3 2 1

First Edition

All these put their trust in their hands; and each becometh wise in his own work. Without them shall no city be inhabited, and men shall not sojourn nor walk up and down therein. They shall not be sought for in the council of the people, and in the assembly they shall not mount on high; they shall not sit in the seat of the judge, and they shall not understand the covenant of judgment; neither shall they declare instruction and judgment, and where parables are shall they not be found. But they shall maintain the fabric of the world; and in the handiwork of their craft is their prayer.

—Ecclesiasticus 38: 35–39

CONTENTS

PREFACE

Religion and art stand beside each other like two friendly souls whose
inner relationship, if they suspect it, is still unknown to them.

—F. E. D. Schleiermacher,
On Religion: Speeches to Its Cultural Despisers.
London, 1893

This book and the exhibition "Religious Folk Art in America: Reflections of Faith" have been designed to explore the link between religion and art, particularly between religion and folk art. Folk culture has been termed the unofficial level of the cultural life of a society. Transmitted primarily by oral means from one generation to the next, folk traditions have rarely been recognized for their potential as indicators of patterns in societal values and behavior. In the course of preparing this book, it was necessary to select works that generally reflected the material folk culture of American religious groups. Owing to the vast body of religious material that has been produced by American folk artists, it was necessary to establish clear guidelines for this task. In addition, an overriding concern for a synthesis of religious meaning and religious art had to be developed. The goal was to focus on what André Malraux has termed "true art" as opposed to what he calls "the arts of delectation."[1] This was indeed a perplexing task, as Charles Leslie in *The Anthropology of Folk Religion* has noted:

Since both kinds of art ["true art" and "the arts of delectation"] use the same means to affect our sensibilities, they cannot be distinguished from each other on formal or material grounds. The distinction between them resides in the ends toward which they are directed, and these ends are determined by the kinds of societies in which they are produced. In the past, at least, genuine art nourished the best in man by the loftiest type of fiction, "one based on religious communion. In contrast, the arts of delectation serve no hi-

erarchy oriented by the supernatural and vision of the unseen world" [Malraux]; they seek only to satisfy impulses for diversion.[2]

This volume attempts to focus on works of genuine art that are products of American religious folk culture. For folklorists, fieldwork within a religious community and with the producers of the material culture provides the basis for making such distinctions between true art and art as diversion. Wherever possible, folklore fieldwork studies have been cited. However, the analysis of the historical folk art treated in this book and in the exhibition has also been based upon social and cultural studies.

Religious folk art is but a single strand of the cultural fabric that forms the religious life of a folk group. The term *material folk culture* best describes this segment of the whole of religious expression. Because of the varied nature of material culture among all American religious groups, it has been necessary to examine only works that conform to the following criteria:

1. Objects that served an overt function within a religious context.

2. Objects that expressed a traditional (though at times, personal) view of religious life.

3. Objects that supported a religious view of life and enhanced folk religion.

4. Objects that documented religious sites, events, or personalities.

5. Objects that expressed a visionary view of religious experience.

6. Objects that were designed to communicate a message, evangelize, or attract the attention of those beyond the folk group.

The organization of this book has been based on a chronological approach to the development of religious denominations and the related folk attitudes, beliefs, narratives, and art. The discussion that follows is presented in three parts, each of which focuses on a particular period of the American experience. Chapter 1 deals with the origins of religious folk art in America. The interplay of religion and art in the experience of native Americans, the Spanish Catholics of the American Southwest, and the New England Puritans provides the focus for this section. Chapter 2 examines the expansion of religious life in America through the increased use of evangelistic practices, the strengthening of women's roles within religious structures, the rise of sectarian movements, the redistribution of denominational membership, and the steady influx of immigrant religious customs. This section explores the ways in which these changes and growth affected the manifestations of the spirit found in the nineteenth- and early twentieth-century period. Chapter 3 considers the religious iconography of America's folk culture, giving particular attention to twentieth-century art as well as to the work of certain independent nineteenth-century artists who were not restricted to the aesthetic traditions of particular groups. The material discussed in this section has been grouped into three major categories: (1) scriptural or traditional, (2) documentary, and (3) visionary or symbolic. These categories make it possible to detect persisting or changing patterns of iconography and to determine their significance. Throughout these three parts the religious folk art of America will be considered with respect both to its iconographical continuity and change and to its cultural context, giving special attention to the way in which such art reflects the spiritual beliefs and values of the American people. The variety of American religious material culture will be especially evident. But what is perhaps most notable as a common thread running through the work of religious folk artists has been best expressed in Ecclesiasticus 38:39: "In the handiwork of their craft is their prayer."

Notes

1. See André Malraux, *The Psychology of Art*, trans. Stuart Gilbert (New York: Pantheon Books, 1949).

2. Charles Leslie, *The Anthropology of Folk Religion* (New York: Alfred A. Knopf and Random House, 1960), pp. xii–xiii.

RELIGIOUS FOLK ART IN AMERICA

Chapter 1
FAITH MADE PERFECT

"by works was faith made perfect."
—James 2:22

ORIGINS OF THE AMERICAN RELIGIOUS EXPERIENCE

Historians of religion have shared with theologians a preoccupation with the intellectual expression of religion. They have tended to concentrate their attention on the written records of the world's religions, as though such records provided the truest evidence of what men and women have felt about their gods and their own place in the scheme of things. The importance of such literary evidence is not to be minimized; but the almost exclusive attention given to it has resulted in a serious neglect of the witness of art (all material culture) and ritual. Too often it has been forgotten that man expressed his religious ideas in art and ritual long before he learned to write.[1]

This realization in the words of S. G. F. Brandon provides the underlying premise of this book. Clearly, there is much to be learned from further inquiry into the realm of material folk culture that was inspired by religious faith. The early American experience with religion is often acknowledged to have begun with the Spanish exploration of the New World[2] but a more accurate understanding of American religious values must begin with some investigation of the production of native American religious material and the relationship between the object and its functional meaning.

Folklorists have long recognized the important role of religions in all societies and have sought to document these "orally transmitted superstitions and popular beliefs of civilized peoples."[3] It has recently been estimated that there are over 5,000 primitive, folk, and civilized religions in the world today.[4] Before discussing the nature of material folk culture produced by native Americans, it would be especially valuable to attempt to define what religious folklife entails. In *Folklore and Folklife*, John Messenger formulates such a definition:

> Religious beliefs, to be defined, must involve supernatural entities toward which sacred attitudes are directed by groups of people. These qualifications rule out as religious all nontheistic belief systems. Every religion recognizes spirits and demons, personal and impersonal power, one or more souls, ghosts, fate, luck, magic and witches. In addition, each religion attaches religious significance to certain objects and places, such as the insignia of a priest or the mountain abode of a deity.[5]

Most peoples that developed identities over time as members of folk religious groups maintained stable philosophical and practical patterns as well. The native American tribes invite examination as folk groups.

THE NATIVE AMERICAN EXPERIENCE

So often today any discussion of the material culture of native Americans paints a portrait of tribal units in isolation in Western culture. And yet, as Sydney E. Ahlstrom has noted in his monumental work, *A Religious History of the American People*, "Even those with ties to Africa or

Asia or those most ancient of migrants from Asia who are called Indians spend most of their lives in the contexts and institutions that were shaped by the western tradition."[6] Realization of this fact provides a critical perspective on the arts of native Americans. Their art has been a by-product of Western tradition and should not be divorced from the much-heralded European influence on North America's indigenous peoples.

To appreciate the interrelationship between native Americans' religious values and their material culture, one must recognize the beliefs that shaped their view of the world around them. Ralph T. Coe has stated this perspective most succinctly:

> The Indian lived within his land, not on it. Therefore his works occupy space in harmony with the land, and the scale is human, usually restricted to what can be held in a hand, put on a man or set on a saddle, although occasionally it might at most rival a tree in scale (necessarily so in the case of something like a totem pole).[7]

In native American tribal life, men assumed the dominant role of maintaining the religious functions of the tribe. This practice of male administration, which extended well beyond the similar Western tradition, is worth consideration as a universal phenomenon of traditional cultural life. In an essay titled "Enriching Daily Life: The Artist and Artisan," Andrew Hunter Whiteford makes this observation:

> Most ritual objects were produced by men but women participated in many phases of religion and were sometimes leaders. What is significant is the extent to which the supernatural permeated every aspect of life. Women were affected as much as men and the concept of a secular life set apart from the supernatural hardly existed.[8]

Perhaps this inability to separate the sacred from the secular was the most common trait of native American religious material culture. Although especially pronounced among native Americans, it has implications as well for the early history of all religious material folk culture in America through the end of the eighteenth century.

The function of art in a folk society is to convey the conventional values of all members of the folk group, not merely to transmit these values but also to weave them carefully into the delicate fabric of folklife. The native American artist participates in all facets of the communal life of the folk group: the tribe. To discuss the role of the artist without reference to his other social responsibilities requires that one be continually aware of the limitations of such a unidimensional approach. Still, some conclusions

can be drawn from such an undertaking. The transmission of traditional art-making skills is primarily hereditary, with children being prepared to assume the social roles of their parents. This cycle allows for prescribed aesthetic conventions in the making of religious ritual objects as well as for some innovation by the individual artist.

The nature of material folk culture is primarily shaped by the ingrained conservative values of the folk group. Folklorists often refer to the existence of three levels of cultural life: the elite (progressive); the popular (normative); and the folk (conservative).[9] Because the artists within each of the levels of social organization respond to their particular audiences, they produce objects that vary considerably. Whereas both elite and popular cultural artifacts are subject to constant innovation, folk cultural artifacts retain a strong link with the past and carry traditional values into the future. Correspondingly, it has been observed that folk cultural artifacts experience "major variation over space [geography] and minor variation over time."[10]

In the creation of religious arts, native American artists reflected the need of a folk group to maintain traditional values. Martin Friedman has observed this fact in his essay titled "Of Traditions and Esthetics":

> In Indian art personal attitudes are subordinated to those of the group. The basic objects of Indian material culture are responses to physical and religious needs and, at their most elementary, pertain to food, shelter and the survival of the society. Indian art is concerned with continuity, and ceremonial objects, particularly, help preserve the culture.[11]

Thus, a critical function of native American material culture is its reinforcement of the conservative religious values of tribal groups.

The religious architecture of the Pueblo Indians provides an excellent example of the integration of religious beliefs into handmade forms. Ceremonial chambers used by the Hopi Indians were called *kivas*, a term that has taken on a similar meaning for all Pueblo Indians (fig. 1). Although usually circular in design, there are some remaining examples of rectangular design in the Hopi villages of Arizona. Embedded partially or fully in the ground, the kiva was generally accessible through a rooftop passage called a *sipapu*. This particular architectural form has been linked to some ancient myths relating to man's first emergence.[12] Patrick King has described the sipapu as a symbolic "opening through which the first people emerged into the new world, represented by the dark interior of the kiva."[13] The basic physical appearance of each kiva was the same. Each contained a fire pit, deflector, ventilator, and benches that ran continuously around the walls. But central to this arrangement was the

ladder to the sipapu to symbolize the "next emergence into another newer world."[14] This tangible expression, in an architectural form, of a belief in a future life is just one example of the ways in which the material culture of Americans has reflected their religious faith.

The integration of art-making into the cultural milieu of native American life can be most clearly demonstrated by attempting to separate the role of the artist from the society in which he or she lives. Indeed, it has been shown that most native American tribal languages had no term or word for art to distinguish it from other societal functions.[15] This finding has led scholars to conclude that there existed a persuasive "unity" in native American culture that makes the discussion of religious art merely an exercise in tracing arbitrarily isolated patterns of behavior in daily life. Perhaps the most appropriate visual image that conveys the complexity of this task is that proposed by Ralph T. Coe in his catalogue essay for the exhibition titled "Sacred Circles: Two Thousand Years of North American Indian Art":

> If the relationship of one thing to another in terms of exact proportional measurement is unclear in Indian art, the Indian traditional assertion of attunement with his creator and his environment—one interdependent upon the other—is met at every turn. It is asserted by what, for lack of a more specific term, we may call "presence" . . . For us the word presence, existing beyond form, used here, emits such multiple associations. That is the Indian way. Seen in this way, the objects, masks, pottery, ceremonial gear, and implements become exponential. The circle often stood for unity in the Indian view, a symbol of tribal unity and a link with the universe. Let it here stand for the psychic awareness underlining the art—its life's blood at one point or another. Only by such acknowledgement are those designs, fabrications of skin and vegetal matter, and carvings no longer static but moving and alive.[16]

Such a poetic sense of the "sacred circles" as symbolic of man's organic role within the natural and supernatural worlds is exemplified by the Pawnee ceremonial drum with a painted series of birds rising above a single ascending bird (fig. 2). The synthesis of beliefs in forms that demonstrate a fluid sense of a life that is unified, and in Coe's words, "moving and alive."[17]

This concept of organic unity dominates the communal aesthetic of not only native American tribes but also tradition-bound folk groups. While the forms produced by the artists of each group vary considerably, the values expressed remain consistent. Such diverse objects as a Tlingit canoe ornament, carved from wood and painted to

provoke a supernatural presence (fig. 3), the Politaka (cloud) kachina made by the Hopi of Arizona (fig. 4), or the wood and horsehair Iroquois mask used during childbirth (fig. 5) have in common a profound connection with each tribe's religious belief system. Moreover, the various belief systems had in common faith in the presence of supernatural beings in the forests, mountains, and waters, and this assumption led to the acceptance of a world populated by spirits in the form of animals, birds, and vegetation.

Although the persistence of traditional folk cultural society has been stressed, even the most rigid belief systems are susceptible to challenge and change. Christianity made significant inroads in the belief systems of tribal groups throughout North America after the influx of missionaries and general widespread white settlement. The effect of French missionaries in the Great Lakes area can be shown by an examination of the material cultural objects produced by North Americans under French influence. A carved crucifix dated 1796 (fig. 6) is believed to have been made by a local Indian from the Detroit area for Father Gabriel Richard, a French missionary. Or perhaps more dramatically, a carved group of figures that make up a Nativity scene (fig. 7) was found in Cross Village, an Ottawa Indian settlement near the historic Straits of Mackinac. Such material evidence testifies to the "breaking" of the unified circle of traditional tribal religious convictions (fig. 8). There are many other examples of the interaction of conflicting religious value systems. Dennis Cusick's series of watercolors depicts Seneca Indians heeding the Christian call to "keep the Sabbath" (figs. 9–11). This scene of Christian Indians exemplifies the way one traditional faith was being adapted to another. Photographs such as the scene (fig. 12) of Indians at Cross Village returning from church also convey the human dynamics of social change at work at the level of society that has come to be known as folk.

Some religious rites, such as the mysterious Ghost Dance of the Plains Indians, were direct reactions to the intersection of the distinctive religious principles of faith. Many Indian tribes, rejecting the efforts of white missionaries to convert them, practiced their religious convictions in seclusion. Eventually their secrecy became a necessity as traditional native American religious rites were declared "Indian offenses" and perceived to be criminal acts against white society. One writer has noted that during that time, "Giveaway feasts, the sun dance, the time-hallowed way of burying the dead, even the building of a sweat-lodge, were punishable by a jail sentence."[18] This condition prompted a wide assortment of Plains Indians tribes to listen with hope to a Paiute Indian medicine man, Wovoka, as he explained his vision of hope for all native Americans,

the Ghost Dance. According to Wovoka's vision, a new world was on the horizon and to bring it into reality, Indians were to dance the Ghost Dance for five days every six weeks. Moving in circles, wearing clothing that symbolized their ascendant spirits, men and women danced hand in hand (fig. 13). Wovoka claimed that the Ghost Dance would bring a new world where the "white man would disappear, go back to his faraway lands across the Big Water, or simply be rolled up."[19] This translation of a Ghost Dance song offers a glimpse into the expectations of those who danced:

> I come to tell news
> I come to tell news
> The buffaloes are coming again
> The buffaloes are coming again
> My father tells
> The Dead People are coming again
> The Dead People are coming again
> My father tells
> The earth will be made new
> The earth will be made new
> Says the mother.[20]

Ironically, this inspired religious ritual dance was misunderstood by white observers to be a sign of rising Indian opposition. This nonviolent religious act was used by military officials to justify the attack on Sitting Bull that resulted in his death. The Ghost Dance ritual was believed by Indians to have the potential to liberate them from white dominance by 1890. But it was used against them, resulting in the further suppression of native American re-

ligious practices. The prophet Wovoka had touted the Ghost Dance ritual as a reprieve from cultural extinction, and yet it was the result of a confrontation between Indian and Christian belief systems.

Despite the widespread assault on the folk religious beliefs of native Americans, many of their religious practices have been maintained essentially intact through the last few centuries. One little-known example of persisting material culture patterns can be traced to the Eastern Woodlands Indians of the Great Lakes region where the practice of fabricating a material culture to correspond with oral cultural traditions resulted in the development of a splint basket formed in the shape of a strawberry. The strawberry basket symbolizes the legend that Indians passing from this life to the next will be nourished at a strawberry patch during the journey (a variation suggests that a large strawberry rather than a patch will provide sustenance). Generations of Woodlands Indians have woven splint baskets in the form of strawberries, dyed them red and green to simulate the berry and stem, and then buried the baskets with their dead. As traditional community values have steadily eroded and fewer Indians have learned to make the baskets, the practice of this ritual has declined. However, there are still some basketmakers who continue to produce strawberry baskets as part of this tradition. The steps remain the same: (1) the selection of wood from a black ash tree; (2) the cutting, pounding, peeling, and preparation of the black ash; (3) the weaving of the basket; and (4) the dyeing of the basket (sometimes steps 3 and 4 are reversed). One of the celebrated weavers of these baskets was the late Alice Bennett (1895–1978), a Chippewa Indian who taught her son, Russell Bennett (b.1926), the traditional skills (fig. 14). The strawberry basket is but one indication of the durability of certain religious folk traditions, survivals of a past era when tribal life was more vital and less threatened by outside forces.

THE SPANISH CATHOLIC EXPERIENCE IN THE SOUTHWEST

Spanish Catholic Missions in America

The Spanish Catholic influence has had a dramatic effect on the culture of the North American continent. In *The Mission as a Frontier Institution in the Spanish American*

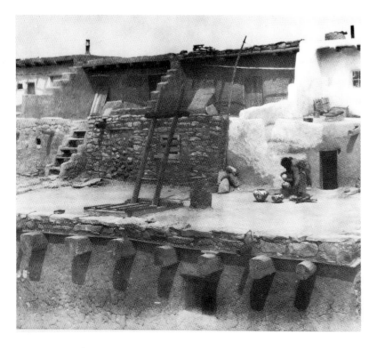

1. Kiva, Acoma Pueblo. The term *kiva* is used to describe a subterranean room that serves as the center of Pueblo Indian ritual and religious life. A ladder leads down into an inner room of this square kiva design, which differs from the round kivas of the Rio Grande area. (Photograph: Museum of New Mexico)

Colonies, Herbert Eugene Bolton calls attention to that impact:

> One of the marvels in the history of the modern world is the way in which that little Iberian nation, Spain, when most of her blood and treasure were absorbed in European wars, with a handful of men took possession of the Caribbean archipelago, and by rapid yet steady advance spread her culture, her religion, her law, and her language over more than half of the two American continents, where they still are dominant and are still secure.[21]

Even though there were settlements in Florida as early as 1565 (St. Augustine), this area was never to become especially fruitful for the Spanish empire; rather, it was the Southwest where Spanish missionary activity made tremendous inroads. As a direct response to the tales of the Seven Cities of Cíbola (also known as the Seven Cities of Gold), the expedition led by Francisco Vásquez de Coronado revealed the potential for missionary work, as well as the natural wonders of the Grand Canyon, the Zuni villages of New Mexico, and the territory known today as Oklahoma, Kansas, and western Texas. Eventually, the area known as New Mexico expanded to include much of what is now Arizona, Colorado, Nevada, and Utah.

In addition to the Southwest, another major area of Spanish Catholic influence was California. The success of the missionary zeal of the Spanish in California was immense, as Sydney Ahlstrom has so categorically stated:

> In California, the mission system prospered as nowhere else, chiefly because the Indians were not warlike, olive trees flourished, grain grew bountifully, and sheep and cattle multiplied so rapidly that whole herds had to be slaughtered for lack of an adequate market. Equally important was the fact that white settlers did not swarm in to disrupt the situation . . . Each of California's twenty-one missions was adjacent to a village where from one to three thousand Indians lived. Between 1769 and 1845, perhaps a hundred thousand of them were baptized through the labors of 145 Franciscans, of whom 45 were at work in 1805—their year of maximum strength. After they had been won from their wilderness ways, they were given the rudiments of Christian nurture, then fitted to the demands of a hundred western tasks . . . They tilled the land, herded stock, tanned cowhides, built roads and bridges, and in order to raise a mission chapel, they quarried stone, hewed beams, and molded bricks . . . The missions were thus the most important institutions of Old California, undergirding both its social and economic life.[22]

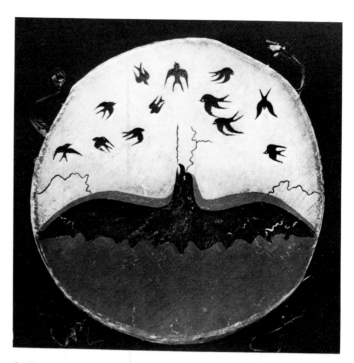

2. Pawnee painted ceremonial drum. Collected by George Dorsey, 1902. Painted rawhide, double-headed, 3¾" x 23" diam. This painted ceremonial drum depicts stylized birds in flight. The supernatural animal imagery is widespread in American Indian material culture. (Field Museum of Natural History)

Even though California did provide a receptive cultural climate for missionary work by the nineteenth century, the earlier Spanish colonization of the Southwest and the period that followed produced perhaps the most distinctive religious folk arts in North America.

The *Santero* as Symbol Maker

The earliest record of the existence of European religious art can be traced to the epic story of the Oñate expedition of 1598 recorded by Gaspar Pérez de Villagrá.[23] Two simulacra are mentioned among the articles in the newly established New Mexican colony. Some twenty years later a record of the supplies for Franciscan missionaries led by Fray Alonso de Benavides (1624) listed religious paintings and statuary among the many other items brought by the missionaries.[24] Such early accounts of religious articles are quite limited and not directly related to the later rise in local folk art production. The successful Pueblo Indian rebellion of 1680 has been cited as being partially responsible for the destruction of what religious art there was, but whatever the causes, little information exists. Archaeological remains give only remote clues as to what art was in use during the period between 1598 and 1680 in New

Mexico. The period that followed was to become known as the era of the *santero*.

It is widely agreed today that the *santos*, the depictions of holy subjects made in colonial New Mexico, were fundamentally different when compared to the religious art of other Spanish colonies. E. Boyd has concluded that the differences existed in the "materials, intensity of feeling and lack of theatrical affection."[25] To grasp the nature of the cultural geography of New Mexico, the comments of George Kubler are most instructive:

As soon as we examine the map of Spanish America, a striking phenomenon becomes apparent: artistic geography and political geography do not correspond. The latter is integral and monolithic, while the former is both multiple and diverse . . . The answer becomes apparent only when we realize that political territories exist because of spiritual affinities and elusive harmonies whose presence has been overlooked . . . Such an atlas of artistic geography contains fewer states than the political atlas. Their governments are tenuous, since no one rules, unless it is each individual artist or craftsman, confronted by his own world of forms, and seeking out his alliances and treaty partners more by affinity and sympathy than by rule of force.[26]

Kubler has proposed that the santero of New Mexico can be related to the artistic traditions of an area that includes Mexico, north and west of the Valley of Mexico (including the southwestern United States). The initial art-making tradition that was to find a place in the American Southwest was brought into this region from Mexico until approximately 1750. But in the years that followed, right through the end of the nineteenth century, local artists—the santeros—drew on the past religious imagery plus localized folk community values in the creation of their work. The santero occupied a prescribed place in the folklife of the local communities of New Mexico. To fashion evocative renderings of localized versions of religious attitudes and aspirations was the santero's mission. These provincial artists developed their patterns of expression in a traditional folk manner. Some art historians have stressed the fact that these artists and their peoples lived in isolation, since the New Mexican territories developed apart from the other Spanish colonies to the south, resulting in an emerging sense of independence and self-reliance.[27] This condition allowed for the development of a distinctive folk tradition that shaped the art that was to be produced in New Mexico.

It must always be remembered that the religious folk art of New Mexico cannot be divorced from the religious life of the New Mexican. Perhaps José Espinosa has stated this inextricable connection best:

New Mexican santos, like all Christian images, were intended to function as vincula between God and His creatures by evoking the personalities of Christ, His mother and the saints, coming into existence without artistic theory and unaccompanied by the ends of profane art . . . Their folk art was not imposed upon their religious practices, but on the contrary, issued from those practices . . . New Mexican religious folk art was periodic and local, within the framework of a faith which is timeless and universal. Historically and religiously, the importance of this art lies in its being such a sincere and complete expression of the spirit that produced it.[28]

Such religious folk expression took its purest visible form in what are commonly referred to as santos. The term *santo* in Spanish is both a noun (a "holy person" or "holy subject") and an adjective simply meaning "holy." Although this term was widely applied to an assortment of religious objects, more definitive terms were also used. The *retablo* was a painted canvas or wood panel that most frequently took the form of an altar screen (fig. 15). Retablos were usually executed over hand-hewn pine that was treated with gesso before painting and finished with a wax and/or rosinlike coating. *Bultos* were carved religious figures that either were completely carved in the round and with careful attention to all the details of the figure (also referred to as *imagen de bulto*) (figs. 16, 17), or were partially carved versions with only the heads, the hands, and sometimes the feet fully delineated and the body of the figure clothed in handmade vestments (also known as a *bulto a vestir*). The santero used primarily cottonwood or pinewood, locally made gesso from gypsum, and both imported and native water-based paints (the most common imported paints were vermilion and indigo). With these limited resources the santero set out to fabricate what one writer has referred to as "The homemade personable saints of New Mexico . . . born out of a deep-felt spiritual need, in their creators as well as in the persons requesting them, and not from any commercial motive or even for art's sake alone."[29]

Today's viewer of earlier santos figures is often baffled by the preoccupation with death evidenced by the carved death carts and the elaboration of somber religious personages and funeral processions. To modern eyes this material folk culture seems puzzling. How could one live in the constant presence of these reminders of death? In answer to the query, the New Mexican would have likely responded as the Mexican poet Octavio Paz has written of his own country's preoccupation with death, "The Mexican chases after it, mocks it, courts it, hugs it, sleeps with it; it is one of his playthings and his most lasting love."[30] However, there are some significant differences between this thoroughly Mexican outlook and that of the New Mex-

ican whose preoccupation with death never allows for humor in the face of man's predicament: death's inevitability. For the New Mexican, the awareness of death is a solemn state of mind that makes man yearn for God's forgiveness, never knowing the certainty of God's grace. The New Mexican psyche is thus psychologically prepared to live the life of a penitent, accepting his suffering as part of his life on this earth and expressing that state of being through the creation of santos figures and through participation in dramatic Penitente activities such as self-flagellation and simulated crucifixion.

The santero fulfilled the expectations of his community by producing a complex set of symbols, related to religious convictions, that mirrored each man's personal relationship to his Catholic view of God. Although each santos figure was an individualized work of art, there remain some basic commonalities between the depictions of particular saints, events, or even processional figures. New Mexican santeros responded to the more localized folk interpretations of their Catholic convictions. Rather than resulting in work that followed the lead of the other early Spanish colonies, geographic separation encouraged the cultivation of folk arts that were infused with the distinctive folklore surrounding their particular experience. Such a situation provided fertile ground for innovative folk expression and led to the introduction of more humanistic renderings of saints rather than the conventional manner of Mexican and Spanish iconography. Among the Franciscans who settled in New Mexico was Fray Andrés García, who was born in Puebla, Mexico, and lived in New Mexico from 1748 to 1778. He is acknowledged as the earliest known santero in New Mexico. Bultos, retablos, santos, and assorted church articles are known to have been made by Fray Andrés García, and some still remain in the villages where they were made. Even though some fragments of another artist's work still exist, little is known of this so-called Eighteenth Century Novice Painter.[31] Pedro Antonio Frequís (1749–1831) holds the distinction of being the first native-born santero in New Mexico, based on what evidence remains for scholars to examine. Many of his works were signed with the brand *PF*, either on the reverse of the piece, or within the actual composition. E. Boyd has noted that the brand appears on the "rump" of animals such as the donkey in his depiction of The Flight into Egypt.[32] Other notable santeros such as Molleno, the "Laguna Santero," and "A. J. Santero" seem to have been displaced in the minds of most historians by a prolific and well-documented pair of santeros, with nearly identical names. Unrelated to one another, each left a distinctive body of art. José Aragón, who was productive in New Mexico from 1820 to 1835, is recognized for "delicacy and rather sweet red, pink, and blue color schemes."[33] Also, his many works

reflect his articulate nature through descriptive titles or prayers within the composition of his works. The other, José Rafael Aragón, associated with the village of Cordova, was especially active during the period from 1826 to 1850. Characterized by stark backgrounds for simple yet clearly painted figures, his imagery conveys a passionately didactic religious quality even today (fig. 16). Although the folk traditions of the New Mexican santero were carried on by some local folk artists such as Miguel Herrera, J.R. Velásquez, and J. B. Ortega, it is surprising to realize that so few santeros were at work in the eighteenth and nineteenth centuries.

The period from 1790 to 1850, often referred to as the Secular Period, marked the rise of the Penitente Brotherhood (Los Hermanos Penitentes). Because of its role in the local community, the material culture of the Penitentes deserves careful scrutiny. The Penitente Brotherhood, a lay religious group (the Third Order of Saint Francis) among the Catholics of the Southwest, has often been misunderstood. Although the origins of the Penitente Brotherhood have been much disputed, scholars such as Marta Weigle are convinced that the Penitentes were not "aberrant." "They exist well within the history of Spanish Catholicism and its mystical, penitential, and Franciscan traditions. Maintained by colonists isolated on a hostile frontier with a climate similar to their Spanish homeland, it is not surprising that this is so."[34] The Penitentes, best known for their processions that include self-flagellation and simulated crucifixions, attempt to act out local folk religious customs, as Weigle has observed:

. . . Perhaps, the most overall perspective on the Penitente is as a folk religion with unique historical and sociocultural complexities. This designation is not derogatory in the slightest. The term denotes a traditional, relatively organized system of religious beliefs, symbols, and practices shared on a community level. These are clearly related to the theology, liturgy, and hierarchy of the official religion, but the exact relationship is variable. Thus, e.g., the local folk religion may coexist with the more universal religion, or it may be in active tension with current, official doctrine and practice. In fact, throughout their history, the Penitentes have had to accommodate to changes in Church and State policies while maintaining rituals and activities satisfactory to their own spiritual and social needs.[35]

Often the attention of scholars to the art of a people ignores or devalues the formalized setting or context in which the art was utilized. Knowledge of where and how art objects were used provides critical information to achieve a fuller understanding of material culture. In the case of the folk arts of the Southwest, each individual

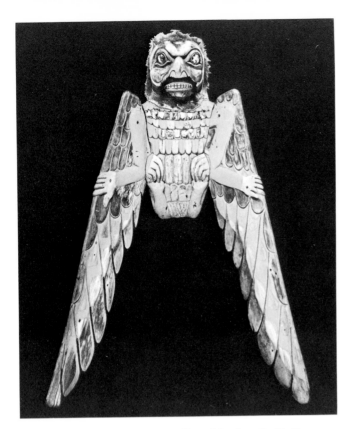

3. Tlingit canoe ornament. Collected by Lt. G. T. Emmons, 1902. Carved and painted wood, 52″ x 32½″. Although the canoe ornament has long been regarded as a unique local artistic cultural tradition, recent studies have suggested that there may have been Asian interactions with Northwest Coast Indians. (Field Museum of Natural History)

village had a series of places that were focal points for the religious activities of the folk group: the parish church (*parroquia*); a *camposanto*; a *morada*; a morada yard; and *calvarios* (sites where large crosses were mounted as processional settings). The most significant religious site was the morada, a building that normally was composed of two rooms: a chapel and a meeting room for the Penitente Brothers. Among the ritual objects found in use by Penitentes at a morada were candelabra, lanterns, wooden clackers, drums, and the better-known large Penitente crosses that were left outside the morada. More critical to the ritual experience of the participants in flagellation rites were the yucca or rope whips and flints to inflict cuts on the body. It was also common to maintain an area, sometimes with a tub or basin, for cleaning the wounds of the Penitentes. Finally, a collection of santos was housed in the morada, and often small crucifixes were hung on the walls.

The death cart (*carreta del muerto*) (fig. 19) has perhaps the most lasting impact on the uninformed viewer of the material folk culture of the Southwest. Originally, the image of a death cart appeared in late medieval stage productions and even as early as 1600 in a Mexican fresco,

but the Penitente death cart took on deep cultural meaning in the folklife of the Southwest. Also called Doña Sebastiana, the carved skeleton figure was usually armed with a bow and arrow or a hatchet and was seated in an oxcart. Traditionally, stones filled the cart to stress the burden of man's penance in his inevitable battle with death. Ely Leyba has written of this human condition in this way: "They believed that if any person would pray to the image of Sebastiana, that their lives would be prolonged, so each time they came to a church, a prayer was offered to this image [which was frequently housed in the parish church], and again and again they prayed with devotion before it."[36] Although such carved death carts continue to be made today in keeping with the role that the form served in the past, they are but a reflection of a time when the death cart stirred a deeper intensity in devotion.

The traditional role of the santero has been retained into the twentieth century. Santeros such as José Dolores Lopez, George T. Lopez, Leo Salazar, and Horacio Valdez (figs. 20–24) continue to produce objects with religious themes that are guided by a sense of community aesthetic that is shaped by the past and the everyday life of the present. As folk artists, these santeros respond to their local community in the same way as their audience. While they integrate some values of the broader audience beyond their own immediate community, their art is designed to appeal to and please their friends and neighbors. The changes in character of the santos figures, such as unpainted cottonwood that in the past would have been painted, serve as a reminder of the living nature of the folk process. These carvings do not conform to George Kubler's category of artistic "fragments": "isolated pieces of the native tradition are repeated without comprehension, as meaningless but pleasurable acts or forms."[37] In direct contrast, the behavioral pattern that instructs the artistic process is vital and feeds on both tradition and changed contexts.

THE NEW ENGLAND PURITAN EXPERIENCE

The Puritan Aesthetic: "Making Abstruce Things Plain"[38]

The prevailing perception of the cultural life of New England Puritans has been colored by popularized accounts of the lives of its most important citizens. Such liberties taken with Puritan cultural history have left the deep impression on the minds of most Americans that Colonial New England Puritan life was devoid of visual artistic expression. Allusions to the purging of churches of the "idolatrous arts of painting, free standing sculpture and stained glass windows—as signs of pernicious Roman Catholic influence"[39] have been numerous in Puritan lit-

erature and even more widespread in later historical treatises. Through the last three centuries, writers have unfortunately all too quickly equated the visual artistic expression with the "enthusiasm" that Puritans were known to abhor. The accounts by William Bradford in his "History of Plimouth Plantation" of the "great licenciousness at Meriemounte" and the reaction of "Mr. John Indecott . . . who visiting those parts caused the May-polle to be cutt downe (and rebuked them for their profanes)[40] have been used to ascribe an ascetic character to Puritan life. There remains, however, a body of visual artistic expression, the folk arts, largely overlooked and dismissed because they are so deeply integrated into the lives of the Puritans.

An often-quoted passage from Moses Coit Tyler's *History of American Literature* has been used inaccurately to sum up the accomplishments in the visual arts (or purported lack thereof) in Puritan New England:

> In proportion to his devotion to the ideas that won for him derisive honor of his name, was he at war with nearly every form of the beautiful. He himself believed that there was an inappeasable feud between religion and art; hence, the duty of suppressing art was bound up in his soul with the master purpose of promoting religion. He cultivated the grim and the ugly . . . In the logic and fury of his tremendous faith, he turned away from music, from sculpture and painting, from architecture, from the adornments of costumes, from the pleasures and embellishments of society.[41]

This summary has led many writers to conclude that aesthetic Puritan values were idiosyncratic and have in no way provided a legacy for the visual arts in America. Such an attitude has clearly drawn its generalization from a comparison of the developed cultural life in England (London in particular) with the cultural life of New England, which was still in its infancy. Closer examination of Puritan culture reveals a quite different picture, as noted by John Kouwenhoven:

> The forms we have so long neglected . . . are in reality the products of a unique kind of folk art, created under conditions which had never before existed. They represent the unself-conscious efforts of common people to create satisfying patterns out of the elements of their environments

. . . It is the art of sovereign, even if uncultivated, people rather than of groups cut off from the main currents of contemporary life. The patterns it evolved were not those which are inspired by ancient traditions of race or class; on the contrary, they were imposed by the driving energies of an unprecedented social structure.[42]

The Puritan's visual aesthetic is intricately interwoven into the very fabric of the cultural life of the seventeenth century. To untangle the Puritan view of art, one must adopt a revisionist position in reassessing the role of visual expression in Puritan life and its lasting influence on the mature American art tradition. Three myths need to be dispelled: (1) the myth of *scarcity* of artistic production; (2) the myth of *art as frivolity;* (3) the myth of an *antiaesthetic* Puritan past. Central to the disposal of these myths lies the cultivated plain style of prose employed by the Puritan ministry. The "plain style" and the elaborate religious morphology of conversion have implications for the visual arts and provide critical insights into the Puritan aesthetic.

The Myth of Scarcity: An Overlooked Heritage

The "myth of scarcity of artistic production" has grown out of the images of sterility often conveyed in depictions

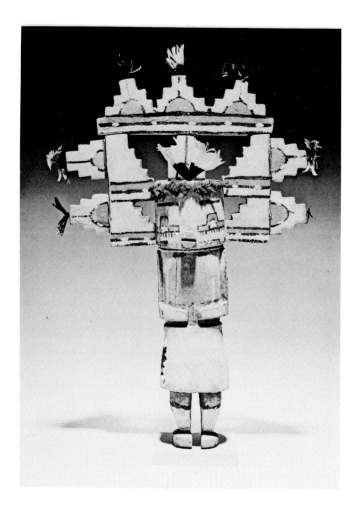

4. Pueblo (Hopi) Politaka (cloud) kachina. Arizona. Collected in 1890s. Carved and painted wood, 15¼″ x 9¾″. The kachina as an artistic form has evolved from a simplified figure to a carefully rendered depiction of one of the approximately 350 Kachina spiritual forces that comprise the Pueblo spiritual world. (Denver Art Museum)

of the Puritan encroachment on an American wilderness with little time for leisure (in the twentieth-century sense of that word). On the contrary, one can learn through numerous diaries and written accounts that the Puritans not only found time for self-expression through their formal commitment to personal histories but even encouraged the act through their ministry. The widespread phenomenon of Puritan literary activity, today more fully acknowledged,[43] can be contrasted with the still lingering misconception that there was a paucity of visual artistic activity. This misconception stems from a narrow concept of what constitutes art. Scholars have searched for "high-style" forms of expression similar in manner to those of London. The empirical evidence proves that very little of that kind of material culture was produced in Colonial New England. But when one turns to the type of visual art actually created, one unearths a significant body of work. As pointed out by Talbot Faulkner Hamlin in *The American Spirit in Architecture:*

> Throughout the seventeenth century, farming and fishing remained the chief industries, and the ministry the only profession. As a result, all sorts of home industries—spinning, weaving, quilting, and all the varied activities that a home requires—throve. Despite the growing importance of seafaring, despite the growing number of skilled tradesmen, England remained remote and money scarce. Only that was bought which could not be made; the colonist of those times and his wife had become true jacks-of-all-trades.[44]

Although rarely discussed at length in Puritan literature, the artisan and the handcraft tradition were part of daily life in Puritan New England. The "jack-of-all-trades" label was in fact a reality for many Puritans, as Richard McLanathan has noted in *The American Tradition in the Arts:*

> Those who knew a craft or set out to learn one did especially well. Some combined half a dozen activities. John Hull, for instance, was a farmer, a blacksmith, a breeder of cattle, and a merchant whose ships traded with the West Indies, England and Spain. Not only the first and one of the best colonial silversmiths, he also served as treasurer of the Bay Colony and as mintmaster, produced the famous pine tree shillings . . . There was always work for turners, joiners, carpenters, millers, housewrights and shipwrights, blacksmiths and whitesmiths, shoemakers, saddlers and coopers, and [one] rarely limited himself to one category, but turned his hand to whatever was needed. And especially in the earlier days, so many of the basic necessities had to be supplied that there was little time for any but the most useful.[45]

The rubric of *craft* has long been assigned an inferior place in the realm of art history. Yet, the most powerful statements of Puritan visual artistic expression were made *within* the craft tradition. In the last twenty years, there has been a reawakening to the common sensibilities that are shared by art and craft idioms, resulting in greater appreciation of craft techniques. The prevalence of home industries and the widespread mastery of useful skills produced a craft tradition at the expense of a European fine arts tradition in Puritan New England. A number of factors have to be taken into account to convey accurately the ways in which the arts were subordinated by the Puritans to a commonplace position in a society that stressed practicality. Their art was not created as a statement of limited and unique divine revelation, contrary to the common belief. Much has been made of the prominence of gravestone carving as a sculptural form, owing primarily to the fact that gravestones have survived intact in great numbers. The "uniqueness" of the gravestones has been the subject of heated debate.[46] Gravestones stand as a testament to the popularity of "many conventional images and forms" and "also infinite variation within the limits of convention" in Puritan visual language ("not to mention unconventional designs, which suggest . . . rather than residual embellishment, an artistic consciousness at play in the carving process itself"[47]). Other media in Puritan folk arts, such as textiles, furniture, and the decorative arts, also demonstrate traditional images as well as infinite variation. Scarcity in these more perishable media is a result of the dual role of aesthetic expression and function. Few textile examples remain today, because of extensive use and the natural erosion of fibers. Coupled with the practice of re-using woven fabric in other objects (mattress filling and patchwork creations, for example), these factors have severely limited the number of extant examples. But early accounts of quiltmaking in American home magazines attest to the tremendous number of quilts made in Colonial America. In 1883, *Arthur's Home Magazine* stated that

> three-quarters of American bedcovers were quilts . . . It is probably safe to say that in earlier times almost all American homes used some quilts, along with their home-woven blankets . . . In many parts of the country there was a custom that a young girl make a baker's dozen of quilt tops before she became engaged, twelve utility quilts and one great quilt for her bridal bed.[48]

Such frequent references to other textile media offer evidence to support the conclusion that domestic artistic activity was a part of Puritan life.

The Puritan home was the center of artistic production and display, although on a modest scale:

The spirit of pride in new homes, recently established in what had been a wilderness, expressed itself in ways that went beyond the purely functional. Blankets and coverlets were woven in decorative patterns, chests were carved and painted in variations of designs handed down for generations and were often inscribed with initials and dates, bed hangings were embroidered, the curtains were hung at the windows.[49]

Contrary to common opinion, the use of bright colors was common in Puritan homes. Today one can often see only traces of the brightly dyed fibers used in samplers, bed rugs, quilts, and other textile forms, which have faded through the centuries. In addition, since the time of the earliest Puritan settlements, both the Puritans and many of their neighbors painted their furniture with vividly colored pigments, including red, yellow, green, and blue. As is the case in textiles of the same period, the natural aging process has tempered the true colors that graced these and other household objects. It is to the home, then, that one must turn to assess accurately the quantity and quality of artistic production in Puritan New England.

The Myth of Art as Frivolity: "They Who Covet More Sauce Than Meat, They Must Provide Cooks to Their Minde"[50]

"His way of preaching was plain, aiming to shoot his Arrows not over his people's heads, but into their Hearts and Consciences . . . The Lord gave him an excellent faculty in making abstruce things plain . . ."[51] In such a way did Increase Mather describe Richard Mather (fig. 26). The religious elite was able to impart Puritan theology more effectively and to a greater number by relying on a "humble and submissive plain style," as Perry Miller and Thomas Johnson have explained: "Puritans adopted plainness to give the application of their sermons more force and directness; there is ready use of figure in their sermons, but the intent is less to enrich the color of the prose than to vitalize the point at issue, to intensify the concreteness, or clarify the doctrine."[52] Like Puritan preaching, Puritan writing has long been synonymous with the use of the plain style, which served as a vehicle to project a message, for the art of writing was far from a vacuous pattern of communication. In the same fashion Puritan visual arts were not mere frivolity but served a utilitarian purpose.

"Let not what should be sauce, rather than food for you, engross all your application,"[53] advised Cotton Mather. The plain style in Puritan literature was a response to the belief that artistic embellishment played a subservient role to utilitarian arts. John Cotton viewed the plain style as a reaction to an art that, by casting a magic spell,

"tempted men away from truth to fable."[54] It is for this very reason that the visual arts tradition was shaped by a "plain style" that emphasized functionality and simplicity rather than dramatic spiritual revelation. As McLanathan has observed, "The Puritans shared with their times the idea that the arts were largely practical . . . But even more than their contemporaries, they believed that the arts, in the limited use of them that the Puritan faith allowed, were part of life rather than an adornment, and were supposed to fulfill a useful purpose."[55]

Any discussion of Puritan folk art usually focuses first on the incorporation of utility in form and second on the particular way in which the artist created his "style." Through the use of his linear and flat technique the artist attempted to project a truth of vision rather than to captivate an audience with a cultivated style. Such a combination of graphic technique and adherence to truth of vision enabled the folk artist to serve admirably as historian, in the Puritan sense espoused by Urian Oakes and summarized by Miller and Johnson:

> The first function of the historian is to relate everything that has happened, to exclude nothing, to erect no standards or criteria on a purely human basis . . . Yet at the same time the historian is not merely to relate what has happened, but to interpret it. He must show wherein events have fulfilled God's purposes wherever the purposes can be ascertained.[56]

The folk artist records what he knows to be true, regardless of the principles of perspective and proportion, "to relate everything that has happened, to exclude nothing." The plain style of artistic expression was a natural extension of the literary dictate of Increase Mather that encouraged others "to shoot their Arrows not over people's heads, but into their Hearts and Consciences."[57]

The imagery of the folk art expression of Puritan New England is filled with depictions of man, nature, and poetic symbolism.[58] The art served to reinforce the restraint and order that the Puritans' morphology of conversion imposed on their lives. Aesthetic considerations were to serve as social instruments for the Puritans. Miller and Johnson note that "The Puritan conceived beauty as order, the order of things as they are, not as they appear, as they are in pure and abstract conception, as they are in the mind of God."[59] The development of this distinctive American folk art tradition is deeply rooted in a concern for understanding things as they are, not as they appear. This attitude contrasts sharply with many European fine art traditions that are founded on appearances, leading some contemporary art historians to speculate that the American folk art tradition was the forerunner to the in-

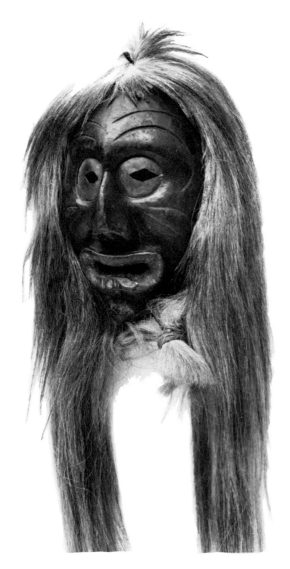

5. Iroquois (Seneca) mask. Genessee Valley, New York, 1905. Carved and painted wood with horsehair and tin, H. 10¾″. Iroquois masks, or "false faces," are often praised for their dramatic, aesthetic qualities but it is important to remember that these masks were sacred religious objects in tribal life. This mask was used during childbirth. (Museum of the American Indian; Joseph Keppler Collection)

troduction of abstract ideas through abstract art in the twentieth century.

Barbara Novak has capsulized the essence of folk art as embodying much of the character of the Puritan plain style:

It has always amazed me that the primitive [folk artist] can work directly in front of the object, aiming hard for realism, checking constantly back to the object as he works, and yet end up with something that is much truer to the mind's eye than to anything the physical eye has perceived . . . The

primitive work, obviously ideographic, has an appealing decorative sense of abstract rhythm, which caused the artist to repeat the curved motif . . . The conceptual nature of the American vision is one of the distinguishing qualities in American art. It is accompanied by a strong feeling for the linear, for the wholeness of objects that must not rationally be allowed to lose their tactile identity.[60]

The Myth of an Antiaesthetic Puritan Past

Lord Guide My Heart that I may do thy will
And find my hands with such convenient skill
As will conduce to virtue void of shame
And I will give Glory to Thy name.[61]

These words were embroidered into a sampler made around 1636 by Loara Standish, daughter of Puritan leader Myles Standish. The often-used verse conveys the interrelated nature of the practical arts and religious artistic expression. The concept that Puritan life espoused an antiaesthetic attitude is clearly inconsistent with Puritan thought. In the words of Dickran and Ann Tashjian, "the plain style was perhaps the first popular American art form, created by a religious elite to convey their complex ideas to the populace at large."[62] The adaptability of Puritan religious doctrine to secularization in the eighteenth century has been carefully established by twentieth-century social historians, who have acknowledged that the seeds of the American personality were planted in Puritan theology. Puritan attitudes toward artistic expression have affected contemporary approaches to art in America. The essential stress on functionality and simplicity in the service of a higher purpose was inherent in the Puritan aesthetic. Functionality, in particular, has led to the acceptance of technology in the creation of American art. John Kouwenhoven has commented on the American contribution to the art of the times: "The men and women who built a civilization in the American wilderness had to relearn a truth which many of their European contemporaries had been able to get along without, the truth of function."[63] The emphatic stress on function shaped American artistic expression, and the corresponding restraints on style of expression characterized much of American art through the nineteenth century and served as a catalyst for the art of this century.[64] The Puritans left an artistic legacy that has affected the life of every American's aesthetic experience.

Material Culture in Puritan New England

Puritan religious material culture was shaped by the need to maintain a plain style of aesthetic values. The most

appropriate center of the practice of the plain style was the Puritan meetinghouse, which was truly a functional space for both sacred and secular activities, but the latter often dominated. In a major study entitled *New England Meeting House and Church: 1630–1850*, Peter Benes and Phillip D. Zimmerman defined the uses of this Puritan structure:

"Meeting house" as a term first occurs in American usage in 1632, when John Winthrop alludes in his *Journal* to the "new meeting house" at Dorchester, Massachusetts. By it he meant, simply, the house that had recently been built in Dorchester for the purpose of holding religious and secular meetings. The term was deeply significant because implied in its use was a definition of the term *church* that distinguished Puritans who accompanied Winthrop from the Church of England whom they left behind. To Winthrop, a church was a covenanted body of people. As Richard Mather was to state later, "There is no just ground in scripture to apply such a trope as church to a house of public assembly."[65]

This led to the acceptance of the view that a building could serve both the municipal and religious needs of a local community. Benes and Zimmerman have discovered that the meetinghouse served diverse roles within its community, functioning as a schoolhouse, courthouse, meeting hall, town hall, parsonage, powder house, and fortress. It has been estimated that during the period from 1630 to 1850 between three and four thousand meetinghouses were built in New England, with the vast majority being constructed in the eighteenth century. Thus, meetinghouses played a central role in the lives of Puritan and Protestant communities throughout New England.

Recent studies have revealed that New England meetinghouses were far from austere in terms of their decoration. The Benes and Zimmerman study concluded that "rural meeting houses" after 1760 are known to have been painted yellow, orange, white, brown, blue, and green. Some were painted in combinations: for instance, a yellow front with a red roof and back, as in Harwich, Massachusetts (1792), or light yellow clapboard with green doors, as in Keene, New Hampshire (1790). Until the nineteenth century, the most common clapboard colors were "spruce yellow," "light yellow," or "yellow," and the most common roof color was "Spanish brown" (a dull red).[66] Aside from the exterior colors, there were other notable common features in New England meetinghouses. The pulpit was often stark and simply constructed but, on occasions, a carved archangel Gabriel might hang above it as in the meetinghouse in Royalston, Massachusetts, or a painting of an angel or a cherub might hang above the pulpit.[67] Other decorative touches included the widespread use of a pulpit cushion and a pulpit hourglass for the often lengthy Puritan sermons. The importance of the hourglass was mentioned in the diary of Samuel Sewall. He wrote of his failure to time his sermon and the unfortunate results: "Being afraid to look on the glass, ignorantly and unwittingly I stood two hours and a half." Obviously, the hourglass on the pulpit was of particular interest not only to the minister but to the congregation as well.[68]

The pews were covered with cushions decorated by needlework. Footstools and armrests also displayed embroidery. In the eighteenth and nineteenth centuries a young girl's education stressed needlework as being a necessity so that both the church and the state would prosper. Although Cotton Mather in his book *Ornaments* stressed above all else religious education for women, he also wrote of the "virtuous Maid" that she "learned housewifery and needlework."[69]

Before the rise of the numerous seminaries for young girls that appeared in the early nineteenth century, most young women learned their basic needle skills at home or at dame schools, within the prevailing folk pattern of transmission: the oral tradition. As in the years that were to follow, the sampler comprised a full assortment of newly learned stitches in a relatively formalized composi-

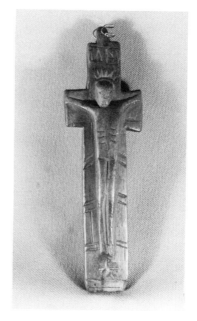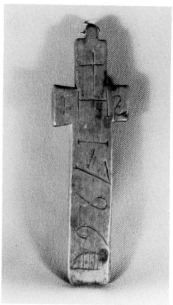

6. Potawatomi crucifix (front and back). Detroit area. 1796. Carved wood, 5¼". This crucifix is believed to have been carved by a Potawatomi Indian for Father Gabriel Richard, a French missionary. (Photograph: Folk Arts Division, The Museum, Michigan State University; collection of Mr. and Mrs. James O. Keene)

tion. Among the earliest of these samplers are pictorial depictions of biblical stories, which were especially suitable for young women, in keeping with Cotton Mather's attitude toward the ideal "virtuous Maid." In 1744, Mary Williams created a needlework picture titled "The Queen of Sheba Admiring the Wisdom of Solomon (fig. 27). Such attempts to translate an Old Testament tale into visual statements often resulted in a loss of historical accuracy, as in this work in which the figures, including Solomon and Sheba, are stitched in Colonial dress. Other biblical stories were re-created in stitchery, such as the story of Adam and Eve in the Garden of Eden (fig. 28) and the hanging of Absalom by Joab (fig. 29). The influence of prints on the depictions of these tales seems most likely, because different versions of these stories display common elements and compositions.

The sampler by Mary Titcomb of Newport, Rhode Island, of around 1760, which also depicts an Adam and Eve scene, is quite noteworthy because it is made of crewel stitchery on linen (fig. 30). Crewelwork in New England, although popular, was decidedly less complex than that produced in England, and the stitches were usually confined to the following: buttonhole, flat, herringbone, running or outline, French, and bullion knot.[70] The few examples of early New England crewelwork still extant tend to be sections of bed curtains. The most remarkable examples are those created by Mary Bulman of York, Maine, around 1745 (fig. 31). The valances, embroidered on linen, are filled with flowers and trees and carefully rendered verses expressing religious fervor. Two of the verses read as follows:

(Footboard panel)

Jesus Has All My Powers Possest
My Hopes My Fears My Joys

He The Dear Sovereign Of My Breast
Shall Still Command My Voice

Some Of The Fairest Choirs Above
Shall Flock Around My Song
With Joy To Hear The Name They Love
Sound From A Mortal Tongue

His Charms Shall Make My Numbers Flo
And Hold The Falling Floods
While Silence Sits On Ev'ry Bough
And Bends The Listning Wood

(Side panel)

I'll Carve Our Passion On The Bark
And Every Wounded Tree
Shall Drop And Rear Some Mistic Mark
That Jesus Dy'd For Me

The Swains Shall Wonder When They Read
Inscribed On All The Grove
The Heaven Itself Came Down And Bled
To Win A Mortals Love

There remain additional examples of needlework that seem entirely original concepts. Prudence Punderson Rossiter (1758–1784) of Connecticut, for example, stitched needlework pictures of each of the twelve disciples, in which she captured their individual character. Borrowing the attire and setting from Colonial life, the artist created a noble portrait of St. James leaning on a Queen Anne side chair. She also stitched a pathetic view of Judas fallen from the tree on which he had hanged himself (fig. 32). The inscription below Judas reads: "Judas Iscariot, who betray'd his Lord and hang'd himself." These scripturally based creations, like other needlework pictures of the eighteenth century, were directly inspired by the New Testament.

In addition to being influenced by Scripture in their choice of iconography, eighteenth-century artists were inspired to create works that documented their religious life. Numerous examples of needlework samplers, such as the sampler completed by Susan Smith in 1794, depicted the parish church as the focal point of the piece (fig. 33). Many of these attempts to document the artist's church

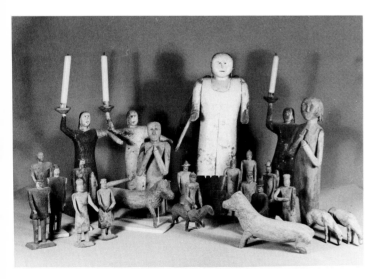

7. Ottawa Nativity scene. Cross Village, Michigan. c. 1850. Carved and painted wood, 13″ (tallest figure). The introduction of Christianity to the Woodlands Indians is visibly demonstrated in this Nativity scene made by an Ottawa Indian. (Photograph: Folk Arts Division, The Museum, Michigan State University; collection of Mr. and Mrs. James O. Keene)

also included at least one religiously inspired verse. In the sampler by Susan Smith, a verse from the Reverend Isaac Watts's *Lyric Poems Sacred to Devotion* gives this advice to the reader:

Let Virtue be a Guide to Thee

In the fair book of life divine
May God inscribe his Name
There let it fill some humble Place
Beneath the slaughtered lamb.

These needlework exercises, undertaken as a labor of religious devotion, were also placed in the homes of the makers where they entreated others to maintain their spiritual values. A more direct example of didactic needlework is Lydia Hollingsworth's sampler of 1759 (fig. 34), which depicts in a straightforward manner the Lord's Prayer and the Apostles' Creed. The embroidered prayers are surrounded by floral decoration in silk and silver thread and the top is finished off with a colorful butterfly. Depictions of religious life by New England folk artists of the seventeenth and eighteenth centuries are virtually nonexistent in painting and sculpture. It is only in these needlework pictures that one can find evidence of the churches of the period and the popular verses and prayers of the day.

The earliest-known Congregational Church of Christ was established in 1629 in Plymouth, with the goal of redefining and purifying the Anglican Church. Behind this reform movement was what Sydney Ahlstrom has identified as "a fierce tradition of anti-Catholicism, both visceral and dogmatic . . . one of Puritanism's most active legacies to Anglo-American civilization."[71] New England was to be recognized in the centuries to follow as the place where Puritanism reached its greatest acceptance and strength. However, it is important to remember, when considering the reform nature of the "Puritan experiment,"[72] that it was undertaken because, in the words of Ahlstrom again, "the Anglican church had not gone far enough in its reforms . . . But while they [the Puritans] refused to abide by some of its tenets . . . they still considered themselves a part of the Anglican church and sought only to 'purify' it unlike the Pilgrims of Plymouth who had separated from it."[73] Although other churches organized in the seventeenth century gained in numbers in the years that followed the Great Awakening, nevertheless, according to R. H. Tawney, "the growth, triumph and transformation of the Puritan spirit was the most fundamental movement of the seventeenth century."[74]

Before considering the impact of the Great Awakening on the folklife of America, the work of the New England

8. Ottawa maple sugar mold. Sault Ste. Marie, Michigan. c. 1900. Carved wood, 22½" x 3". Maple sugar molds usually were decorated with imagery drawn from natural forms. This mold with crucifixes documents the influence of Catholic missionaries. (Folk Arts Division, The Museum, Michigan State University; collection of Bayliss Library)

stonecarvers should be examined as evidence of the Puritan plain style in its truest form. Much has been written on the subject of Puritan tombstones as a folk expression of religious convictions. Harriette Forbes has noted the aesthetic function of the Puritan tombstone:

In the carvings of the gravestones, often very beautiful, always very thoughtful, we meet the most characteristic expression of the Puritan as artist . . . we have little other sculpture from his austere hand, and yet upon the graves [there are] . . . many admirable contemporary portraits, arrangements of flowers and fruits renaissant in their richness and beauty; there are ships cut in stone with the riggings of the day; even God himself is pictured rolling up

the firmament, in Newport, Rhode Island, and also in Rhode Island one may see Adam and Eve stand naked and unashamed.[75] (fig. 35)

The Puritan burying grounds, like the churchyards of England, were usually next to the meetinghouses. The earliest stones of these burial grounds had little or no ornamentation, but the late seventeenth century brought a flowering of visual expression in the handiwork of isolated rural stonecarvers. These carvers were taught through the oral tradition that governs true folk expression. Peter Benes has noted that this "folk activity was pursued against the background of a larger, commercial, popular, or cultivated activity, and assumed a folk identity from its role as a counterculture nourished by Puritan separatism and sustained by the region's physical isolation."[76] Thus, this imagery was often indigenous to a particular community and the result of a folk artist's attempt to appeal to the aesthetic of his town or village. This sense of regional identity was in keeping with the persistent character of folk culture, which did not seek a wider popular appeal to other geographic audiences.

From the earliest gravestone carvings on wood to later carvings on slate, shale, and granite, the iconography of the Puritan gravestones has prompted scholars to speculate on the clues to the religious life of New England that lie in the carvings. The most convincing work has been conducted by James Deetz, who, working with Edwin Dethlefsen, has identified three basic design elements on New England gravestones during the period from 1680 to 1820. The earliest image is the winged death's-head (fig. 36), which was then replaced by the winged cherub in the eighteenth century, which toward the end of the eighteenth century was replaced by a willow tree overhanging a pedestaled urn. This characterization of basic design elements does not deny localized interpretations of these elements by folk artists. By carefully analyzing the succession of styles as expressed in iconography, Deetz contends that a fuller understanding of the geographical influence of Puritanism can emerge:

> This stylistic succession, repeated in cemetery after cemetery, is a clear index of important changes in the religious views of New Englanders. The period of decline of death's-heads coincides with the decline of orthodox Puritanism. In the late-seventeenth century, the Puritan Church was still dominant in the area. Likewise, death's-heads were the nearly universal style of gravestone decoration. The early part of the eighteenth century saw the beginnings of change in orthodoxy, culminating in the great religious revival movements of the mid-eighteenth century known as the Great Awakening. The final shift seen in gravestone design

is to the urn-and-willow style . . . These changes seem to indicate a secularization of the religion . . . Some have seen the Puritans as "iconophobic," feeling that to portray a cherub would be to introduce the image of a heavenly being, which could lead to idolatry. The death's-head was a more earthly and neutral symbol, serving as a graphic reminder of death and resurrection. During the Great Awakening, in the period from the 1720s to 1760s, revivalist preachers such as Jonathan Edwards preached a different approach to religion, in which the individual was personally involved with the supernatural. Such a view was more compatible with designs such as the cherub; it also freed the iconography of the gravestone from the rigid adherence to one symbol, the death's-head, and the trend eventually involved a softening of this harsh symbolism. Cherubs represent such a softening.[77]

Other students have revealed that there are parallels between the role of a bedboard and a headstone of a grave, for the Puritans often equated death with a state of sleep, especially the death of young children.[78] Another writer, Allan I. Ludwig, has hypothesized on the symbols of Puritan gravestones by drawing heavily on Paul Tillich's five characteristics of religious symbols: their figurative quality, their perceptibility, their power, their acceptability, and their unconditional transcendence.[79] Ludwig's work is based on the contention that "in order to be symbolic a form must be socially rooted and socially supported." He concludes his study with this pronouncement on Puritan gravestone iconography: "It was an art which substituted emblems of death, symbols of Resurrection, and iconic soul representations for the normative and allegorical cycles we normally associate with high religious art. The imagery endured and prospered until 1815 [figs. 36–40] when it finally succumbed to the neo-classical style."[80] The dissemination of the neoclassical style led not only to a religious change but also to a dramatic transformation in the way that folk artistry was transmitted. The once-isolated local folk artist was eventually influenced by popular source books that illustrated the work of formally trained artists and designers. Thus, by the beginning of the nineteenth century, New England gravestone iconography was seldom the original creation of the local folk artist in stone.

The Decline of Puritan Dominance in New England

The seventeenth century witnessed the formation of new churches. Quakers, Separatists, Baptists, and other new religious groups were to find religious tolerance in Rhode Island where they planted their roots in the New World. The much-desired separation of church and state proved to be a reality for the new congregations. Even

though other churches made inroads in New England, Puritan influence in the form of the Congregational Church of Christ was dominant until the revocation of the Massachusetts Bay Charter in 1684. This event signaled the decline of Congregational dominance, and the new charter of 1691, making Massachusetts a royal colony, introduced a substantial change that further undermined Puritan church power. Voting privileges once earned through church membership were now awarded only to property owners. Although Anglican theology was to find greater acceptance in the years that followed, the most overwhelming challenge to Puritan theology was not to surface until 1740 and 1741, the years of the Great Awakening.

The Enlightenment was an intellectual revolution shaped by Lockean principles and Newtonian thought, which set the stage for the Great Awakening. This Age of Reason was to be followed by a full swing of the pendulum of philosophical thought, which resulted in an Age of Emotion. Ahlstrom has described the nature of the Great Awakening in New England:

> The chief events of the awakening were of two sorts: first, the whirlwind campaigns of the "Great Itinerants," Whitefield, Tennent, and the highly unstable Davenport, followed by a large number of lay itinerants and clerical interlopers; second, the intensified extension of the preaching and pastoral labors of the regular New England ministers, now awakened to the power of personal evangelism. Historians have stressed the first of these because of the immense controversy it stirred up, but the latter was by far more lasting and significant.[81]

The impact of the Great Awakening did awaken the "power of personal evangelism" in Protestant churches such as the Baptist and the Methodist and it stressed the shared spiritual legacy of Americans. The most outward signs of this new emotional evangelism were the widespread reports of screaming, crying, and fainting during church sermons, but, more important, the disciplined routine of normal church life was overturned. Emotional religious zeal, stressing a common fellowship among all people, replaced the reserved dialogue of Puritan church leaders over Congregational Church doctrine. The enthusiasm of this period would not be sustained but would reappear in the Second Great Awakening in the nineteenth century.

The rise of Puritanism, the Enlightenment, and the Great Awakening were ideological movements that shaped the early American experience. The American Revolution brought with it another philosophical shift in the religious life of Americans. This change would lead to a steady decline in church membership and a growing appreciation of the natural laws of man. Lockean philosophy and Newtonian cosmology were integrated into the principles of Christian rationalism. In the words of one writer, "the natural religion flourished in alliance with revealed religion."[82]

Following the American Revolution, church life in America declined to its lowest point of influence. It has been estimated that during the period from 1780 to 1800 "not more than one in twenty or possibly one in ten"[83] seemed to have any church affiliation. The state of religion during the period of the American Revolution might best be summarized by the thoughts expressed in 1818 by John Adams in a letter to Hezekiah Niles:

> What do we mean by the American Revolution? Do we mean the American war? The Revolution was effected before the war commenced. The Revolution was in the minds and hearts of the people; a change in their religious sentiments of their own obligations . . .[84]

Notes

1. S. G. F. Brandon, *Man and God in Art and Ritual: A Study of Iconography, Architecture and Ritual Action as Primary Evidence of Religious Belief and Practice* (New York: Charles Scribners Sons, 1975), p. ix.

2. This pattern of ignoring native American religious belief systems is especially apparent in historical surveys of religion in America.

3. John C. Messenger, "Folk Religion," in Richard M. Dorson, ed., *Folklore and Folklife* (Chicago: University of Chicago Press, 1972), p. 217.

4. *Ibid.*, p. 218.

5. *Ibid.*

6. Sydney E. Ahlstrom, *A Religious History of the American People* (Garden City, N.Y.: Image Books, Doubleday & Co., 1975), vol. 1, p. 45.

7. Ralph T. Coe, *Sacred Circles, Two Thousand Years of North American Indian Art* (title essay) (Kansas City, Mo.: Nelson Gallery of Art–Atkins Museum of Fine Arts, 1977), p. 11.

8. Andrew Hunter Whiteford, "Enriching Daily Life: The Artist and Artisan," *American Indian Art: Form and Tradition* (exhibition catalogue) (New York: Dutton Paperbacks, 1972), p. 10.

9. Henry Glassie, *Patterns in the Material Folk Culture of the Eastern United States* (Philadelphia: University of Pennsylvania Press, 1968), pp. 4–5.

10. *Ibid.*, p. 33.

11. Martin Friedman, "Of Traditions and Esthetics," *American Indian Art: Form and Tradition*, p. 24.

12. Patrick King, *Pueblo Indian Religious Architecture* (Salt Lake City, Utah: Publisher's Press, 1975), p. 1.

13. *Ibid.*

14. *Ibid.*

15. Coe, *Sacred Circles*, p. 12.

16. *Ibid.*, p. 14.

17. *Ibid.*

18. Richard Erdoes, *The Sun Dance People* (New York: Vintage Books, 1972), p. 175.

19. *Ibid.*, p. 178.

20. *Ibid.*, p. 177.

21. Herbert Eugene Bolton, *The Mission as a Frontier Institution in the Spanish American Colonies* (El Paso, Tex.: Texas Western College Press, 1962), pp. 1–2.

22. Ahlstrom, *A Religious History of the American People*, vol. 1, p. 80.

23. See Gaspar Pérez de Villagrá, *Historia de la Neuva Mexico*, trans. Gilberto Espinosa (Alcalá, 1610; reprint ed., Los Angeles: Quivira Society Publications, 4, 1933).

24. See José E. Espinosa, *Saints in the Valleys*, 2d ed. (Albuquerque, N.M.: University of New Mexico, 1967), p. 3.

25. E. Boyd, *The New Mexico Santero* (Santa Fe: The Museum of New Mexico, 1972), p. 3.

26. George Kubler, *Santos: An Exhibition of the Religious Folk Art of New Mexico* (catalogue) (Fort Worth: Amon Carter Museum of Western Art, 1964), pp. 1–2.

27. Boyd, *The New Mexico Santero*, p. 4.

28. Espinosa, *Saints in the Valleys*, p. xii.

29. Fray Angélico Chavez, Foreword, in Espinosa, *Saints in the Valleys*, p. ix.

30. Octavio Paz, in George Mills, *The People of the Saints* (Colorado Springs: Taylor Museum, Colorado Springs Fine Arts Center, 1967), p. 55.

31. Boyd, *The New Mexico Santero*, p. 7.

32. *Ibid.*, p. 10.

33. *Ibid.*, p. 13.

34. Marta Weigle, *The Penitentes of the Southwest* (Santa Fe: Ancient City Press, 1970), p. 13.

35. *Ibid.*, pp. 3–4.

36. Ely Leyba, "The Church of the Twelve Apostles," *New Mexico Magazine* 11 (June 1933), p. 49.

37. See George Kubler, "On the Colonial Extinction of the Motifs of Pre-Columbian Art," in Charlotte M. Otten, ed., *Anthropology and Art* (Garden City, N.Y.: Natural History Press, 1971), pp. 212–226.

38. Increase Mather, "The Life of Richard Mather," in Perry Miller and Thomas H. Johnson, eds., *The Puritans* (1938; reprint ed., New York: Harper & Row, 1963), p. 494.

39. Dickran Tashjian and Ann Tashjian, *Memorials for Children of Change* (Middletown, Conn.: Wesleyan University Press, 1974), p. 3.

40. William Bradford, "History of Plimouth Plantation," in *The Puritans*, pp. 108–109.

41. Moses Coit Tyler, *A History of American Literature* (New York: Putnam's Sons, 1878), p. 228.

42. John Kouwenhoven, *Made in America* (Newton Centre, Mass.: Charles T. Branford Co., 1948), p. 15.

43. Miller and Johnson, *The Puritans*, p. 461.

44. Talbot Faulkner Hamlin, *The American Spirit in Architecture* (New Haven, Conn.: Yale University Press, 1926), p. 27.

45. Richard McLanathan, *The American Tradition in the Arts* (New York: Harcourt, Brace & World, 1969), p. 15.

46. See Allan I. Ludwig, *Graven Images, New England Stonecarving and Its Symbols, 1650–1815* (Middletown, Conn.: Wesleyan University Press, 1966), chap. 1; and Tashjian and Tashjian, *Memorials for Children of Change*, pp. 3–12.

47. Tashjian and Tashjian, *Memorials for Children of Change*, p. 7.

48. Quoted in Jonathan Holstein, *The Pieced Quilt: An American Design Tradition* (New York: Galahad Books, 1973), p. 81.

49. McLanathan, *The American Tradition in the Arts*, p. 15.

50. Thomas Hooker, "Preface to a Survey of the Summe of Church Discipline," in *The Puritans*, p. 673.

51. Increase Mather, "The Life of Richard Mather," p. 494.

52. *Ibid.*, p. 70.

53. Cotton Mather, "Of Poetry and Style," *ibid.*, p. 686.

54. John Cotton, *ibid.*, p. 667.

55. McLanathan, *The American Tradition in the Arts*, p. 16.

56. Miller and Johnson, *The Puritans*, p. 83. See also Urian Oakes, "New-England Pleaded With" ("History is not only philosophy teaching by example, but also theology exemplified." M & J), in *The Puritans*.

57. Increase Mather, "The Life of Richard Mather," *ibid.*, p. 494.

58. Numerous examples of Colonial textiles, watercolors, and oil paintings incorporate verse in the composition of their works. Frequently, the verse is religiously inspired or drawn from the Old Testament.

59. Miller and Johnson, *The Puritans*, p. 62.

60. Barbara Novak, *American Painting of the Nineteenth Century* (New York: Praeger Publications, 1969), pp. 98–100.

61. Loara Standish (sampler) in Ethel Stanwood Bolton and Eva Johnston Coe, *American Samplers* (New York: Dover Publications, 1973), p. 297.

62. Tashjian and Tashjian, *Memorials for Children of Change*, p. 37.

63. Kouwenhoven, *Made in America*, p. 16.

64. McLanathan, *The American Tradition in the Arts*, p. 15. Also, note that the exhibition titled "The Flowering of American Folk Art" (Whitney Museum of American Art, 1974) displayed examples of American folk art that represent the true "flowering" of American arts prior to 1876.

65. Peter Benes and Phillip D. Zimmerman, *New England Meeting House and Church: 1630–1850* (exhibition catalogue) (Boston: Boston University Press, 1979), p. 1.

66. *Ibid.*, p. 21.

67. *Ibid.*, p. 17.

68. Samuel Sewall, *Diary of Samuel Sewall 1674–1729*, ed. M. Halsey Thomas (New York: Farrar, Straus & Giroux, 1973), vol. 1, p. 11.

69. Cotton Mather, *Ornaments* for the Daughters of Zion, Boston, 1692.

70. Catherine A. Hedlund, *A Primer of New England Crewel Embroidery* (Sturbridge, Mass.: Old Sturbridge Village, 1973), p. 11.

71. Ahlstrom, *A Religious History of the American People*, vol. 1, p. 159.

72. See Francis J. Bremer, *The Puritan Experiment* (New York: St. Martin's Press, 1976).

73. Ahlstrom, *A Religious History of the American People*, vol. 1, p. 132.

74. R. H. Tawney, *Religion and the Rise of Capitalism* (New York: Harcourt, Brace & Co., 1926), p. 165.

75. Harriette Merrifield Forbes, *Gravestones of Early New England* (1927; reprint ed., New York: Da Capo Press, 1967), p. 2.

76. Peter Benes, *The Masks of Orthodoxy* (Amherst: The University of Massachusetts Press, 1977), p. 11.

77. James Deetz, *In Small Things Forgotten* (New York: Doubleday & Co., 1977), pp. 69–71.

78. Benes, *The Masks of Orthodoxy*, p. 43.

79. Ludwig, *Graven Images*, p. 15.

80. *Ibid.*, p. 423.

81. Ahlstrom, *A Religious History of the American People*, vol. 1, p. 353.

82. *Ibid.*, p. 443.

83. *Ibid.*, p. 444.

84. John Adams to Hezekiah Niles, 1818, Massachusetts Historical Society, Boston.

9. Dennis Cusick: *Keep the Sabbath.* Buffalo Creek, New York. July 16, 1821. Watercolor on paper, 8″ x 11″. Respect for the Sabbath Day is a primary lesson taught in this watercolor by a Seneca Indian illustrating Indians at prayer with a Bible open on the teacher's desk. (Photograph: Aida & Bob Mates)

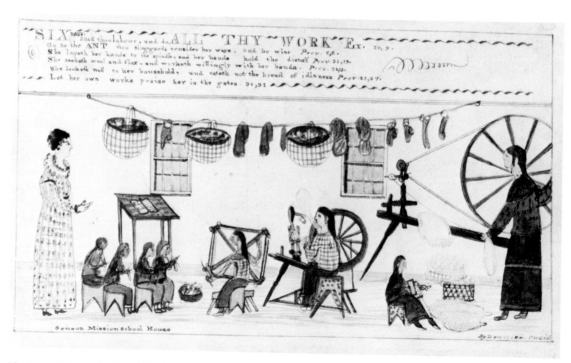

10. Dennis Cusick: *Do All Thy Work.* Seneca Mission School House, Buffalo Creek, New York. c. 1827. Watercolor on paper, 8″ x 11″. Seneca Indians are depicted learning the rudiments of New England domestic life. Among proverbs quoted at the top of the composition is one that instructs, "Let her own works praise her in the gates" (Prov. 31:31). (Photograph: Aida & Bob Mates)

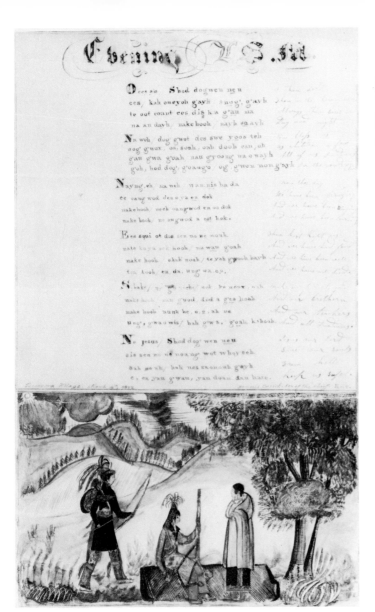

11. Dennis Cusick: *A Seneca Prayer.* Tuscarora Village, New York. March 4, 1822. Watercolor on paper. This watercolor is combined with a prayer in the language of the Seneca. The final verse reads in English: "Jesus our Lord,/Save our souls/from hell,/Keep us safe." (Photograph: Aida & Bob Mates)

12. Indians at Cross Village, Michigan, returning from church. Late nineteenth century. This scene conveys the success of Catholic missionaries' conversion of American Indians. Here a procession of Woodlands Indians returns from church. (Photograph: Collections of Michigan Department of State, State Archives)

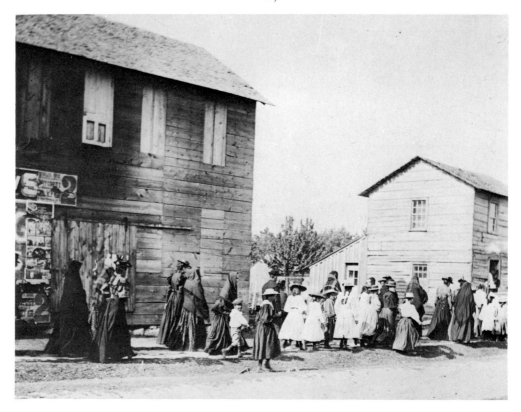

13. Arapaho Ghost Dance shirt. c. 1890. Painted buckskin with fringes, 31" x 21½". Images of birds, stars, turtles, and a man decorate this Ghost Dance shirt used by adherents of the Ghost Dance religion that predicted the return of the buffalo and the extermination of the white man. (Museum of the American Indian, Heye Foundation)

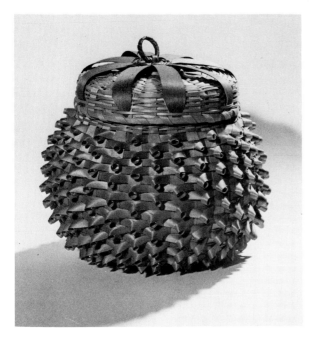

14. Alice Bennett, Russell Bennett, Eli Thomas, and a-nonymous maker: Chippewa strawberry basket. 1977. Black ash splints with red and green dye. The strawberry basket served as a symbolic reminder of the need to prepare oneself for the afterlife. A Chippewa legend taught that one would be nourished at a strawberry patch on his final journey. (Photograph: Folk Arts Division, The Museum, Michigan State University)

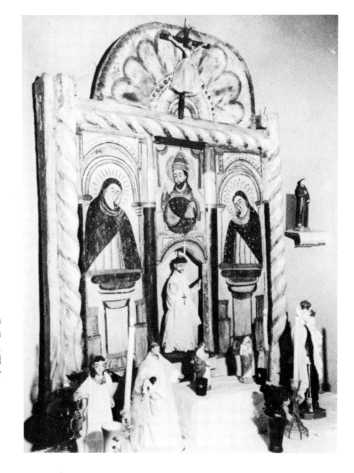

15. Altar screen. Chimayó, New Mexico. Eighteenth century. This photograph records an altar screen with several painted panels. Known as a *retablo* (or tabla), these religious paintings are executed on gesso-covered pine panels with tempera. Retablos can be either low reliefs or flat painted panels. (Private collection)

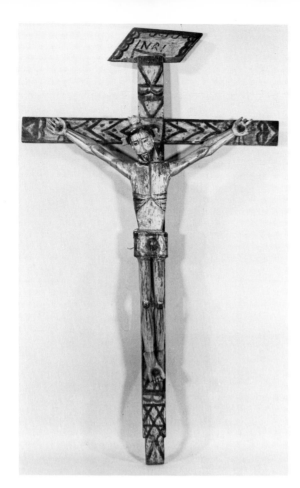

16. José Benito Ortega: Bulto. New Mexico. Nineteenth century. Wood and gesso, polychromed, 45½″. Considered to be one of the most active and documented santeros of the late nineteenth century, Ortega carved primarily bultos in a clean and precise style. (Museum of American Folk Art)

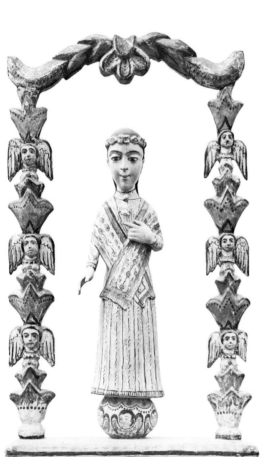

17. *Job.* New Mexico. Second half of nineteenth century. Gessoed and painted cottonwood and tin, 14½″. Job is recognized as a symbol of Christian patience and faith. There is some dispute whether this figure may in fact not be Job but rather an eighteenth-century Mexican figure known as Ecce Homo. (Taylor Museum, Colorado Springs Fine Arts Center)

18. José Rafael Aragón: Nuestra Señora de la Immaculada Concepción. Cordova, New Mexico. 1828–1835. Cottonwood, 21½″. José Rafael Aragón was a santero who worked in the Cordova, New Mexico, area and produced both painted retablos and bultos, such as this example. (Taylor Museum, Colorado Springs Fine Arts Center)

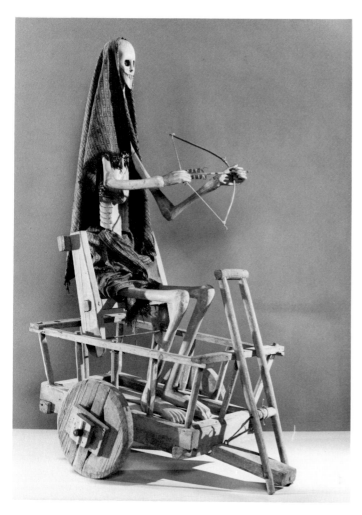

19. José Inex Herra: Death cart (carreta del muerto). El Rito area, New Mexico. c. 1900. Gessoed and painted cottonwood root, 48″. The death cart was drawn in the Penitente processions to Calvary during Holy Week rituals. The female figure of death (La Doña Sebastiana) is usually depicted holding a bow and arrow, which replaces the scythe, a European symbol of death held by the "reaper." (Courtesy The Denver Art Museum)

20. José Dolores Lopez: *Nuestra Señora de la Luz*. Cordova, New Mexico. 1936. Cottonwood, 40″. José Dolores Lopez is recognized as a major force in the revival of Spanish colonial religious carving during the 1920s. (Taylor Museum, Colorado Springs Fine Arts Center)

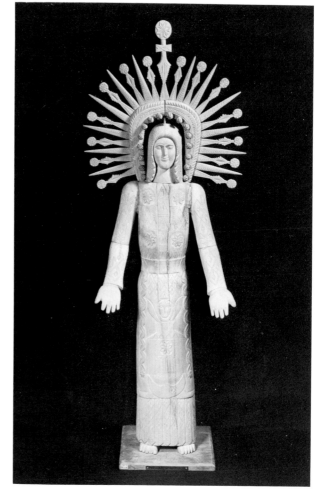

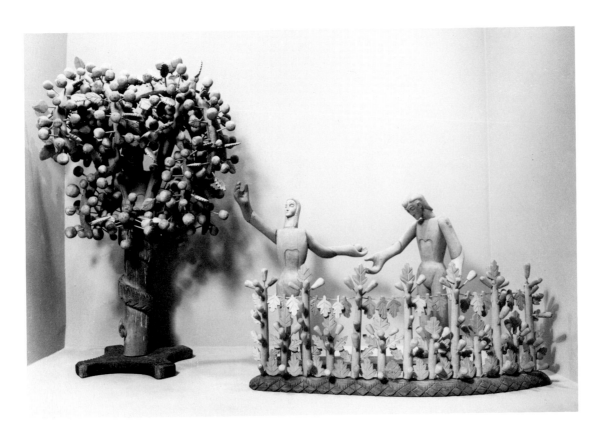

21. José Dolores Lopez: *Adam and Eve and the Serpent*. Cordova, New Mexico. c. 1930. Cottonwood, tree 24⅞″, figures 13″ and 14″, garden 8½″ x 21¼″. Lopez's carving in unpainted cottonwood expressed his religious feeling using imagery drawn from an unlikely source, an old book of illustrations of the Garden of Eden printed in France. (Collection, The Museum of Modern Art, New York; Gift of Mrs. Meredith Hare)

22. George T. Lopez, *Saint Michael and the Dragon*. Cordova, New Mexico. c. 1960. Cottonwood, 40″. The son of José Dolores Lopez, he has carried on the family tradition of teaching his relatives to carve religious personages in unpainted wood. (Smithsonian Institution, National Museum of American History)

23. George T. Lopez: *San Rafael* (Saint Raphael). Cordova, New Mexico. c. 1963. Unpainted cottonwood, 13½". The selling of religious images to collectors has raised some ethical and religious conflicts for some carvers. George Lopez has resolved these conflicts by noting that as long as the objects are not blessed, they are to be considered as dolls. (Collection of Taylor Museum, Colorado Springs Fine Arts Center)

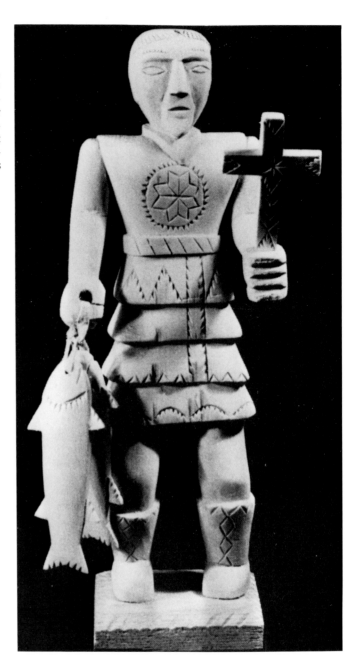

24. Leo G. Salazar: *St. Peter as a Fisher of Men*. Taos, New Mexico. 1973. Unpainted juniper wood, 32½". Salazar learned to carve from his uncle and has since taught his three sons to carve religious figures utilizing the native juniper wood of Taos. (Collection of Taylor Museum, Colorado Springs Fine Arts Center)

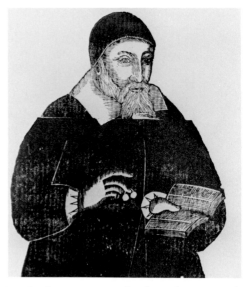

25. *The Progress of Sin.* 1774. Woodcut. In this wood-cut, the Kingdom of Zion is surrounded by a world of temptations. (Photograph: Folk Arts Division, The Museum, Michigan State University)

26. John Foster: *Mr. Richard Mather.* Massachusetts. 1670. Woodcut, 6⅛″ x 4⅞″. This woodcut portrait of Mr. Richard Mather appeared in *The Life and Death of . . . Richard Mather.* Mather was a minister in Dorchester, Massachusetts, and the father of Increase and grandfather of Cotton Mather. (Photograph: George M. Cushing; Massachusetts Historical Society, The Granger Collection)

27. Mary Williams: *The Queen of Sheba Admiring the Wisdom of Solomon.* New England. 1744. Sampler, polychrome petit point, 22″ x 18″. The meeting of Solomon and Sheba wearing Colonial attire is depicted in this unusually vividly colored needlework picture executed primarily in green, blue, and orange. (Smithsonian Institution, National Museum of American History)

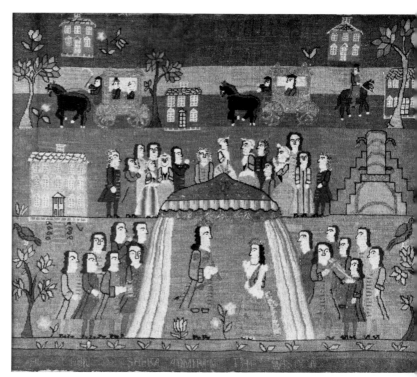

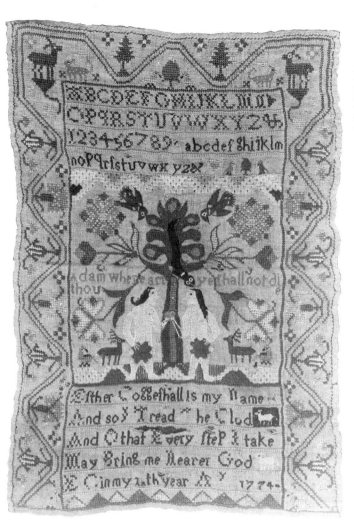

28. Esther Coggeshall: *Adam and Eve* sampler. Newport, Rhode Island. 1774. Silk on linen, 21½″ x 19½″. Esther Coggeshall was ten years old when she executed this sampler and the verse reads, "Esther Coggeshall is my Name,/And so I Tread he [the] Clod [Earth],/And O that Every step I take/May Bring me Nearer God." (The Connecticut Historical Society)

29. *Joab Slaying Absalom*. Boston or Salem, Massachusetts. 1760–1780. Silk embroidery needlework, 20¼″ x 22″. In addition to this biblical story recorded in thread, other popular religious topics were the Judgment of Solomon, Jacob's Dream, the Adoration of the Christ Child, Lazarus, the Poor Beggar, the Expulsion of Hagar, and the Ten Commandments. (Courtesy, The Henry Francis du Pont Winterthur Museum)

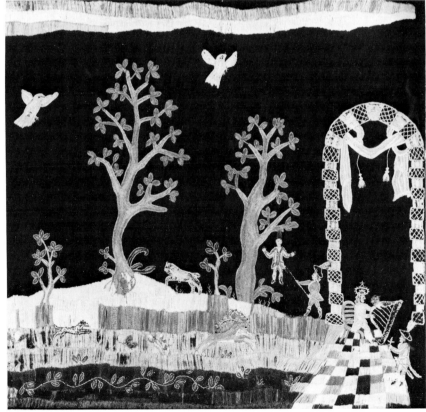

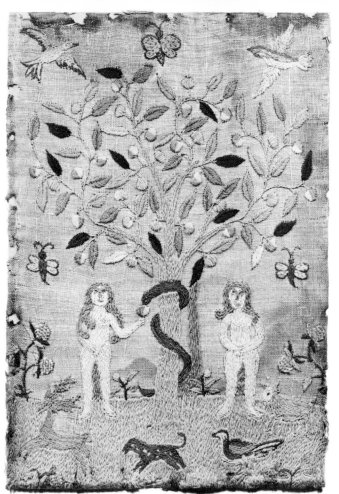

30. Mary Titcomb: *Adam and Eve*. Newport, Rhode Island. c. 1760. Crewelwork on linen, 13″ x 8¾″. Although most needlework depictions of Adam and Eve in the Garden were part of a sampler, others, like this piece, were created simply as needlework pictures. (Photograph: E. Irving Blomstrann; courtesy Wadsworth Atheneum)

31. Mary Bulman: Valance for four-post bed. York, Maine. c. 1745. Crewelwork on linen. These panels are only part of perhaps the finest complete set of American crewel bedcoverings. Mary Bulman is thought to have designed and embroidered this set while her husband was serving as a surgeon under Sir William Pepperell. (Old Gaol Museum)

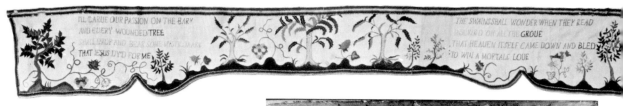

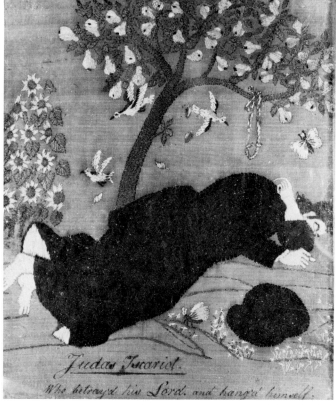

32. Prudence Punderson Rossiter: *Judas Iscariot*. Preston, Connecticut. c. 1776. Needlework, silk thread on satin, 8″ x 7″. This needlework picture depicts Judas after the betrayal, and the verse at the bottom reads, "Judas Iscariot, Who betray'd his Lord and hang'd himself." (The Connecticut Historical Society)

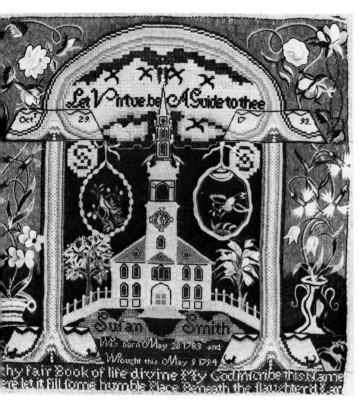

33. Susan Smith: Sampler. New England. October 29, 1793 (completed May 9, 1794). Silk embroidery on canvas, 16¾″ x 16¾″. Susan Smith created her first sampler, a view of the First Baptist Meeting House of Providence, Rhode Island, when she was a student in the well-known Polly Balch's School in Providence. (Courtesy, The Henry Francis du Pont Winterthur Museum)

34. Lydia Hollingsworth: *The Lord's Prayer/ The Creed*. Probably Philadelphia. 1759. Silk and silver thread on linen, 21″ x 16¾″. The importance of prayer is emphasized in the verses of many samplers and is especially graphic in this piece that served as an ever-present reminder of the place of prayer in the Colonial home. (Photograph: Helga Photo Studio, Inc.; Daughters of the American Revolution Museum, Gift of Hannah A. Babcock)

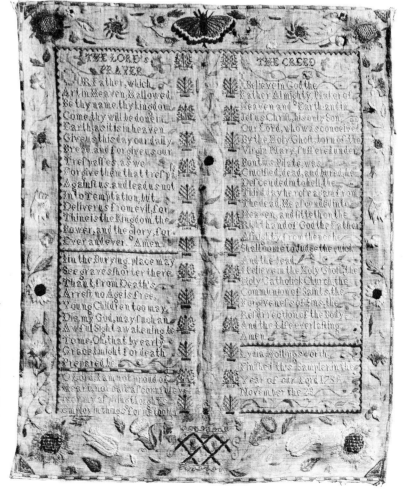

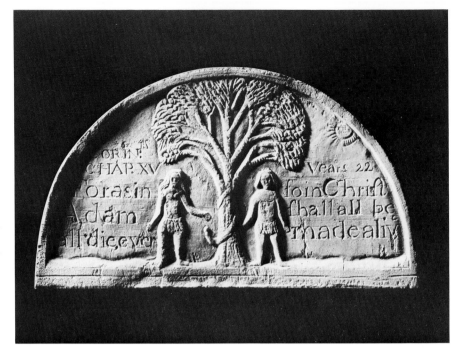

35. Gravestone of Sara Swan. Bristol, Rhode Island. 1767. Slate, 6″ x 10″. A popular theme in needlework and painting, this Adam and Eve in the Garden is a rare example in carved stone. (Photograph: Francis Y. Duval and Ivan B. Rigby)

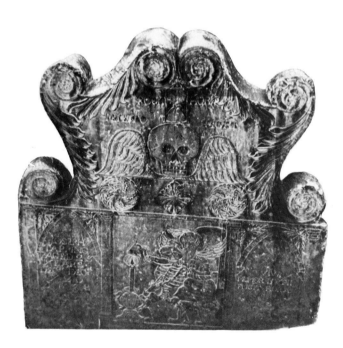

36. Gravestone of Joseph Tapping. Boston. 1678. Slate, 28½″ x 28½″. This stone is recognized as perhaps the finest illustration of Puritan religious imagery on a single gravestone. The allegorical snuffing out of the candle of life is in the central lower panel. Father Time with scythe in hand reminds the viewer of the passage of time, and the death's-head and hourglass in the upper central panel serve to reinforce the Latin verses acknowledging man's ultimate end. (Photograph: Folk Arts Division, The Museum, Michigan State University)

37. Joseph and Nathaniel Lawson: Gravestone of Rev. Jonathan Pierpont. Wakefield, Massachusetts. 1709. Slate, H. 27½″. Carved by the famous Lawson family of carvers, this stone records portraits of the Rev. Pierpont on the outer shoulders of the gravestone with his book of prayer in hand. Also note the center top of the stone with a robustly carved death's-head and figures holding an hourglass. (Photograph: Folk Arts Division, The Museum, Michigan State University)

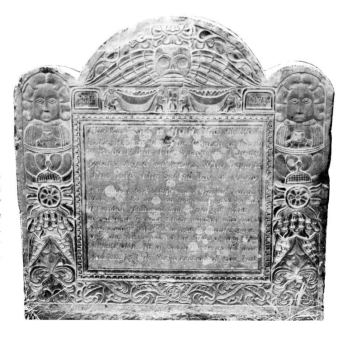

38. Gravestone of Eliakim Hayden. Essex, Connecticut. 1797. Brownstone, 16″ x 12″. Drawing on both the Old and New Testaments for imagery, the carver has combined the Ark of Salvation with a dove and a cross, symbols of the soul and eternal life. (Photograph: Francis Y. Duval and Ivan B. Rigby)

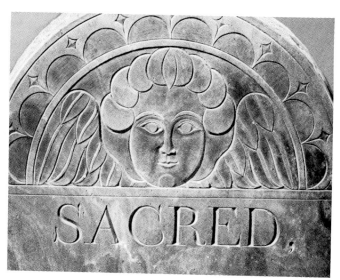

39. Detail of gravestone of David Mellvill. Newport, Rhode Island. 1793. The cherub eventually replaced the death's-head as the primary image of New England gravestones. This change reflected the decline of orthodox Puritanism. (Photograph: Daniel and Jessie Lie Farber; The Rhode Island Historical Society)

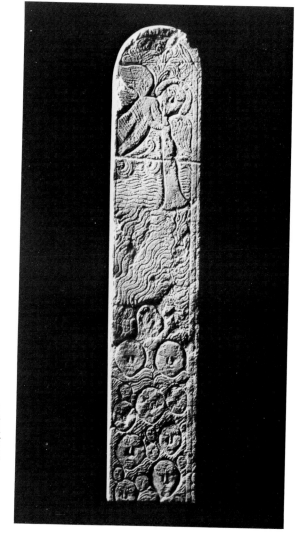

40. Gravestone of Lt. Nathaniel Thayer. Braintree, Massachusetts. 1768. Slate, 20″ x 4″. The trumpet call for the resurrection of man is dramatically portrayed on the outermost border panels of this testament of faith in stone. (Photograph: Francis Y. Duval and Ivan B. Rigby)

Chapter 2
ALL TO THE GLORY OF GOD

"Whatsoever ye do, do all to the glory of God."
—I Corinthians 10:32

THE EXPANSION OF RELIGIOUS LIFE AND ART IN AMERICA

After the war, the Presbyterians and, to a far greater extent, the Baptists and Methodists, extended their conquests in the back country by following the great migration into the trans-Appalachian regions. They would thus continue the Great Awakening—or at least keep revival fervor alive when it flickered low elsewhere. For this reason, the story of the frontier awakenings in the South is not only an important chapter in itself, but a prologue to the "Great Revival in the West," which is, in turn, a vital link between the Colonial Awakening and the tumultuous events which shaped American evangelical Protestantism during the early nineteenth century.[1]

Historian Sydney E. Ahlstrom depicts the atmosphere at the close of the eighteenth century as ripe for religious regeneration in established population centers and evangelistic encroachments on the Western frontier. Most major religious groups had been introduced into the American scene by the early nineteeth century and, for the most part, had grown in membership at a rate consistent with the overall growth of the United States population.

This growth of membership usually occurred in rather distinct geographical locations, thus contributing to a general interdenominational compatibility. However, by the end of the nineteenth century, a number of significant changes had occurred. These included an increase in the use of evangelistic methods, notably the camp meeting; a strengthening of women's role in fostering and maintaining religious activities; the organization of missionary and benevolent societies; the expansion of religion through the founding of colleges and the increased distribution of literature; major shifts in established denominational membership; the rise of popular, predominantly middle-class Protestant denominations; an influx of immigrant religious folk traditions; and the establishment of a sprinkling of utopian and religious sects. All of these changes had an effect, to a greater or lesser extent, on the forms, distribution, and quantity of religious material culture produced.

Camp-Meeting Revivalism

Although many conditions contributed to the profound changes that American religious groups underwent during the close of the eighteenth and the opening of the nineteenth century, perhaps no single event signified the extent of those changes more than the revival meeting held at Cane Ridge, Kentucky. Called by Presbyterian preacher the Rev. Barton W. Stone, the meeting commenced on August 6, 1801, and continued for six days. It was perhaps the largest revival ever held in this era, with reports of from ten thousand to twenty-five thousand participants. Eyewitness reports recounted events of staggering propor-

tions. Peter Cartwright told of thousands shouting simultaneously; another preacher commented on the hundreds of fallen people crying for mercy; yet another estimated that he saw "at least five hundred swept down in a moment, as if a battery of a thousand guns had been opened upon them, and then immediately followed shrieks and shouts that rent the very heavens."[2] James P. Finley recorded his firsthand observations:

The noise was like the roar of Niagara. The vast sea of human beings seemed to be agitated as if by a storm. I counted seven ministers, all preaching at one time, some on stumps, others in wagons . . . Some of the people were singing, others praying, some crying for mercy in the most piteous accents, while others were shouting most vociferously.[3]

Accounts of the Cane Ridge meeting vary widely in assessing both actual events and eventual effects that the meeting had on American religious history, but most historians agree that camp-meeting revivalism in general left a definite mark on American religious institutions (fig. 41).

Although it seemed at times as if "the camp meeting appeared suddenly on the American frontier as the most striking manifestation of the Great Revival" (the Second Great Awakening),[4] the format for camp meetings had evolved quite naturally from the efforts of organized churches to educate those living on the frontier. To devoted Eastern churchmen, the thought of the religious apathy and moral laxity so associated with the frontier life provoked a corresponding increase in righteous and fervent piety. The Eastern churchmen's enthusiasm for educating the crude backwoodsmen is understandable when one considers the heightened religious atmosphere produced by the home church revivals. For, as Charles A. Johnson notes, "Religious growth in the border areas was an interactive process in which the denominations of both sections [East and West] participated and through which they were modified."[5] Eastern religious leaders realized that the practices of their well-ordered home churches could not be transferred intact into a pioneer society. Circuit-riding preachers, teacher-preachers, and farmer-preachers were all employed to bring the Christian faith to the border areas (fig. 42). Whether prompted by the desire to transfer Yankee religious doctrine to the newly settled portions of the Western frontier, to expand membership in competitive denominations, to nurture their own westward-moving members, or to establish denominational schools—whatever the reasons—churches embarked on home missionary movements. As early as 1784, Connecticut Congregational churches began sending out missionaries to the western emigrants.[6] Although many denominations, particularly Baptists and Presbyterians, participated in this westward effort, none were to have as much effect or be as much affected by the frontier religious movement as the Methodists. As Johnson remarks,

The Methodist Episcopal Church was one of the most successful leaders in this struggle against godlessness. The combination of a democratic theology which stressed the American doctrine of free will and an autocratic religious organization made it peculiarly suitable to frontier conditions. It was fortunate, too, in having no great historical traditions to restrict its innovating impulses. Unlike the Presbyterians and Congregationalists who looked for their own members cut adrift in the West, the Methodists considered all men potential converts. Through a transplanted itinerancy system, changed into rural practice by Francis Asbury in 1772, the Church of John Wesley was able to keep in touch with a people on the move. The local ministry was composed of the located preacher, class leader and exhorter; the traveling minister, on the other hand, was attached to no one community. Through him the church was kept in the vanguard of civilization.[7]

Periodically during the course of the circuit rider's travels, a quarterly meeting would be called by the local preacher. Since frontier church meetinghouses were usually too small to contain the members that came to worship, these meetings were held in a wooded clearing. At first, worshipers would meet only for one day, then return to their homes at night. Then, as meetings extended to two, three, and even ten days, worshipers began lodging in the neighborhood. Inevitably, the protracted outdoor sessions led people to bring their own shelter and enough provisions for staying right on the ground at the meeting site. James McGready, a Presbyterian evangelist working in North Carolina, has been credited with holding the first planned "camp meeting" in the United States in 1800.[8] Noting the success of holding extended meetings out-of-doors, McGready sent out notices calling worshipers to a meeting at Gasper River, Logan County, Kentucky. There McGready joined with other powerful evangelists in fostering an intense religious experience. Through singing, exhortation, oratory, and prayer, the gathered worshipers were swept into a religious frenzy that was dissipated only with their feelings and expressions of a "delivered" state.

The success of McGready's outdoor evangelism spread quickly, and his techniques were adopted by countless frontier preachers. The meetings were usually held in cleared areas near water sources, hence the revival names: Muddy Creek, Cabin Creek, and so on. When there was no clearing large enough, woodsmen simply leveled the

trees and used the felled timbers for makeshift outdoor pews. Although the format varied slightly according to locale or initiating denomination, camp meetings were generally laid out in similar seating plans: rectangular, oblong, and, the most popular, circular.[9] Manuals were even printed prescribing favorable layouts and suggesting certain scriptural texts to be read and hymns to be sung. The pattern of the camp meeting became predictable: exhortations were continued nonstop; songs were sung; calls for confession and admission of faith were made; and hand-clapping was encouraged. The manifestation of feeling took foreseeable forms, culminating in dancing, jerking, swooning, rolling, barking (noises described by some observers as "doglike"), and speaking in tongues. The intensity of the experience left few participants or observers unmoved (fig. 43). So effective were the meetings that most denominations engaged in this form of evangelism to some extent. Even Shakers participated in missionary work and camp-meeting revivals. Under the Plan of Union of 1801, the Presbyterians and the Congregationalists sanctioned only rational revivalism in which there was very little commotion or animal feelings.[10] By the end of the first decade, the open-air revival had become mainly a Methodist institution. Curiously, although camp meetings were most popular in the Methodist denomination, they were never an official institution of the church. Annual reports submitted by Methodist clergy and official church records omit mention of the encampment proceedings. As Whitney Cross has suggested, "Revivalism was throughout the period a folk movement, contesting clerical conservatism."[11] Methodists gathered at camp meetings well into the latter part of the nineteenth century. The meeting continued to be a familiar event in rural areas through the entire warm season of the year (see fig. 179). It has been noted that "a meeting planned for the free interval after the wheat and hay harvests were in and before corn-cutting time could be assured of a much better attendance."[12] As maturing communities became more settled and wealthy, the need for religious communion and secular sociability that the periodic camp meeting afforded was met with more permanent structures. Land was often donated on which a wooden auditorium was raised and the open-air revivals moved inside. Further amenities, such as tent platforms or cottages, were provided for the overnight worshipers.[13] Eventually, as larger in-town churches were established, the camp meetings were replaced with protracted in-church revival meetings. Although the setting was changed, the essential format of tearful testimonies, exhortations, prayer, and hymn singing was retained.

The revivalism that began to brew in Jonathan Edwards's day and that fermented in the latter part of the eighteenth century seemingly erupted by the time of the Cane Ridge meeting as a remarkable revival of revivalism. This was a time of profound change in American religious history, and revivalism can be credited with several far-reaching effects. First, the organized revival became a major mode of church expansion, creating a tremendous growth in the membership of churches that employed revivalistic techniques. Second, a new sense of purpose and community was fostered in those more-established churches that incorporated in-house revivalism. Faltering churches gained new strength through utilizing an expanded repertoire of evangelistic practices. Third, the camp-meeting revival did serve as an effective and powerful tool for meeting the spiritual and social needs of the isolated settler who lacked both church and neighbors. Last, the revival created an atmosphere in which each participant might undergo a personal change of heart in a public situation.

The legacy of the camp meeting is still in evidence today. For example, in-house revivals are very much a part of some denominations; evangelists such as Billy Graham and Oral Roberts continue to attract thousands to their emotion-packed services; churches occasionally hold old-

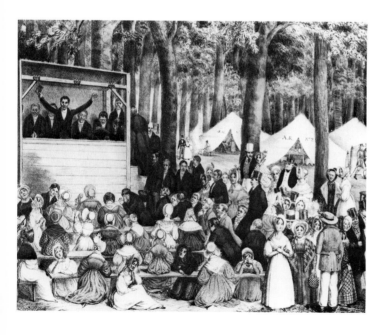

41. Edward Williams Clay: *Methodist Camp Meeting* (detail). New York City. Lithograph published by H. R. Robinson in 1837. Camp meetings provided an opportunity not only for religious instruction but also for social gatherings—a welcome change for those in the widespread frontier settlements. These primarily rural events attracted urban artists such as Clay. (Courtesy The New-York Historical Society)

time religious services that incorporate songs once used in camp meetings; and some denominations convene summer camp revivals, such as those held each year by the Seventh-Day Adventists at Grand Ledge, Michigan (fig. 44). Traveling the backroads of this nation's rural areas, one may sometimes see those white wooden structures that once housed frontier camp meetings. Although most remain deserted, stark reminders of a passing era in American history, once in a while, one will be unboarded, cleaned out, and filled with worshipers. Then, for a few days, the camp meeting will come alive again.

THE STRENGTHENING OF WOMEN'S ROLE IN RELIGIOUS LIFE

As in other aspects of early nineteenth-century society, the role that women played in the religious structure underwent gradual changes, which were most evident in regions that had been transformed from the rough frontier to a cultural environment. In the backwoods, women were still for the most part equal partners in the struggle for survival and in the establishment of a home. Once a home had been carved out of the wilderness and a semblance of a community established, woman's role was largely influenced not by necessity but by an influx of writings defining her proper place. Educational leaders and influential clergy expounded and orated on the "natural role" of women—a position for which they found justification in religious doctrine. The split in male-female roles had been decreed in Scripture and had been validated in the Judeo-Christian tradition. The Rev. Henry Grew, speaking at the Fifth National Woman's Rights Convention in Philadelphia in 1854, "quoted numerous texts to show that it was clearly the will of God that man should be superior in power and authority to women; and asserted that no lesson is more plainly and frequently taught in the Bible, than woman's subjection."[14] Caleb Atwater, Esq., writing in *The Ladies Repository*, explained, "Religion is exactly what a woman needs, for it gives her that dignity that best suits her dependence."[15] Barbara Welter identified the "attributes of the 'cult of true womanhood' . . . as piety, purity, submissiveness and domesticity . . . [and] religion or piety was the core of woman's virtue, the source of her strength . . ."[16] Working for the church and upholding re-

ligious values within the family served to enhance a woman's place. In order to prepare young women for their prescribed role in the upper and newly forming middle class in America, women's seminaries offered courses designed to aid them in their tasks. Mount Holyoke's catalogue promised to make female education "a handmaid to the Gospel and an efficient auxiliary in the great task of renovating the world."[17] The seminary offered special attention to religious guidance in addition to course offerings of a more secular nature. Many seminaries originated among religious groups as an outgrowth of the religious fervor stimulated by the Second Great Awakening. Most schools offered Bible reading, singing, and praying exercises. However, as Whitney Cross has noted, "Theology, which observed Christianity as a system of thought and demanded some pretense to reasoning and analysis, gained no such attention as it held in the men's colleges and graduate seminaries."[18] This emphasis on the spiritual prompted young women to depict their understanding of religion in life in such drawings as Betsey Clark's *Mechanical View of the Faculties of the Soul* (fig. 45). Courses in the secular vein were designed to guide and enhance woman's role as wife and mother. Cooking and other household arts, reading, writing, perhaps some basic math and chemistry, and of course needlework were all part of the seminary curriculum. For those women who would be so unfortunate as to find themselves without a family, the seminaries "advocated women as missionary teachers, and seminary prin-

42. A. U. Waud: *The Circuit Preacher*. Washington, D.C. Lithograph published in *Harper's Weekly*, October 12, 1867. Circuit-riding preachers brought a religious message to newly settled portions of the Western frontier. These traveling missionaries were occasionally the recipients of quilts made by the women of their district. (Courtesy the Collections of The Library of Congress)

cipals became recruiting agents for teachers and participated in crusades to send teachers into the West and South as cultural and civilizing influences."[19] Eventually, most missionaries were women.

Although women composed the overwhelming majority of church membership in early nineteenth-century America, few participated in church leadership. On the home front, women were expected to provide a domestic model of piety as depicted in *The Happy Family* (fig. 46), a popular print of the day. It was expected that their time be spent in daily devotions, Scripture reading (fig. 47), and perhaps some knitting or weaving to help pay the minister. In his book *Ornaments*, the Puritan leader Cotton Mather gave more attention to women's religious instruction than to their intellectual training, a view substantiated by other educators and clergy of the period. Women were expected not only to improve their own religious character but also to impart moral and religious knowledge to their children. At an early age children were taught how to read using the Bible or small chapbooks. Often girls were taught both the basics of sewing and the alphabet through stitching letters onto a canvas. Adorned with images of flowers, animals, and architecture, these samplers were usually inscribed with a verse, then signed and dated by the maker (figs. 48–50). Ethel Stanwood Bolton and Eva Johnston Coe, authors of the landmark book *American Samplers*, divided into categories the verses they had recorded after examining hundreds of samplers in public and private collections. In a letter to Bolton and Coe, Barrett Wendell observed of their divisions that "To pass to substance of these artless epigrams, a great many of them concern religion, mostly of a Calvinistic shade, sometimes pretty deep . . . and at least one hundred and eighty-eight of these rhymes directly concern the orthodox principles of New England religion and a great many more imply them."[20]

In "'Remember Me': The Sources of American Sampler Verses," Toni Flores Fratto suggests that the selection of rhymes by the sampler maker was usually not completely original, but "in tradition . . . following a sampler style and using not only designs, but also verses common to the samplers and to a number of other cultural artifacts of her time."[21] Popular phrases were often borrowed from other samplers, commonplace books, textbooks on penmanship, hymnbooks, children's religious readers, and, less frequently, classical literary sources. The Rev. Isaac Watts's hymnal, *Songs, Divine and Moral, for the Use of Children*, was one of the most quoted sources. The 1802 Boston edition provided a sampler maker in 1862 (fig. 50) with the following lines:

> There is an Hour when I must die
> Nor do I know how soon 'twill come;

> How many young as I
> Are call'd by Death to here their Dom.[22]

Whatever the source, the verses found embroidered on samplers reflect the young woman's preoccupation with certain subjects: death, piety, and duty. The following verses are typical popular sampler verses of the nineteenth century:

> As this fair sampler shall continue still
> The guide and model of my future skill
> May Christ the great exemplar of
> mankind
> Direct my ways and regulate my mind.[23]

> Jesus permit thy gracious name to stand
> As the first efforts of an infants hand[24]

The sampler produced in 1833 by Julia Ann Niver of Crawford, New Hampshire (fig. 48), carries the following verses, which underscore the sampler maker's concern with religion:

> Young sinners to counsel give ear
> From Juvenile levity cease
> The God of Omnipotence fear
> The fountain of wisdom and peace
> The gospel illumines the way
> To climes of extatick delight
> Where storms never ruffle the day
> And where it will never be night.

> Your pleasures are empty and vain
> And can but a moment endure
> They yield but confusion and pain
> The soul to destruction allure
> Why slight ye the Saviour O say
> To save you he yielded his breath
> The tempests of life he can lay
> And cheer the lone valley of death.

Needlework samplers also provided an unexpected source of architectural documentation.[25] Although young girls often copied subject matter or design motifs from the Bible, engravings, or other samplers, they occasionally turned to the buildings in their communities for subjects. One such young artist faithfully recorded in thread the style and colors used in the local church or meetinghouse (fig. 49).

As young women matured, they were accorded the additional responsibility of caring for the sick and mourning the dead. Women were central to the mourning practices

of the nineteenth century. In line with the belief that women were naturally more pious than men was the attitude that women were better suited to express feelings in their approach to life. Turn-of-the-century interest in Romanticism, coupled with an increased sense of a national culture, prompted the production of numerous painted and stitched mourning scenes that pictured deceased American heroes or family members. In *Mourning Becomes America*, Anita Schorsch states:

> popular religious thought allowed image-making for the first time in America, blessing this elegant and sensual approach to the Spirit by calling it Christian art. The state of mourning, therefore, gradually became as beautiful as it was virtuous, embodying Christian, patriotic and personal meanings as a new art form was born from ancient motifs and ideas.[26]

Schorsch underlines the compatibility of the production of mourning pictures with the female role of piety:

> Sophisticated Protestant icons, the handicraft of "finished" young ladies, mourning pictures were de rigueur. They were fashionable and they were Christian . . . and the mourning picture was indigenous to prosperous, educated, liberalized Protestants. It allowed the worship of God and the worship of mundane pleasures to coexist. It was, like all neoclassic art, very much of its time.[27]

Rendered primarily by young women who received some training in dame or boarding schools, these mourning pictures included standard motifs, each suggesting meaning on a personal or religious level. Biblical, classical, and natural images were used to evoke sorrow for the passing of a loved one (figs. 51 and 52).

Schorsch carefully analyzes the iconography incorporated in the mourning picture. Reflecting the national interest in neoclassicism, the American mourning picture usually included at least the following images: an urn, suggesting the spirit of the dead; a mourning figure, known in Christian art as the mourning Madonna or Virgin; and a willow tree, both an ancient symbol of the house of mourning and a Christian symbol of the Resurrection. Additional common symbols included the standing oak, representing Christ; the fallen oak, symbol of a life struck down in its prime; the open grave, symbol of the temporal nature of life; and the thistle, symbol of earthly sorrow. The setting in which these symbols were placed was invariably a garden, which was in itself a Christian symbol of the Resurrection. Schorsch suggests that motifs, color, and layout were employed in a complex way to create "an imaginary landscape consisting of Christian symbols

reinforcing the idea of the redemption of the spirit through the death of the flesh . . . [and that] trained to work Christian symbolism before they could read or write, women pursued the 'feminine arts' to glorify God without apology or explanation."[28]

As an American middle class began to emerge, families of means sent their daughters to day classes or boarding schools where they not only received additional religious guidance, as already noted, but also were given instruction in feminine accomplishments, such as music, dance, painting, and fancy needlework. The needlework, especially, was considered a necessary achievement for a polished young woman. Evidence of accomplishment for the young student was the needlework or painted picture, suitable for framing, that she brought home from class. The method of instruction most often employed by teachers was demonstration and copying of printed illustrations. Drawing from life and nature was not encouraged; rather, students were urged to take as their examples the engravings and lithographs found in the Bible and other books, as well as the prints hung on their walls (figs. 53 and 54). Because the subject matter most often found in the schoolgirl pictures was drawn from the popular books and prints of this period, it is not surprising that so much of the schoolgirl work is religious in nature (figs. 53–60). By perfecting their needle and painting skills and by choosing religious imagery as subject matter, young girls were doing double duty. They were strengthening their model roles as domestic artists and religious caretakers, while improving the religious atmosphere of the home with stitched and painted scriptural pictures.

Women, Religion, and Quiltmaking

On the public front, women did not enjoy an active or aggressive role in religious work until the beginning of the nineteenth century. Then, in the wave of the revivalistic fervor sweeping the country, their already recognized role in maintaining the domestic religious structure was greatly strengthened. Women dominated revivals and prayer circles, organized Sunday schools (fig. 61), established missionary societies, and, more devotedly than ever, supported and attended their home churches. With their time, energy, and money, women became an active force within the church (fig. 62). "A group of Congregational women organized the Boston Female Society for Propagating the Diffusion of Christian Knowledge in 1801. . . . A year later, the first of these so-called female 'cent' societies was organized, in which members, mainly middle-class women, contributed a penny a week to support missionary activity."[29] Through the establishment of ladies' aid or auxiliary societies in churches, women's organiza-

tions were able to develop means of raising funds for both home church needs and missionary work. A popular method of raising money was to solicit funds from church members and local businesses. A small amount was paid for the privilege of having their names embroidered or inked onto a quilt made by the ladies' aid societies (fig. 63). When completed, the fully inscribed quilt was raffled off to raise even more funds. The link between quilting and church work was well established by the twentieth century and flourished particularly in rural communities. Although the number of both ladies' aid societies and church-associated quilting clubs has somewhat diminished in the latter part of the twentieth century, women's groups continue to quilt for the church, often setting up frames right in the church building.

Another type of quilt commonly produced by women of a particular church was the *album* or *presentation* quilt, so named because each block was pieced or appliquéd and signed by a different woman, and then the finished quilt was presented to the minister or minister's wife. In *The Romance of the Patchwork Quilt in America*, Carrie A. Hall and Rose G. Kretsinger comment on this practice:

One custom that was common in every locality was the making of "Album" quilts. They were highly prized, and especially so when they were made by the women of the congregation as a gift to the minister's wife. Each woman made a block with her name embroidered in the center, then they were set together and a grand "quilting bee" was given at the home of the minister if he had a local church and lived among his flock, but if he was a "circuit rider" and served

many communities, the quilting was done at the home of one of the members of the congregation.[30]

This custom of producing album quilts developed into a particularly popular pastime in some areas of the country, notably Baltimore, Maryland; however, the practice did not always result in presentation pieces to the clergy. Weldon's *Practical Patchwork*, published around 1900, explains that some were also intended for hospital use:

Hospital quilts are made of good-sized squares of red twill and white calico placed alternately like squares on a chess board, the white pieces having texts written on them or Scripture pictures outlined in marking ink; they are much appreciated and prove a great source of interest to the poor invalids.[31]

In addition to often serving religious purposes, the quilt itself sometimes incorporated patterns, motifs, and images based on biblical sources. The vital role that religion played in women's lives was reflected in their choice of patterns for pieced quilts with such names as Jacob's Ladder, Crown of Thorns, Hosanna, Joseph's Coat, David and Goliath, Job's Tears, Forbidden Fruit, and numerous variations of the Star of Bethlehem and the Cross.[32] It has been noted that Quaker women gave religious names to all their quilt patterns, for instance, changing an "ordinary Bears Foot into The Right Hand of True Friendship and a common Swastika into The Pure Symbol of Right Doctrine."[33] The pieced album quilts produced for hospitals were sometimes called *Scripture quilts*. Each block had a large white square on which "a scripture quotation or an old adage of high moral tendency was embroidered in turkey red cotton [or inscribed in marking ink] . . . " Carrie Hall remembers one in her home on which this verse was embroidered: "Learn to be useful and not fanciful. From your Aunt Sally, 1848."[34] A pieced quilt made by Maria Cadman Hubbard in 1848 (fig. 64) displays the extent to which some women went to convey these scriptural or moral messages. Each of the inscriptions on her red and white quilt was constructed by piecing together tiny scraps of material into individual letters.

Quilts created by appliquéing scraps of fabric onto a supporting background provided a means of creating more

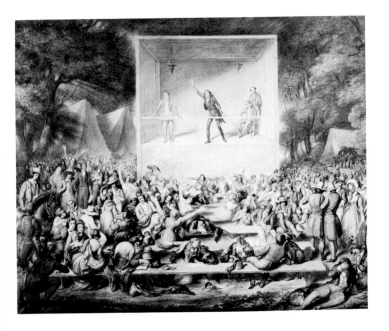

43. J. Maze Burbank: *Religious Camp Meeting* (detail). Provenance unknown. c. 1839. Watercolor on paper, 27" x 37". Burbank, an English caricaturist, exhibited at the Royal Academy this large watercolor of "a camp meeting, or a religious revival, in America, from a sketch taken on the spot." (The Whaling Museum)

expressive images. Either pieced blocks or the entire surface of the quilt might be used to depict biblical scenes or religious symbols, such as the popular Tree of Life. Abby F. Bell Ross's exemplary masterpiece (see fig. 123) is but one of several quilts portraying the Garden of Eden. Other pictorial appliqué quilts document local church architecture or religious events. In the nineteenth-century *Sacret bibel quilt* (fig. 65), Susan Arrowood used appliqué to illustrate a number of scenes from the Old and New Testaments (figs. 65 and 65a). Groups of paper-doll-like figures dressed in stylish nineteenth-century dress are arranged to depict Adam and Eve in the Garden of Eden, Jesus on the mountain sending his disciples into the world to preach, Noah's Ark, the Crucifixion, and Jesus in the Garden of Gethsemane praying. Moral sayings, prayers, and scriptural verses were sometimes appliquéd onto a backing. In 1886 Lavinia Rose, perhaps on the occasion of her son's or daughter's wedding, presented to Daniel and Amarilla a quilt (fig. 66) that had the following pious message appliquéd on the front panel: "The Bible Chart Keep in Full View,/ 'Twill Lead You Safe the Journey Through. Love to You and Yours. Mother."

The women of certain conservative denominations, notably the Amish and Mennonite orders, have gained a marked reputation for their quilting. Such sects, which emigrated from Swiss-German roots, repudiated worldliness and the materiality of Catholic and other Protestant denominations. In their restricted folk communities in places like Indiana and Pennsylvania, these women at first did not have much contact with non-Amish and non-Mennonite neighbors. It has been suggested by scholars that Amish women made few quilts before 1860 and in fact were prohibited from piecing quilts by some district bishops.[35] Gradually, as Amish and Mennonite women began to interact with women of other communities, they became aware of American quilting traditions. Once familiar with the techniques, Amish and Mennonite women quickly incorporated quiltmaking into their domestic and community lives. Quilts provided a means of personal expression that did not run counter to their conservative religious doctrine, or *Ordnung*, the regulations of faith prescribed for each church. Susan Stewart suggests that "in a culture where life is dressed in somber grays, blacks, and deep purples, the quilt provides an interesting contrast for color expression."[36]

This exploration of color was particularly noticeable in the traditional designs that were first popular among Amish women. Typically, these designs were simple, using plain fabrics in unusual and sometimes startling color combinations. A favorite pattern called Sunshine and Shadow (fig. 67) is a quilt composed of small patches of perhaps ten to fifteen colors arranged in alternating light and dark rows. In *A Gallery of Amish Quilts*, Elizabeth Safanda comments on the similarity of the Sunshine and Shadow design to the realities of Amish life:

[The] quilt is a concrete embodiment of the polarization inherent in Amish society—the dualities of light and dark, good and evil, the worldly and the spiritual. . . . religious discipline demands that these people avoid the world— shadow—and pattern their life after scriptural examples— the sunshine.[37]

Safanda suggests that, since the *Ordnung* does not specifically refer to quilts, the Amish woman exercised greater freedom of expression in her choice of color.

Other traditional Amish patterns consisted of strong, simple designs based on the square, the rectangle, and the triangle (fig. 68). Safanda reflects on the use of these designs:

The simplicity of the Amish pieced compositions is influenced by religion as well as practicality. Averil Colby comments in *Patchwork Quilts* that the total number of tiny pieces in a quilt was a source of pride to the seamstress. Partly because excess pride in worldly possessions is considered sinful in Amish society, the early Amish quilts are al-

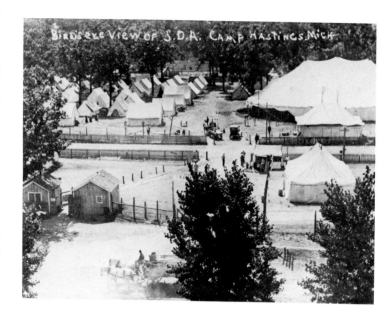

44. Birds'-eye view of S.D.A. Camp, Hastings, Michigan. For two weeks every summer, tents are erected to house the families attending the annual revival now held in nearby Grand Ledge, a rural Midwestern town. (Photograph: Grand Ledge Academy)

39

most uniformly constructed of large simple pieces. It is only at the turn of the century that more intricately pieced formats such as the Sunshine and Shadow, Variable Star, and Sawtooth Diamond have emerged.[38]

The Center Diamond pattern reflects several aspects of Amish culture. Numerous references to Christ as the cornerstone are found in hymnals and Bibles used by the religious sect and the translation of the German word *Eckstein* is "cornerstone" or "diamond."[39] It is interesting to note that the Amish also employ the Germanic folk designs that are used prominently by other Pennsylvania German groups. However, their use of the tulip, heart, star, and feather is confined to the quilting patterns. Safanda cautions against reading too much religious symbolism into the quilt and suggests that an Amish quilt "is simply a functional item whose decoration reflects the spiritual orientation of Amish society."[40]

Quilting bees or clubs offer these women one of the few occasions for social interaction outside the church. Although the opportunity to get together socially is important to the quilters, a sense of religious purpose permeates the occasion. Topics of conversation are ostensibly of an "elevating nature," and sessions may be started and ended with a word of prayer. The finished products are intended either for use by individual quilters or for donation to church fund-raising efforts. The relationship between quilting and fund raising has been noted by Pastor Miller of the Spring Creek Congregation at Hershey, Pennsylvania:

The association between quilting and missionary work came out of the interest of our denomination in world missions in the latter part of the nineteenth century. Many of these missionaries who went out were women and the women of the church strongly identified with them. One way in which they raised funds was through their quilting work. Thus quilting and missionary thrust became related.[41]

Mennonite women remain particularly active in fund raising through the quilt auctions (fig. 69) regularly held by Mennonite Relief Committees. Women in Mennonite churches across the country each donate at least one quilt and sometimes many quilts to each of the Relief sales. The Relief auctions held in Mennonite communities like Shipshewana, Indiana, and Mio, Michigan, have become a major source of funds for missionary work.

EXPANDING RELIGION ON THE HOME FRONT

The same conditions on the frontier that fostered the phenomenal growth of evangelistic revival methods also

encouraged other tactics to save the non-Christian. As early as the late 1600s Jesuit missionary explorers from Europe had sought to bring the Christian faith to the American Indians. Evidence of the persistence of this interaction between Jesuits and Indians is the carved portable altarpiece (fig. 70) purportedly made by an Indian for a Jesuit priest in the latter part of the nineteenth century. Yet in the early years one of the first priorities of religious leaders had been to establish mission schools in which ongoing religious instruction would be available to the new converts (see fig. 9). The early missionary efforts of established Colonial churches were directed toward African or Asian heathens (fig. 71). However, the first Great Awakening that swept the more established New England centers of population had made apparent that there was a great challenge in evangelizing on the home front. Typically, church associations would secure the release of a minister so that he might temporarily work in newly settled regions. For example, Jonathan Edwards, one of the most influential preachers during the Great Awakening, was released to serve as minister to the Day Colony's Indian mission in Stockbridge, Massachusetts.[42] His work was followed by the efforts of Eleazar Wheelock, a graduate of Yale (1733), who devised a plan by which Indian boys would be educated so that they might spread the Gospel to their own people. In 1754, Wheelock opened Moor's Indian Charity School in Lebanon, Connecticut, with two pupils. When he later accepted a call to establish a college in Hanover, New Hampshire, Wheelock opened it (1770) to both whites and Indians. This institution, which became known as Dartmouth College, was a prime supplier of ministers for churches on the frontier.[43]

By the beginning of the nineteenth century it had become evident that neither ministers released for short terms nor the handful of full-time missionaries could keep up with the burgeoning growth of the West. Historian Winthrop Hudson contends:

The beginning of the new era in missionary activity is usually dated from the formation of the New York Missionary Society in 1796 by Presbyterians, Baptists and Dutch Reformed. The primary object of this society, however, was to promote Indian missions. The Missionary Society of Connecticut was the first society to undertake the task of establishing churches in the frontier area.[44]

When the early nineteenth-century wave of revivalistic fervor swept the United States, native Americans became a prime target for evangelistic ministers. In an effort to raise funds for missionary work among Indians, some practices took on aspects of a sideshow. James B. Finley of the Wyandot Mission presented to audiences "a converted In-

dian chief 'Between-the-Logs' whose weird English phrases were supplemented by the remarks of an interpreter."[45] Sparked by the revivalistic spirit of the times, many denominations formed missionary societies that were eventually joined together through interdenominational cooperation. Founded in 1826, the American Home Missionary Society, although primarily Presbyterian, grew out of a federation of religious groups based in New York. Ahlstrom has commented on the missionary's role on the frontier:

> For two generations its missionaries were a major force in the development of the West, not only as apostles and revivalists, but as educators, civic leaders and exponents of eastern culture. The reports of its missionaries, its fundraising activities and its publications on the other hand had a constant invigorating influence on the supporting individuals and churches in the East.[46]

The associations of volunteers, which developed into highly organized missionary societies, also spawned benevolent organizations whose functions were of nearly equal importance. Voluntary associations originally founded by individual denominations and in widely separated areas of the country quickly rallied together when given the opportunity to change American society. Thus, local reform and service societies grew into national organizations charged with producing educational materials, supplying Bibles to converts, fighting intemperance and slavery, founding Sunday Schools for the young, and establishing schools to educate missionaries. Sometimes referred to as the "benevolent empire," these societies helped to enforce a spirit of interdenominational cooperation in which "the best hearts, the most willing hands, and the most vigorous and untiring enterprise" were united in pursuit of common goals.[47]

Spreading the Word

The manufacture and circulation of printed material has long played an important role in the religious education of the American people. As early as the sixteenth century, Mexican Catholics were producing printed holy images. Yvonne Lange has noted that "Printing technology, making its entrance into the Americas in the wake of the conquistadors and the missionary friars who accompanied them, was to give powerful support to the Christian faith that was imposed on the newly found peoples."[48] Lange points out that while the lithographs and chromolithographs of saints contributed to a diminishing of the two-dimensional technique of retablo painting, it did not immediately affect the practice of bulto carving. "Accepted as proper representations of their favorite saints, these prints were given an honored place alongside the wooden imagery."[49]

Printed art continued to perform an important function in the life of not only religious communities in the Southwest but also other religious groups across the country. Birth and marriage certificates, mass cards, festival materials, and instructional prints were produced for various religious audiences. Mortality prints (fig. 72) graphically illustrated the ultimate destinations that would be reached by following either the path of righteousness or the path of evil. *The Tree of Life* and *The Ladder of Fortune* (fig. 73) prints circulated by Currier and Ives depicted these scriptural passages: "Even so every good tree bringeth forth good fruit" (Matthew 7:17) and "Wherefore by their fruits ye shall know them" (Matthew 7:20). Such prints were used either to decorate the walls of a family's home or to instruct children in Sunday schools.

As has been previously noted, prints also provided a subject-matter source for painters and needlework artists. Not only did numerous schoolgirls base their stitched or painted pictures on religious prints, but also some artists were inspired by other printed material. Addie Harrington copied *Thanksgiving Day, Nov. 26, 1863* (fig. 74) from an illustration that appeared in *Harper's Weekly*.

A few of the many methods employed to educate the general American public in religious concerns verged on the theatrical or even sensational. In the late nineteenth century, Carl Christian Anton Christensen, a Mormon, traveled through Utah's Mormon settlements. In each community he would lecture on Mormon Church history as a large painting was unrolled and displayed by lamplight (fig. 75).[50] David Hoy of Walton, New York, created a show wagon called "The Busy World." This horse-drawn wagon was pulled throughout upper New York State during the nineteenth and early twentieth centuries and included numerous carved biblical scenes (figs. 76 and 76a).[51] A nineteenth-century panoramic painting (fig. 77) depicting the life of Christ was recently found in Illinois. Thought to have been found in a church, it is conceivable that this painting might have been used at outdoor or in-church revival meetings.

Denominational Education

Another surge of religious expansion was evidenced in the number of denominational colleges and seminaries that were established in the first quarter of the nineteenth century. Certainly the establishment of European religion on this continent had been earmarked by its foundation on an educated leadership and a literate laity. One of the first priorities of the early colonists was to establish a suitable

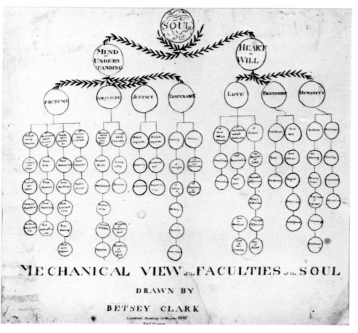

45. Betsey Clark: *Mechanical View of the Faculties of the Soul.*
Litchfield Academy, Connecticut. 1800. Watercolor on paper,
17½" x 19½". Miss Clark's watercolor clearly depicts the
inculcated view of the place of religion in a young woman's up-
bringing. (Litchfield Historical Society)

center to ensure the education of its leadership, a goal ex-
pressed by the author of a 1643 pamphlet designed to raise
funds for Harvard:

> After God had carried us safe to New England, and wee had
> builded our houses, provided necessaries for our liveli-hood,
> rear'd convenient places for Gods worship, and setled the
> Civill Government; One of the next things we longed for,
> and looked after was to advance Learning and perpetuate it
> to Prosperity; dreading to leave an illiterate Ministery to the
> Churches, when our present Ministers shall be in the
> Dust.[52]

Secular and religious education were inextricably bound in
Colonial times. Seven out of nine of this country's earliest
colleges had been chartered by religious groups: Harvard
(1636, Congregational); William and Mary (1693, Angli-
can); Yale (1701, Congregational); Princeton (1746, Pres-
byterian); Brown (1764, as Rhode Island College, Bap-
tist); Dartmouth (1769, Congregational); and Rutgers
(1765, as Queen's College, Dutch Reformed). Columbia
(1754, as King's College) and Pennsylvania (1755) were
nondenominational. As the president of Yale bluntly stated
in 1760, "colleges are societies of Ministers for training up
Persons for the Work of the Ministry."[53]

In the early Colonial period the Enlightenment with its
emphasis on scientific thinking did not have much of an
effect on higher education in America. But by the middle
of the eighteenth century the American college curriculum
was beginning to reflect both the advance of scientific
knowledge and the needs of a changing society. The ad-
vent of the American Revolution awakened the nation's
leaders to the demand not only for an educated civil lead-
ership but also for a trained and patriotic citizenry. As a
nationalistic spirit began to infuse the leadership, the sep-
aration of church and higher education became inevi-
table. In 1819 the Dartmouth College case argued by Dan-
iel Webster finally gave a legal victory to those desiring
secularization of education. Although the case provided
for separate development of religious and secular higher
education, the nonreligious sector did not immediately
surge ahead with college programs; quite the opposite
resulted. The founding of religious colleges experienced a
dramatic increase in the first half of the nineteenth cen-
tury. The long-standing historical link between religious
and secular education, the prevailing evangelistic fervor,
and the marked religious and moral attitudes of state
legislatures meant that even secular schools retained reli-
gious orientations. For many denominations the estab-
lishment of a school on the frontier served purposes simi-
lar to the building of a church, as both provided outposts
from which missionaries, itinerant ministers, and evange-
lists might work. The Baptist Convention of 1820 voted
to stress education as a basic function of the church
and adopted the slogan "Every State its own Baptist
College."[54] Because of these efforts, the frontier was
sprinkled with log-cabin colleges. Whether because of in-
terdenominational competition that fostered college
building or because of general, national opposition to ra-
tionalism and Deism, organized religious institutions had
a profound effect on the growth of American higher educa-
tion.

THE GROWTH AND SHIFTING OF MEMBERSHIP IN
RELIGIOUS GROUPS

Of over 3,000 churches in 1775 in the American Colo-
nies, the most populous and powerful were the Congrega-
tional and Presbyterian churches, with Baptists, Quakers,
and Anglicans rounding out the major Protestant groups.
Of predominantly Scottish origin, Presbyterians settled
primarily in the middle colonies and the Piedmont region
of the South. Congregationalists, who had provided the
nucleus of the settlement at Plymouth, established their
greatest strongholds in the New England area. The
Quakers remained primarily a regionally based denomina-
tion and, although they professed "plain living," they pro-

duced a prolific artist of religious imagery: Edward Hicks.

In the mid-eighteenth century the Anglican Church had already experienced a decline in membership when the laity had fought against the establishment of an American episcopate. Because of its close ties to the Church of England and the fact that large numbers of its members became Tories, the Anglican Church ceased to be a major religious force immediately after the American Revolution. The war served to increase patriotic support among other denominations: Congregationalists and Presbyterians were especially active in promoting resistance to Britain. The worst incendiaries of all, complained Loyalist Joseph Galloway in 1774, were "Congregationalists, Presbyterians and Smugglers."[55] The Baptists, who had been scattered throughout the Colonies, gained a reputation in the new Republic because of their aggressive role in the war, but did not experience substantial increases in membership until the revivalistic era some twenty-five years later.

As has been previously noted, the advent of revivalism brought great changes in the distribution of membership in Protestant denominations, particularly to the Methodists, who had begun as an offshoot of the Church of England. Spearheaded by the leadership of Francis Asbury, American Methodism was the chief vehicle of evangelical Arminianism in this country. With its emphasis on personal religious experience, doctrinal simplicity, and the informal class meeting as the basis of its church structure, Methodism found ready support in the mainstream of American society. Repudiating the formality and educational elitism of the more established Episcopal, Congregational, and Presbyterian denominations, Methodists burgeoned on democratic theology. At a time when Americans were experiencing feelings of individual worth, Methodism was especially appealing.[56] Perhaps this atmosphere of egalitarian participation and emphasis on informality encouraged both group and individual artistic expression for religious purposes. The church was more open to nonelitist contributions, whether in the design of a community church or the use of quilts for fund raising. By the end of the nineteenth century Methodists had become the most numerous religious body in America.

Of the non-Protestant groups in the Colonies, Catholics composed the largest number, settling primarily in Maryland, Pennsylvania, and Rhode Island. According to Ahlstrom, the long French and Indian Wars "had involved a hostile Roman Catholic presence in various areas, and left an enduring legacy of heightened anti-Catholic animosity among colonial Americans."[57] American Catholicism encountered considerable intolerance in the Colonies where "burning the Pope" on Pope Day (November 5) remained a popular diversion for some time in New England. Although the First Continental Congress of 1774 provided for freedom of religion, Catholics were denied full civil and religious rights.

Between 1790 and 1850, over one million immigrants of Roman Catholic background arrived in the United States. This significant increase prompted an outpouring of anti-Catholic feeling, a sentiment that carried "nativist" underpinnings. As immigrant blocs poured into the States, native-born Americans became uneasy, alarmed that their settled ways would be disrupted by the imported folk culture. Much of the hostility to Catholicism was a reaction to its Irish and Italian ethnic roots. Convinced that Roman Catholicism was an international conspiracy to undermine American democracy (fig. 78), some Americans formed the secret Order of United Americans (the Know-Nothing party of the 1850s) to combat this imagined religious threat. The influx of many ethnic groups not only fostered apprehensions among non-Catholics but also created tensions among American Catholics as well. Nativists were confronted with an onslaught from different cultures. The immigrants were generally poor, spoke a different language,

46. *The Happy Family* (detail). Engraving from *Picture Lessons, Illustrating Moral Truth.* c. 1850. Women comprised the overwhelming majority of church membership in early nineteenth-century America, but few participated in church leadership. Instead, women were expected to ensure the religious instruction of their children. (Courtesy, The Historical Society of Pennsylvania)

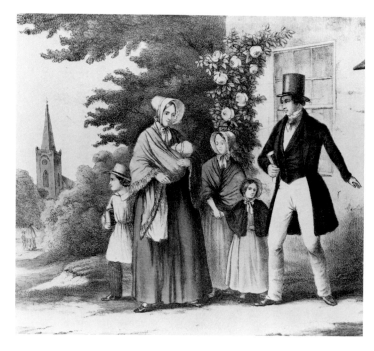

and had different traditions and customs. The folk religious traditions of one Catholic immigrant group did not always match those of either established Catholic Americans or other Catholic immigrants.

The Catholic presence in the eastern portion of the country was evidenced not only in the persistence of traditional folk religious practices among the immigrants but also in the Catholic symbolism incorporated into the material culture of other religious groups. Such influence had been seen in the early eighteenth-century paintings by the Hudson River Dutch Reformed Artists (see figs. 95 and 96) and even in the *Nuestra Señora de Monte Carmelo* by Mary Ann Willson (fig. 79). However, neither outward theological and ethnic biases nor differing internal folk practices prevented the Roman Catholic Church from making great strides in membership and, by 1900, it had 12 million members.

The Jews were one of the smallest religious groups in Colonial America. Although Jews were among the first arrivals, with at least two Jews on Columbus's ships, it was not until 1730 that their first synagogue was built and dedicated. In 1880 it was estimated that the Jewish segment of the population numbered 250,000. Between 1880 and 1900 more than a million Jews entered the country, fleeing the anti-Semitic pressures of eastern Europe. By 1914 their numbers in America had risen to around 3 million.[58] Unlike the pre-1880 Jewish population, which was predominantly German and quite scattered throughout the United States, the new Jewish immigrants were of different cultural backgrounds and crowded into Eastern cities. Therefore the Jewish-American leadership faced a challenge similar to that confronting the Catholic hierarchy: to develop a doctrine that would incorporate all divergent Jewish practices but maintain basic Jewish beliefs.

Within the Jewish culture, the use of artifacts within a religious context is not as widespread as in other religious groups. Nonetheless there are many ways in which the arts play an important role in Jewish life. The construction of a succoth, the decoration of a Torah binder, and the cutting of a paper message are all examples of the way in which art intersects the Jewish experience.

ART AND RELIGIOUS GROUP IDENTITY FOR IMMIGRANTS

Although many groups have contributed to the religious complexion of the United States, a few groups are worth special mention because of the volume or strength of their religious material culture in American history. In any study of religious art attention must be paid to the art of the Pennsylvania Germans—an art that freely incorporated literal religious and symbolic imagery in all areas of production. By 1790 one-twelfth of the American population was made up of individuals who had fled from oppressive churches in German-speaking regions of Europe.[59] At first, these Germanic people had clustered in settlements in Pennsylvania, but later they also settled in Michigan, Texas, Missouri, and places farther west. A plan devised in 1742 and spearheaded by several religious leaders hoped to gather the Pennsylvania religious immigrants together under common theological goals. The meeting had just the opposite effect: instead of unity, a strong denominational consciousness emerged. One group consolidated in Ephrata, Pennsylvania; Moravians renewed their interest in missionary work; Mennonites, Dunkards, Quakers, evangelical Lutherans, Calvinist Reformers, and Schwenkfelders all developed independently while maintaining strong Germanic traditions.

Folk traditions from their German background permeated all facets of Pennsylvania German culture: food, dress, literature, dialect, religion, art, and architecture all incorporated motifs, patterns, symbols, and rituals transported across the ocean from the old country. Lewis Miller's view of the singing choir (fig. 80) at the Old Lutheran Church of York, Pennsylvania, and the baptismal scene (fig. 81) attributed to Durs Rudy provide both documentation of ritual and evidence of Germanic traditions. Pennsylvania folk art did not spring up full-blown but emerged gradually out of this transplanted body of Germanic folk images coming in contact with New World environments. Yet the fund of folk images employed predominantly symbols derived from an interpretation of Christian Scripture.

Among the first folk art forms produced by Pennsylvania Germans were stoveplates for five-sided stoves (fig. 82). In *The Bible in Iron* Henry Chapman Mercer states that "Biblical picture plates attributed to Pennsylvania furnaces date from 1741–1749."[60] A majority of the scenes are representations of Old and New Testament passages, including Adam and Eve, David and Goliath, the Wedding at Cana, and the Miracle of the Oil with the figures dressed in typical eighteenth-century costumes. When the designs of the stoves moved from representational scenes to folk motifs, the stoveplates retained their religious orientation, for the motifs embodied a religious symbolism rooted in medieval Christian art. As John Joseph Stoudt states:

In its main forms then—dower chest, Vorschrift, Taufschein—Pennsylvania folk art was religious in that it employed traditional Christian images that may in the end prove to be universal archetypes, both as designs and

symbols of psychic integration. Some symbols may antedate Christianity, existing in pagan form before they were adapted to Christian interpretation.[61]

Among the symbols and motifs most often used by Pennsylvania German artists were angels, tulips, hearts, parrots, mermaids, Adam and Eves, lambs, unicorns, lilies, doves, pelicans, and six-pointed stars (figs. 83–87). Pastor Frederick Weiser has pointed out that "the mingling of purely secular and obviously religious subjects is typical of the Pennsylvania German mentality . . . [and that] artists did not hesitate to step outside tradition and religion for the source of their decoration."[62] In *Pennsylvania German Illuminated Manuscripts* Henry S. Borneman has commented at length on the symbolic significance of some of the popular motifs. Those motifs that obviously symbolize religious beliefs include the angels (full-bodied or simply winged heads), lilies, doves, and crosses. Those motifs that are mentioned in the Bible but have no particular ecclesiastical symbolism are the deer, stars, peacocks, and serpents. Borneman refutes the popularly held notion that the often-used tulip motif is emblematic of the Trinity: "I have gone through the various hymn-books used by the Pennsylvania German pioneers. Nowhere do I find the tulip used in a symbolic sense . . . my studies have led me to the conclusion that the tulip was used for decorative purposes only."[63]

Another often-used motif is the source of even more controversy. The six-pointed star *(Sechsstern)* is found on barns, tombstones, in manuscripts, and on other objects. Stoudt has outlined the history of the motif:

> Widespread in European folk art, both carved and painted, this design has been traced by a European architect to the South Tyrol, where it has been associated with the Christian monogram, I.H.S. In Europe, this sign was always good luck . . . In Pennsylvania, itinerating barn painters elaborated the sechsstern and designs became more ornate . . . [N]ow this design is popularly, and wrongly, called the Hex sign.[64]

A generally selective use of certain motifs for particular object types has been noted by Borneman: "[T]he general character of the designs in the manuscripts, and on pottery, barns, and furniture on the other hand, greatly differ. There is somewhat of a uniformity of motif in each class, and peculiar to itself."[65] One such use of a motif is employed on young women's dower chests. Here the decorative unicorn motif appropriately paralleled the medieval fable of unicorns as the guardians of maidenhood (fig. 88).

One of the popular Pennsylvania German art forms, the art of illuminating manuscripts in a style of broken lettering called *Fraktur*, made its first appearance at the Ephrata religious settlement. Copy pieces, marriage certificates, birth records, confirmation certificates, house blessings, memorial pieces, bookplates, and labyrinths (figs. 89–92) were among the items produced in this distinctive Pennsylvania German style. In commenting on the popularity of Fraktur after the Revolutionary War, Stoudt suggests that religious art served an important function in a region where there were not enough schools and textbooks and where there were few established churches to record vital statistics. The dower chest, often given to a young girl before marriage, was decorated with numerous motifs of Christian symbolism (fig. 93). Gravestones, quilts, samplers, glassware, linen, tinware, cookie molds, and pottery of the Pennsylvania Germans all carried the Germanic folk motifs that gradually became assimilated into American styles. One German religious folk tradition that persisted was the making of *Putz* at Christmas. In these depictions of the Nativity, small tin, wood, or clay figures were arranged to represent the events of the Christmas season and were placed underneath the tree.

Among those painters who created a body of work with strong religious feeling, a few individuals stand out. John Valentine Haidt, a German immigrant who began his painting at the age of forty-five in a Moravian community in Herrnhagg, Germany, came to Bethlehem, Pennsylvania, in 1754. Trained as a goldsmith, he also received some instruction in drawing at the Royal Academy of Arts in Berlin. As a member of the Moravian Church in America, he did missionary work and, supported by the church, he painted biblical scenes such as *The Nativity*, *The Miracle of the Loaves and the Fishes*, *Christ Before Herod*, *The Crucifixion*, and *The First Fruits* (fig. 94). He was a particularly prolific artist, as this passage in his memoirs reveals: "I hardly need to mention that I have painted, because almost all the congregations have some of my work, which the dear Savior has also let be a blessing to many a heart."[66]

Recent scholarship by Mary Black, Roderic Blackburn, and Ruth Piwonka has led to a greater understanding of a group of approximately thirty-eight scriptural paintings executed for Dutch, Walloon, and Huguenot homes during the eighteenth century in New York. These paintings are evidence of Dutch-European religious values that were brought to the New Netherlands as early as the mid-seventeenth century. They were based largely on prints found in Dutch Bibles imported in the early part of the eighteenth century, but they may also have been influenced by the prints that decorated the walls of Dutch homes. The paintings have a pedantic religious quality

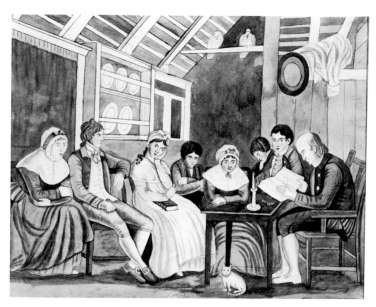

47. Eunice Pinney: *The Cotters Saturday Night*. Connecticut. c. 1815. Watercolor on paper, 12⅛″ x 14⅝″. Although it was usually the woman's task to teach the children, men often assumed the leadership in instructing the adults. Bible study groups, held in the homes of neighbors, offered a chance for adults to share friendship and religious faith. (National Gallery of Art; Gift of Edgar William and Bernice Chrysler Garbisch)

rendered in a linear style. Despite the uneven technical skills that are obvious in the paintings, all of the works reflect the survival of Dutch culture and religious customs.

The isolation of a folk group enhances the rise of localized community values. Piwonka and Blackburn have written of this phenomenon among the eighteenth-century Dutch in New York:

> In the early eighteenth century, the upriver Dutch began to close their society to most outsiders. Their cultural conservatism appears to have been a defensive reaction against the English and French who were cultural and religious antagonists . . . Until the 1760's, the upriver Dutch surrounded themselves with buildings and objects that sustained the cultural environment of a century before.[67]

The role of the Dutch Reformed Church was critical in the preservation of both spiritual and secular life of the Dutch people in New York. The church encouraged the painting of such works as *The Four Evangelists*, attributed to Gerardus Duyckinck (fig. 95); and the *Adoration of the Magi*, by a painter referred to as the "C2 Limner" (fig. 96). These paintings of popular biblical events demonstrate the way that folk art often reinforces local traditions, whether they be secular or religious in nature. Art

production is a response to a need to maintain the continuity of the traditional patterns in life and is often most dramatically acted out when the cultural life of a community is threatened. For the various Germanic religious groups in Pennsylvania and for the Dutch Reformed in Upstate New York, religious imagery helped to maintain those traditions that contributed to the maintenance of both ethnic and religious stability.

AFRO-AMERICAN RELIGION AND ART

Thus far only the development of religious groups in America that reflect native American, Spanish colonial, or European origins has been examined. Yet, attention must also be given to the development of the religious life and art of Afro-Americans. Because this is history that begins with the importation of slaves into America, it is interesting to note that as early as 1670, Virginia, a major slave colony, had legislation that "all servants not being Christians who were brought into the colony by sea were to be slaves for life."[68] At first there was little interest in attempting to convert or catechize blacks. The revivalism of the Great Awakening, however, presaged the conditions for wide-scale conversion of the slaves. In the eighteenth century Jonathan Edwards noted this rising interest in evangelism among the blacks: "There are several Negroes who, from what was seen in them and what is discernable in them since, appear to have been truly born again in the late remarkable season"[69] (fig. 97). The Great Revival period at the turn of the nineteenth century marked a significant moment in the history of American black religious history. Pietistic white attention was turned toward slaves, and an aggressive program of plantation missions was established. The blacks themselves found a certain area of freedom in these events. Black elders were appointed in some churches, black preachers and exhorters led plantation services for slaves, and occasionally an entirely black church was established (fig. 98). In *Slave Religion* Albert J. Raboteau has commented on the acceptance of the Christian belief system by this slave population: "The powerful emotionalism, ecstatic behavior and congregational response of the revival were amenable to the African religious heritage of the slaves, the forms of African dance and song remained in the shout and spirituals of Afro-American converts to evangelical Protestantism."[70] Both Methodists and Baptists swelled the ranks of their membership with substantial numbers of black converts. As Joseph Washington, Jr., has pointed out, "They [Methodists and Baptists] directly attacked slavery in the name of religion while simultaneously embracing blacks as brothers in their fellowships."[71] These two denominations appealed to blacks because their membership was gener-

ally drawn from a middle or lower class; many of their preachers had little or no schooling; and finally, their common use of the camp meeting "proved to be a powerful instrument for accelerating the pace of slave conversions."[72]

The religious instruction of slaves in the Old South was most successful in settled, stable communities. Yet even in its strongest locations, religious instruction was always tainted with the realities of life for the bonded servant or slave. Slaves were taught that being a good Christian meant obeying their owners and that when they were married it was for eternity, although the wedded pair might be sold apart. Blacks were limited by white church leaders from active participation in the church hierarchy, in preacher licensing, and even church-seating arrangements. Even when a black church was independently organized in a Southern town, often it had to be rechartered under the auspices of a local white church. However, despite these limitations, the rise of black religious membership continued, as Raboteau has noted:

By the eve of the Civil War, Christianity had pervaded the slave community. The vast majority of slaves were American-born, and the cultural and linguistic barriers which had impeded the evangelization of earlier generations of African-born slaves were generally no longer a problem . . . [T]he religion of the slaves was both institutional, visible and invisible, formally organized and spontaneously adopted.[73]

The so-called invisible institution began to take shape as blacks molded African traditions and belief systems into social-religious organizations that provided a means of explaining their personal existence in the New World.[74] Ahlstrom states that, "The church was in a sense a surrogate for nationality, answering to diverse social needs and providing an arena for the exercise of leadership. Far more than for whites, the black church served other than strictly religious needs."[75] Religion provided a spiritual avenue to freedom that contrasted sharply with the realities of slavery. It promised both personal freedom and a better life. When blacks sang of the promised land, the spirituals were full of double meaning.

Afro-American religious history consists, then, of a complicated process that blended African customs and beliefs into Euro-American religious institutions. By responding to the tensions inherent in continued oppression, the resulting mixture of Afro-American religious customs has become both more distinctive and more difficult to analyze.

Although African contributions to the body of American religious culture usually center on their music, dance, and sermon types, their material culture is also of note. The blend of African motifs with American religious institutions has produced an array of distinctive artifacts, including quilts, gravesite decorations, churches, church furnishings, and pottery (fig. 99).

The African custom of decorating a grave with the personal belongings of the deceased has persisted, especially in the rural South. Whole and broken pottery, shells, pipes, bottles, and other materials have been placed on top of the grave either to "lay the spirit" or to "free their spirit"[76] (fig. 100). John Michael Vlach has noted in the more recent use of clocks as grave decorations that "they are set at twelve to wake the dead on Judgment Day, or they are set to mark the hour when the deceased passed away."[77]

Although most of the objects used to decorate graves were either personal effects or already available items, occasionally items were made expressly for the gravesites. In *The Afro-American Tradition in Decorative Arts* Vlach has written about three pottery torso figures rumored to have been used on gravesites. The *Preacher Man* reflects Afro-American pottery characteristics of form, construction, materials, and use[78] (fig. 101).

One unusual and outstanding decorative Afro-American gravesite is found in Sunbury, North Carolina, in the county where Charles Colcock Jones, The Apostle to Negro Slaves, served as a plantation missionary.[79] Here Cyrus Bowens constructed an assemblage of large abstract wooden sculptures to adorn his family plot (fig. 102).

The evidence of strong African design influence is found in some Afro-American quiltmaking. This persistence of African design coupled with Christian imagery is especially obvious in two pictorial quilts made between 1886 and 1898 by Harriet Powers of Athens, Georgia (fig. 103). With simple, stylized figures appliquéd onto a background divided into narrative panels, the two quilts depict scenes drawn primarily from the Bible. The images are stark but the biblical stories are unmistakable. Gladys-Marie Fry comments on Powers's choice of images: "At the core of Mrs. Powers' religious symbology are the legends of Biblical heroes such as Noah, Moses, Jonah and Job, all of whom struggled successfully against overwhelming odds. Her source of material includes 'the Bible of the folk' in that she depicts traditional stories which have their origins in Biblical narratives."[80] The technique of appliquéing was a common feature of textiles from West Africa. Powers's appliquéd quilts especially paralleled the narrative textiles made by the Fon of the Dahomey region in West Africa. A photograph of Harriet Powers shows her wearing an apron adorned with the same simple appliquéd shapes. Similar appliquéd images depicting souls en route to Heaven or

Hell are found on another slave's apron from Yalobusha County, Mississippi (fig. 104).

The physical characteristics of the structures in which blacks worshiped were affected by a variety of factors: economics, geography, type of religion, and, sometimes most important, white restrictions. From hush arbors (secret worship locations in the woods) and plantation missions to large urban storefront churches and small meeting halls, blacks have created gathering places for worship. Although little is known about the details of the form and construction of these structures, perhaps even less is known about the church furniture and decoration. Occasionally, an object surfaces accompanied only by speculation about its use. One such object is the church chandelier made by Luther Goines of Maryland[81] (fig. 105).

Although Protestantism attracted most of the black population, a smaller portion of blacks were converted to other faiths, notably Catholicism or Judaism.

However, "no discussion of Africanisms in the religious life of black Americans could be complete without reference to voodoo"[82] (fig. 106). Primarily a system of magic, voodoo flourished as an organized cult in the New Orleans region only until the late nineteenth century. The tradition of voodoo or "root work" continued to exist among slaves, and even today some of these folk beliefs persist among their descendants.

SECTARIAN IMPULSES AND ARTISTIC EXPRESSION

While revivalism was sweeping the country, bringing fresh air into the more staid denominations and igniting tremendous growth in others, America was also witnessing the rise of sharply defined religious sects and utopian societies. Sydney Ahlstrom has commented on the proliferation of sects in the nineteenth century:

The most fundamental divisions in America's religious life are a direct inheritance from the Old World, whose Christian subgroups have simply been projected across the seas by immigration. Many religious American bodies, moreover, are simply regional variants or else parallel churches of different national origin, but within a single confessional communion. Still others have resulted for various reasons from the process of denominational division, not through sect formation. Yet America is undeniably the home of many sects and evangelical ferment frequently did stimulate their formation . . . Sect formation is a movement of people who are spiritually, socially, economically, educationally or in other ways "disinherited" . . . If not disinherited in this sense, the sect's following is at least in search of values, fulfillment, or fellowship that a dominant, socially acceptable church by its nature cannot ordinarily satisfy.[83]

A. Leland Jamison, in his essay "Religions on the American Perimeter," outlines four prominent beliefs that guided the formation of these sects: perfectionism; millennialism, often based on extremely individualistic interpretations of the apocalyptic books of the Bible; universalism; and illuminism, which espoused the possibilities of further revelations of God's word.[84] Owenites, Millerites, Icarians, Amanas, the Swedenborgian movement, the Universalist Church, Spiritualism, Shakers, Rappites, Zoarites, Mormons, and Jehovah's Witnesses were some of the better-known experiments and movements (figs. 107 and 108). All developed modes of conducting their religious life, but some left a more lasting mark than others on the material cultural history of the United States. Of these, perhaps the Shakers are the best known, both for their products designed for private use or public sale and for the drawings, which revealed spiritual messages from God.

The Shaker movement was brought to America in 1774 by Mother Ann Lee who had been converted by members of the Millennial Church in England. She became convinced that not only would the Second Coming of Christ be in the form of a woman but also that she herself was that woman. Shaker communities were founded as millennialist groups, each with an intense biblical orientation laced with spiritualist overtones. Revivalism was incorporated into their worship ritual, providing a continual source of spiritual regeneration for members. Their group dance earmarked their worship service and also gave them their name (fig. 108).

Believing that shaking was an expression acceptable as worship to God, Shaker leaders guided the practice of this exercise into regimented dance rituals. Through careful direction and much practice, the marches, processions, shuffles, and ring dances became an integral part of the Shaker worship service. With the inclusion of dance the services took on a theatrical quality, attracting curious spectators from afar. As a rule these public Sabbath assemblies were orderly, although occasionally the meeting might change its course, as noted by Horace Greeley: "At length, what was a measured dance becomes a wild, discordant frenzy; all apparent design or regulation is lost; and grave manhood and gentler girlhood are whirling round and round, two or three in company, then each for himself."[85]

The material culture of the Shaker order was in perfect harmony with its religious purpose. Shakers stressed an orderliness and a usefulness that infused every aspect of the environment they created (fig. 109). Every item produced or used by Shakers had a specific place and purpose. In *Work and Worship*, Edward Deming Andrews and Faith Andrews mention the following factors that characterized the Shaker output:

1. The recognition and use of native aptitudes and skills;
2. respect for hand labor: hand labor was a sacred privilege, a test of faith;
3. the doctrine of perfectionism: it was the Shakers' desire to excel the world in all good works, including standards of industrial workmanship; and
4. order, utility, and improvement as determinants of the economy.[86]

Objects made for use by the Order, as well as those made for the secular world, were governed by these principles. Both published rules and revealed signs regulated every conceivable aspect of the items made or used by Shakers. For instance, in 1821, *Millennial Laws* carried this section:

Fancy articles of any kind, or articles which are superfluously furnished, trimmed or ornamented, are not suitable for Believers, and may not be used or purchased . . .

Believers may not, in any case or circumstance, manufacture for sale, any article or articles, which are superficially wrought, and which would have a tendency to feed pride and vanity of man, or such as would not be admissable to use among themselves, on account of their superfluity.[87]

The various Shaker settlements and their way of life were objects of intense interest to both domestic and foreign visitors, hundreds of whom came to witness firsthand the remarkable communities. The nineteenth-century historian Charles Nordhoff, having visited several of the communities, reported on the interiors of the buildings:

Strips of home-made carpet, usually of very quiet colors are laid upon the floors, but never tacked down . . . The strips are easily lifted, and the floor beneath is as clean as though it were a table to be eaten from . . . The walls are bare of pictures; not only because all ornament is wrong, but because frames are places where dust will lodge.[88]

Elder Frederick Evans told Nordhoff, "The beautiful is absurd and abnormal. It has no business with us. The divine man has no right to waste money upon what you would call beauty, in his house or daily life, while there are people living in misery."[89]

As Nordhoff and others have observed, bright color and ornamentation were virtually nonexistent in Shaker clothes, housing, or products. Yet there was an area in which both color and ornamentation played key roles: the inspirational drawings and paintings that were created by a few members of the sect (fig. 110). First produced in the so-called Era of Manifestations from 1842 to 1845, these pictorial records of spiritual revelations grew in popularity until around 1859. After the Civil War the Shakers

began to adopt a more worldly outlook, an outlook that eventually contributed to the demise of the Shaker Order and its material culture. In the Shakers' heyday the spiritually inspired art was rendered in thorough harmony with Shaker doctrine. As within any folk group, the artwork displayed more commonalities, stemming from Shaker doctrine, than variations in style. The Andrewses have commented on the relationship of individual artists to a common belief system:

To credit the drawings, paintings, songs or messages to supernatural intervention is to misinterpret the powerful currents of faith and emotion fed by the reservoirs of Shaker culture. Although these manifestations are the work of individuals, they reflect the workings of a communal, or folk, mentality deeply tainted with mysticism.[90]

Usually rendered in ink and watercolor on paper, these images were filled with brightly colored and highly decorated clothes, foods, ornaments, flowers, and musical instruments (fig. 111). It is almost as if the very objects that Shakers were denied in the temporal life were revealed to them as existing in the heavenly life.

Other sectarian groups or utopian societies produced cultural artifacts that reflected or supported their particular philosophy. Although not so striking as the relationship of Shaker philosophy to their production of objects, the material culture of these groups does allow for further examination of their respective religious belief systems. The Harmonists were a group of German Pietists influenced by the strong religious leadership of George Rapp. The Harmonists, or Rappites, as they were sometimes called, built three communities, two in Pennsylvania and one in Indiana. As Paul H. Douglas has noted in his essay "The Material Culture of the Harmony Society," the Harmonists were well "aware of and took from the cultures of the past and those surrounding them in the planning of their villages and in the style of their architecture and artifacts."[91] Although the Harmonists did not adorn the interiors of their dwellings or their worship halls with paintings or statuary, they frequently employed religious symbols and were not opposed to art. In fact, for a while, a museum housed in the same building where they worshiped was filled with both religious and secular paintings. One Harmonist member, Wallrath Werngartner, even became well known for his drawings of birds and flowers. Douglas points out:

The Harmony society had an element of mysticism in its religious philosophy and some items at the three villages have symbolic references reflecting deeply held beliefs of the members. However, since the Harmonists were breaking away from the established church, which they felt was

corrupted and encumbered by an overabundance of religious artifacts having little or no relationship to true religion, the symbolic motifs had a general rather than specific purpose in reminding the members of their special role. Since the village as a whole was an exemplum of the true church, specifically religious objects were unnecessary.[92]

Among the motifs employed by the Harmonists were the Golden Rose, a symbol of the risen Christ and the coming of the Kingdom of God on earth, which was found on everything from newel-posts to ladies' shawls; Virgin Sophia, meaning wisdom; the Lily, indicating hope; and the Pelican, a symbol for Christ. In "Harmonist Folk Art Discovered," Donald Pitzer points out that

> the rose transcended all other flowers in Harmonist theology and art . . . The rose derived its significance from the symbolism attached to the "golden rose" in Martin Luther's translation of the millenial Biblical passage in Micah 4:8, "And Thou Tower of Eden, the Stronghold of the Daughter of Zion, thy golden rose shall come, the former dominion, the Kingdom of the daughter of Jerusalem." Thus the rose was the token of the imminent coming of the Kingdom of God on earth—the time of restoration and brotherhood toward which all the hopes and energies of the Harmony Society were directed.[93]

By citing the case of two writers, Douglas cautions against too enthusiastic an analysis of what appears to be mystical or symbolic elements. The zealous analyzers counted 144 blocks projecting on the interior of a Harmonist grotto, which they concluded represented the "144,000 chosen souls in Christian theology."[94] However, a later and more careful count revealed that there were, in fact, only 142 blocks, thus disproving the original conclusions.

The Zoarites, a company of almost three hundred Separatists who settled in Zoar, Ohio, were another Pietist group that developed a distinctive body of material culture. The Zoarites were a self-sufficient community that produced stoves, furnaces, tinware, quilts, and coverlets retaining traditional German styles and motifs. Frequently, the red, blue, and yellow Zoar Star was used to adorn their crafts. The official seven-pointed star, enclosed by concentric circles, had convex lines or sashes connecting the points of the stars.[95] The Star of Bethlehem illustrated here is attributed to a German Separatist and is considered a variation of the Zoar Star (fig. 112). Unlike the Shaker drawings, which were spiritual revelations given to artists or "instruments," Zoar devotional art simply consisted of interpretations of mystic Pietism by talented artists in the community.

Of the newly formed religious movements, the rise of the Church of Jesus Christ of Latter-Day Saints, or Mormons, provided the basis both for the direct support of art and for some of the most frequent appearances of religious symbols in material culture. This support was founded in an approach to art that, although contrary to other denominational stances, was entirely consonant with Mormon doctrine. Basic Mormon belief holds that one must unselfishly use his God-given gifts to the fullest. As Steven P. Sondrup has noted in the introduction to *Arts and Inspiration,*

> Beginning perhaps with the Lord's admonition to Emma Smith (wife of Mormon founder, Joseph) to collect sacred hymns and continuing through the calling of art missionaries to study painting in France and through various other kinds of direct and indirect support of the arts, the Church fostered the cultivation of aesthetic sensitivity.[96]

Whether by sending Mormon artists to study in France, establishing Public Works (church-sponsored shops) to provide work for immigrant craftsmen, or commissioning architects and artists to help build and beautify the Mormon Zion, the church was instrumental in fostering a wide array of art production.

Mormonism also encouraged the use of a variety of symbols to strengthen the identification with their religious movement. Some of the symbols were consciously created to augment church theology; others were popular motifs simply adopted by Mormons as part of the symbolic language of the church. Clasped hands, the all-seeing eye, the horn of plenty, and the beehive were all motifs adopted as institutional symbols of the mid-nineteenth century Church of Jesus Christ of Latter-Day Saints. Of these, the beehive has continued as by far the most pervasive Mormon symbol (fig. 113). In commenting on the beehive in Mormon symbolism, Susan and Richard Oman recently stated:

> The beehive has a special Mormon context and name, which was important. The Book of Mormon, in describing the Jaredites (a group that migrated to America from the tower of Babel), explains that "they did also carry with them deseret, which, my interpretation, is a honey bee; and thus they did carry with them swarms of bees." In January 1849, when Church leaders established a provisional government until territorial or state status for the area had been approved, the Great Basin was christened "Deseret."[97]

The beehive was an early institutional symbol in the formation of the Mormon kingdom in Utah. An 1881 article

in the *Deseret News* described its symbolic function as follows:

> The hive and bee form our communal coat of arms. The symbol is adopted extensively in our local institutions. It is a significant representation of the industry, harmony, order and frugality of the people, and of the sweet results of their toil, union and intelligent cooperation.[98]

As the church-state of Zion became incorporated into the federal state of Utah, the beehive symbol persisted even though its meaning was transferred into new contexts. Hal Cannon, in the introduction to *The Grand Beehive*, comments on the pervasiveness of the symbol: "Once the beehive was an evocative symbol of a fervently-held faith, capable of eliciting sacrifice from believers and anger from enemies. Now it is a neutral traditional motif and is used easily and widely, but at the cost of much of its emotional force."[99] From the official state seal to neon signs, from souvenirs to clothing labels, from ice cream molds to totem poles, from doorknobs to Utah State highway signs, the beehive motif has been integrated into the Utah landscape.

The Mormon Church's position of encouraging the individual to develop his talent to the fullest generates an attitude of tolerance when a sincere artist's efforts do not produce great masterpieces. Such is the case with the nineteenth-century painter Carl Christian Anton Christensen (see fig. 75), who traveled through Mormon settlements giving lectures on church history as each of his paintings was unrolled and displayed by lamplight. When his stored-away paintings were recently brought out, Church Elder Boyd K. Packer had this to say: "Brother Christensen was not masterful in his painting, but our heritage was there. Some said it was not great art, but what it lacked in technique was more than compensated for in feeling."[100]

In some of the major utopian experiments and sectarian movements, artists were known for art that reflected a collective religious cultural identity yet did not serve a clear-cut role in religious documentation or ritual. In such cases, however, these member-artists provided through their work important visual data about the cultural history of their particular religious community. For instance, Bishop Hill, a short-lived colony of Swedish immigrants in Henry County, Illinois, is famous for being the home of the well-known folk painter Olof Krans (1838–1916).[101] A self-appointed historian in paint, he produced numerous portraits of many of the early settlers in Bishop Hill. From 1896 to 1915 Emil "Maler" Kym of Buhler, Kansas, painted genre scenes of his Swiss homeland on the interior walls of neighboring Mennonite homes.[102] Another member-artist,

Anna Bock (a pseudonym used at the artist's request), paints Mennonite genre scenes from memory, photographs, or real life. While presenting evidence of the material cultural life of their particular religious communities, the artists also provide for themselves a confirmation of the sense of community identity. For instance, Kym employed the Swiss imagery of his European-Mennonite heritage, and Bock carefully deleted all non-Mennonite items in her paintings. These member-artists have worked within and preserved an identification with the traditional religious values of their respective communities. Bock clearly underscored the underlying sense of a religious belief system when she commented on her dissatisfaction with non-Mennonite representations of her community's life-style: "They couldn't get anything right—the buggies were all wrong and everything. We live what I paint and I paint what I see."[103] Thus the member-artist helped to retain the fundamental values that bound a religious group.

Not every religious sect or denomination produced a significant body of material culture. Indeed, some groups followed a doctrine that frowned on, or even forbade, any emphasis on decoration. For some religious groups almost all of their material culture bore the stamp of their religious persuasions, whereas for other religious groups only a small portion of their material culture reflected their doctrine. Yet all religious groups, even those that professed a plain style of living, surrounded themselves with distinctive cultural materials that reflected their religious philosophy. Whether in the physical layout of the place of worship, the fashion of dress worn by church members, or in the materials produced for use in religious ceremonies, cultural artifacts gave evidence of the belief system of a particular religious group.

As each immigrant group arrived in America, bringing with it its own set of cultural traditions, the religious fabric in this country grew ever more textured. Some immigrants transported their homeland religion with them, joining in worship with previous immigrants from their country. Their worship experience was closely modeled after the customs of the old country, as in the case of some of the Pennsylvania German orders. Other immigrants blended their Old World religious traditions with the established New World churches, finding the adaptation geographically or socially easier than maintaining a strict adherence to homeland ways. Yet, depending on their choice of residency, immigrants were able to hold on to ethnic religious customs to a greater or lesser extent. Wherever a sizable, cohesive community of immigrants settled in a fairly localized place, the strength and continuity of Old World traditions were enhanced, as has already been seen in the case of the sectarian movements. Even in smaller commu-

nities of immigrants who shared similar religious beliefs, traditions associated with their church ties continued to find support and encouragement (fig. 114). For some immigrants the persistence of tradition found public or community outlets. From the celebrations of saints' days (fig. 115) to the form and symbolism incorporated into grave markers (figs. 116–118), ethnic groups have managed to leave the stamp of their European heritage on the visual and material life of their American communities.[104]

Some immigrants have maintained folk and official religious practices in less conspicuous environments. An example is the prevalent use of *eikonostasi* (sacred corners containing icons) in the homes of Greek Americans. Of their use, Robert Teske comments: "[The] eikonostasi suggest the important, if not dominant, role of the Greek American extended family in the formation and maintenance of this particular folk-religious complex" (fig. 119). The fact that a Greek Orthodox family maintains the eikonostasi is not only a reflection but also a validation of their religious belief. Teske writes that "the notion that the family may indeed be the heart of the Greek American folk religion suggests a simple plan for investigating the character and functioning of the folk religion of any large community."[105]

And finally, some immigrants have adopted the material aspects of the prevalent religious beliefs of a community. For instance, the Sikh family shown here has maintained its homeland religion while incorporating the material customs of the Christian holiday into American family life (fig. 120). Objects and the behaviors associated with them have been completely divorced from their religious meaning. Instead, the artifacts carry a social value that helps the Sikh family blend into its community.

As the variety of religious faiths in America expanded and the numbers of individuals practicing those faiths shifted, the production of religious art was affected. In fact, the types of religious objects, their manner of production, and their functions were as varied as the religious communities of which they were a part. Whether the material culture served an overt function within a religious context or simply reflected a religious view of life, it has been evident that religious folk art has been an integral part of the growth and maintenance of religious life in America.

Notes

1. Sydney E. Ahlstrom, *A Religious History of the American People* (Garden City, N.Y.: Image Books, Doubleday & Co., 1975), vol. 1, p. 402.

2. Charles A. Johnson, *The Frontier Camp Meeting* (Dallas, Tex.: Southern Methodist University Press, 1955), p. 65.

3. *Ibid.*, p. 64.

4. *Ibid.*, p. 25.

5. *Ibid.*, p. 17.

6. Whitney R. Cross, *The Burned-Over District* (Ithaca, N.Y.: Cornell University Press, 1950), p. 19.

7. Johnson, *The Frontier Camp Meeting*, p. 18.

8. *Ibid.*, pp. 32–38.

9. For a description of a camp meeting, see William M. Clements, "The Physical Layout of the Methodist Camp Meeting," *Pioneer America* 5, no. 1 (January 1973), pp. 9–15.

10. Johnson, *The Frontier Camp Meeting*, p. 70.

11. Cross, *The Burned-Over District*, p. 271.

12. Johnson, *The Frontier Camp Meeting*, p. 86.

13. Charles Stanfield, "Pitman Grove: A Camp Meeting as Urban Nucleus," *Pioneer America* 7, no. 1 (January 1975), pp. 36–44.

14. Aileen S. Kraditor, ed., *Up from the Pedestal* (Chicago: Quadrangle Books, 1968), p. 108.

15. Barbara Welter, *Dimity Convictions* (Athens, Ohio: Ohio University Press, 1976), p. 22.

16. *Ibid.*, p. 21.

17. *Ibid.*, p. 23.

18. Cross, *The Burned-Over District*, p. 89.

19. Keith Melder, "Masks of Oppression: The Female Seminary Movement in the United States," *New York History* 55, no. 3 (July 1974), p. 273.

20. Ethel Stanwood Bolton and Eva Johnston Coe, *American Samplers* (New York: Dover Publications, 1973), p. 248.

21. Toni Flores Fratto, "'Remember Me': The Sources of American Sampler Verses," *New York Folklore* 2, nos. 3 & 4 (Winter 1976), p. 205.

22. *Ibid.*, p. 217.

23. Bolton and Coe, *American Samplers*, p. 323.

24. *Ibid.*, p. 319.

25. Peter Benes and Phillip D. Zimmerman, *New England Meeting House and Church: 1630–1850* (Boston: Boston University Press and The Currier Gallery of Art, 1979), p. 24.

26. Anita Schorsch, *Morning Becomes America* (catalogue) (Clinton, N.J.: The Main Street Press, 1976), unpaged.

27. *Ibid.*

28. *Ibid.* See also Anita Schorsch, "A Key to the Kingdom: The Iconography of a Mourning Picture," *Winterthur Portfolio* 14, no. 1 (Spring 1979).

29. Linda Grant DePauw and Conover Hunt, *"Remember the Ladies": Women in America, 1750–1815* (New York: The Viking Press, 1976), p. 78.

30. Carrie A. Hall and Rose G. Kretsinger, *The Romance of the Patchwork Quilt in America* (New York: Bonanza Books, 1935), p. 22.

31. Quoted in Sheila Betterton, *The American Quilt Tradition* (exhibition catalogue) (Bath, England: The American Museum in Britain, 1976), p. 26.

32. For lists of religious names of quilt patterns, see Ruth E. Finley, *Old Patchwork Quilts* (Newton Centre, Mass.: Charles T. Branford Co., 1929), p. 106; Jonathan Holstein, *The Pieced Quilt: An American Design Tradition* (New York: Galahad Books, 1973), p. 59; Dolores A. Hinson, "Religion in American Quilts," *The Antiques Journal* (July 1973), pp. 13–15; and Hall and Kretsinger, *The Romance of the Patchwork Quilt*, p. 20.

33. Hinson, "Religion in American Quilts," pp. 14–15.

34. Hall and Kretsinger, *The Romance of the Patchwork Quilt*, p. 20.

35. Robert Bishop and Elizabeth Safanda, *A Gallery of Amish Quilts* (New York: Dutton Paperbacks, 1976), p. 15.

36. Susan Stewart, "Sociological Aspects of Quilting in Three Breth-

ren Communities in Southeastern Pennsylvania," *Pennsylvania Folklife* 23, no. 3 (Spring 1974), p. 25.

37. Bishop and Safanda, *A Gallery of Amish Quilts*, p. 20.

38. *Ibid.*, p. 22.

39. Phyllis Haders, *Sunshine and Shadow: The Amish and Their Quilts* (Clinton, N.J.: The Main Street Press, 1976), p. 31.

40. Bishop and Safanda, *A Gallery of Amish Quilts*, p. 24.

41. Stewart, "Sociological Aspects of Quilting," p. 19.

42. Ahlstrom, *A Religious History of the American People*, vol. 1, p. 374.

43. *Ibid.*, p. 356.

44. Winthrop S. Hudson, *Religion in America*, 2d ed. (New York: Charles Scribner's Sons, 1973), p. 146.

45. Johnson, *Frontier Camp Meeting*, p. 130.

46. Ahlstrom, *A Religious History of the American People*, vol. 1, p. 513.

47. Hudson, *Religion in America*, p. 151.

48. Yvonne Lange, "Lithography, An Agent of Technological Change in Religious Folk Art: A Thesis," *Western Folklore* 33, no. 1 (January 1974), p. 53.

49. *Ibid.*

50. Boyd K. Packer, "The Arts and the Spirit of the Lord," in Steven P. Sondrup, ed., *Arts and Inspiration* (Provo, Utah: Brigham Young University Press, 1980), p. 14.

51. Robert Bishop, *American Folk Sculpture* (New York: Dutton Paperbacks, 1983), pp. 276–277.

52. Richard Hofstadter and Wilson Smith, eds., *American Higher Education: A Documentary History* (Chicago: University of Chicago Press, 1961), vol. 1, p. 6.

53. Russel B. Nye, *The Cultural Life of the New Nation, 1776–1830* (New York: Harper & Row, 1960), p. 151.

54. *Ibid.*, p. 178.

55. *Ibid.*, p. 196.

56. Ahlstrom, *A Religious History of the American People*, vol. 1, p. 451.

57. *Ibid.*, p. 403.

58. Hudson, *Religion in America*, p. 261.

59. John Joseph Stoudt, *Sunbonnets and Shoofly Pies: A Pennsylvania Dutch Cultural History* (New York: Castle Books, 1973), p. 9.

60. Henry C. Mercer, *The Bible in Iron: Pictured Stoves and Stoveplates of the Pennsylvania Germans* (Narberth, Pa.: Livingston Publishing Company, 1961), p. 49.

61. Stoudt, *Sunbonnets and Shoofly Pies*, p. 143.

62. Frederick S. Weiser, "Piety and Protocol in Folk Art: Pennsylvania German Fraktur Birth and Baptismal Certificates," *Winterthur Portfolio* 8 (1973), pp. 36, 43.

63. Henry S. Borneman, *Pennsylvania German Illuminated Manuscripts* (New York: Dover Publications, 1973), p. 57.

64. Stoudt, *Sunbonnets and Shoofly Pies*, p. 162.

65. Borneman, *Pennsylvania German Illuminated Manuscripts*, p. 37.

66. Quoted in Vernon Nelson, *John Valentine Haidt* (exhibition catalogue) (Williamsburg, Va.: Colonial Williamsburg, Inc., 1966), p. 12.

67. Ruth Piwonka and Roderic H. Blackburn, Introduction in *A Remnant in the Wilderness* (exhibition catalogue) (Albany, N.Y.: The Albany Institute of History and Art for the Bard College Center, 1980), p. 13.

68. Sydney E. Ahlstrom, *A Religious History of the American People* (Garden City, N.Y.: Image Books, Doubleday & Co., 1975), vol. 2, p. 699.

69. Quoted in Albert J. Raboteau, *Slave Religion* (New York: Oxford University Press, 1978), p. 128.

70. *Ibid.*, p. 149.

71. Joseph R. Washington, Jr., *Black Sects and Cults* (Garden City, N.Y.: Doubleday & Co., 1972), p. 41.

72. Raboteau, *Slave Religion*, p. 132.

73. *Ibid.*, p. 212.

74. For further discussion of the formation of the "invisible institution," see Henry H. Mitchell, *Black Belief: Folk Beliefs of Blacks in America and West Africa* (New York: Harper & Row, 1975).

75. Ahlstrom, *A Religious History of the American People*, vol. 2, p. 710.

76. Raboteau, *Slave Religion*, p. 85.

77. John Michael Vlach, *The Afro-American Tradition in Decorative Arts* (Cleveland, Ohio: The Cleveland Museum of Art, 1978), p. 144.

78. *Ibid.*, pp. 92–93.

79. For information on Charles Colcock Jones, see Erskine Clark, *Wrestlin' Jacob* (Atlanta, Ga.: John Knox Press, 1979).

80. Gladys-Marie Fry, "Harriet Powers: Portrait of a Black Quilter" in *Missing Pieces: Georgia Folk Art, 1770–1976* (exhibition catalogue) (Atlanta, Ga.: Georgia Council for the Arts and Humanities, 1976), p. 17.

81. Vlach, *The Afro-American Tradition in Decorative Arts*, pp. 39, 43.

82. Raboteau, *Slave Religion*, p. 75.

83. Ahlstrom, *A Religious History of the American People*, vol. 2, p. 572.

84. A. Leland Jamison, "Religions on the American Perimeter," in A. Leland Jamison and James Ward Smith, eds., *The Shaping of American Religion* (Princeton, N.J.: Princeton University Press, 1961), pp. 197–198.

85. Quoted in Edward Deming Andrews, *The People Called Shakers* (New York: Dover Publications, 1963), p. 144.

86. Edward Deming Andrews and Faith Andrews, *Work and Worship* (Greenwich, Conn.: New York Graphic Society, 1974), p. 8.

87. *Ibid.*, p. 139.

88. Charles Nordhoff, *The Communistic Societies of the United States* (New York: Dover Publications, 1966), pp. 137–138.

89. *Ibid.*, p. 164.

90. Edward Deming Andrews and Faith Andrews, *Visions of the Heavenly Sphere* (Charlottesville, Va.: The University of Virginia Press for The Henry Francis du Pont Winterthur Museum, 1969), p. 63.

91. Paul H. Douglas, "The Material Culture of the Harmony Society," *Pennsylvania Folklife* 24, no. 3 (1974), p. 4.

92. *Ibid.*, pp. 13–14.

93. Donald E. Pitzer, "Harmonist Folk Art Discovered," *Historic Preservation* (October–December 1977), p. 12.

94. Douglas, "The Material Culture of the Harmony Society," p. 12.

95. Lynette I. Rhodes, *American Folk Art from the Traditional to the Naïve* (Cleveland, Ohio: The Cleveland Museum of Art, 1978), p. 82.

96. Sondrup, *Arts and Inspiration*, p. xi.

97. Susan Oman and Richard Oman, "Mormon Iconography," in Hal Cannon, ed., *Utah Folk Art* (Provo, Utah: Brigham Young University Press, 1980), p. 116.

98. *Ibid.*

99. Hal Cannon, *The Grand Beehive* (catalogue) (Salt Lake City: University of Utah Press, 1980), unpaged.

100. Packer, "The Arts and the Spirit of the Lord," p. 14.

101. For an overview of Krans's paintings, see George Swank, *Painter Krans* (Galva, Ill.: Galvaland Press, 1976).

102. Steve Friesen, "Emil 'Maler' Kym, Great Plains Folk Artist," *The Clarion* (Fall 1978), pp. 34–39.

103. Simon Bronner, "'We Live What I Paint and I Paint What I See': A Mennonite Artist in Northern Indiana," *Indiana Folklore* 12, no. 1 (1979), p. 7.

104. For a discussion of the use of some markers, see Lewis Marquardt, "Metal Grave Markers in German-Russian Cemeteries of Emmons County, North Dakota," *Journal of the American Historical Society of Germans from Russia* 2, no. 1 (Spring 1979), pp. 18–26.

105. Robert Thomas Teske, "The Eikonostasi Among Greek-Philadelphians," *Pennsylvania Folklife* 23, no. 1 (1973), p. 28.

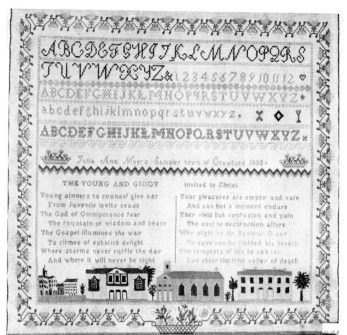

48. Julia Ann Niver: *The Young and Giddy Invited to Christ*. Crawford, New Hampshire. 1833. Silk on linen, 19″ x 19½″. "Young sinners to counsel give ear,/From Juvenile levity cease;/The God of Omnipotence fear,/The fountain of wisdom and peace." The first stanza of Niver's sampler inscription bears testimony to a deep concern with religion. (Cooper Union Museum for the Arts of Decoration)

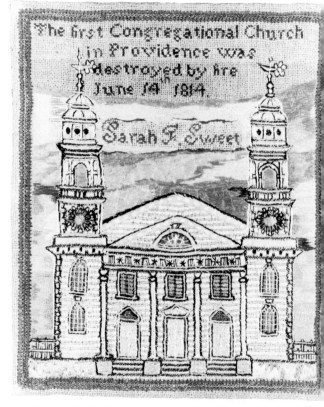

49. Sarah F. Sweet: Sampler. Providence, Rhode Island. c. 1815. Silk on linen, 10½″ x 9″. It was not uncommon for churches to be depicted on a sampler. Often these textile renderings provide important documentary evidence of the colors used in early New England architecture. (The Rhode Island Historical Society)

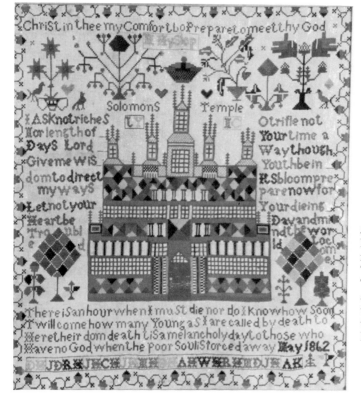

50. M. Hyslop: *Solomon's Temple* sampler. Probably Pennsylvania. May 1862. Embroidery on canvas, 25⅜″ x 23⅝″. This magnificent sampler depicts Solomon's Temple, a subject seldom selected by sampler artists. The placement of metallic paper behind the canvas and the selection of strong colors for the embroidery thread enhance the appeal of this graphic interpretation. (Photograph: Folk Arts Division, The Museum, Michigan State University; private collection)

51. Unidentified artist: Beeckman family mourning picture. New York. c. 1795. Silk and paint on silk, 20″ x 25″. Mourning pictures were rendered by women and reflected the late eighteenth- and early nineteenth-century interest in neoclassicism. Classical, biblical, and natural images were combined to evoke a sober landscape. (Collection Albany Institute of History and Art)

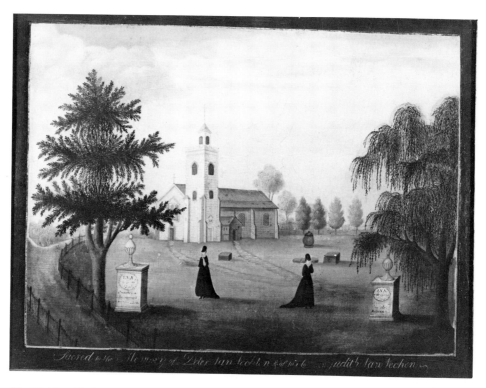

52. Unidentified artist: *Peter Van Vechten Memorial*. New York State. c. 1800. Oil on canvas, 18¼″ x 20¼″. Anita Schorsch has suggested that the creation of mourning pictures was almost an expected practice for "finished" young ladies. (Photograph: William Knorr; Collection Albany Institute of History and Art, Anonymous Gift)

53. Robert Campbell: *Philip Baptizing the Eunuch*. Philadelphia. c. 1822. Engraving on woven paper, 17⅜″ x 10½″. Engravings such as this one provided a copying source for schoolgirls to translate into watercolor or needlework pictures. (Courtesy, The Henry Francis du Pont Winterthur Museum; Gift of Francis James Dallett)

54. *The Tower of Babel* (Conversation 12). Lithograph in *Scripture Prints* by Mrs. Sherwood. New York. 1832. Young women were not encouraged to draw from life; therefore, they often turned to biblical illustrations found in Bibles or in popular prints. (The Henry Francis du Pont Winterthur Museum, Winterthur Museum Libraries)

55. Ann Johnson: *Baptisam of our Savour.* Provenance unknown. c. 1840. Watercolor on paper, 19⅞″ x 26″. Ann Johnson's rendering of this baptismal scene was copied from a print that was widely circulated in the nineteenth century. (Courtesy Abby Aldrich Rockefeller Folk Art Center)

56. Unidentified artist: *Moses in the Bulrushes.* Provenance unknown. First quarter of nineteenth century. Watercolor and silk on satin, 19¾″ x 18½″. Watercolor and needlework are combined in this picture. Moses in the Bulrushes was to be a favorite subject among schoolgirl artists. (Courtesy Abby Aldrich Rockefeller Folk Art Center)

57. Sophia Wetherbe: *Joseph's Dream.* New England. 1810. Needlework and watercolor on satin, 25″ x 32″. Wetherbe's interpretation of the Joseph's Dream scene is typical of the schoolgirl art genre. (New York State Historical Association, Cooperstown)

58. Unidentified artist: *Ruth and Naomi*. Probably New England. 1830–1840. Watercolor on velvet, 21½″ x 24½″. When theorem painting (painting with the use of stencils) became fashionable, it was inevitable that young women would attempt biblical scenes that incorporated this technique into their work. This watercolor on velvet displays both freehand and stencil techniques. Publications such as the *Ladies' Home Journal* carried "how-to" columns on such skills as theorem painting. (Photograph: Henry E. Peach; Old Sturbridge Village)

59. Unidentified artist: *Joseph Sold by His Brethren*. Provenance unknown. c. 1840. Watercolor on paper, 21⅝″ x 26⅜″. In choosing religious subjects for their artwork, women would not only adorn their household interiors but also provide ever-present visual religious instruction. (Courtesy Abby Aldrich Rockefeller Folk Art Center)

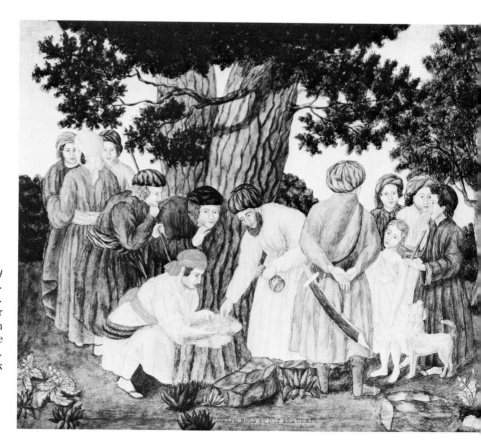

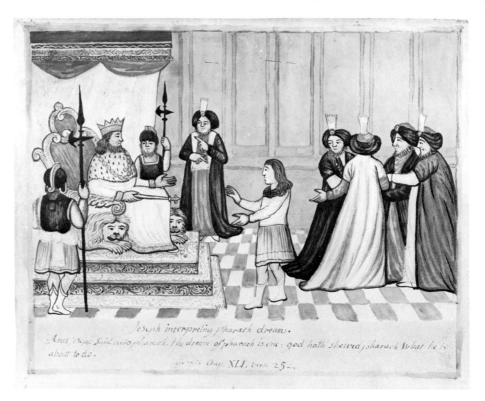

60. Unidentified artist: *Joseph Interpreting Pharaoh's Dream*. Provenance unknown. c. 1815. Watercolor on paper, 9″ x 11″. Many schoolgirl pictures included the biblical verse that was being depicted visually. (Courtesy Abby Aldrich Rockefeller Folk Art Center)

61. Unidentified artist: Drawing. New Jersey or New England. 1810–1825. Watercolor and ink on paper, 2¼″ x 12⅛″. Inscribed "We are going to attend Sunday School and Shun bad company, today," this drawing bears visual and literal witness to the importance accorded the growth of Sunday schools in the early nineteenth century. (Courtesy, The Henry Francis du Pont Winterthur Museum)

62. Currier & Ives lithograph. *Womans Holy War*. 1874. In the nineteenth century women became much more publicly active in religious work and they led "grand charges" on such works of the enemy as the sale and consumption of liquor. (Collections of The Library of Congress)

63. Friendship album quilt. Sewing Society of the Methodist Episcopal Church, Elizabethport, New Jersey. c. 1852. Appliquéd cotton, 99¼" x 100". Sewing societies or ladies' aid societies often produced quilts to present to church officials or to use as fund raisers. (Museum of American Folk Art; Gift of Phyllis Haders)

64. Maria Cadman Hubbard: *Pieties* quilt. Probably New England. 1848. Pieced cotton, 88½" x 81½". This quilt, made by Hubbard at the age of seventy-nine, has pious sayings constructed of tiny squares of material pieced together. Quilts of this type were usually fashioned from white and turkey-red cotton. (Photograph: George E. Schoellkopf Gallery; private collection)

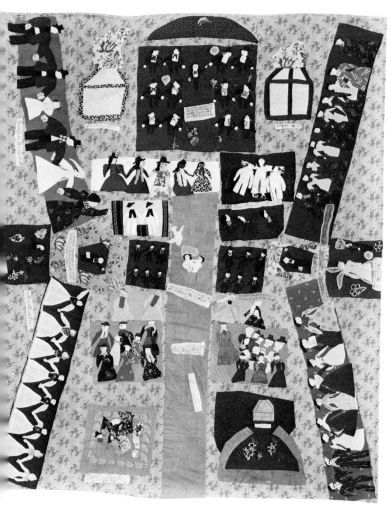

65, 65a. Susan Arrowood: *Sacret bibel* quilt, and detail. Found in Pennsylvania. Late nineteenth century. Appliquéd cotton, 86″ x 71″. Familiar visual and literal biblical scenes are combined in this highly unusual appliquéd spread. The Baptism of Jesus, Adam and Eve in the Garden, and the twelve disciples are among the biblical illustrations depicted in nineteenth-century clothing. (Photograph courtesy Thos. K. Woodard: American Antiques & Quilts; private collection)

66. Lavinia Rose: Daniel and Amarilla quilt. 1860. Appliquéd cotton, 82″ x 84″. This quilt of the "Scripture quilt" genre was perhaps created on the occasion of her son's or daughter's wedding. (Photograph courtesy Thos. K. Woodard: American Antiques & Quilts; collection of Joanna S. Rose)

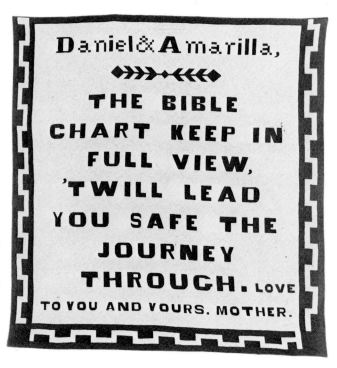

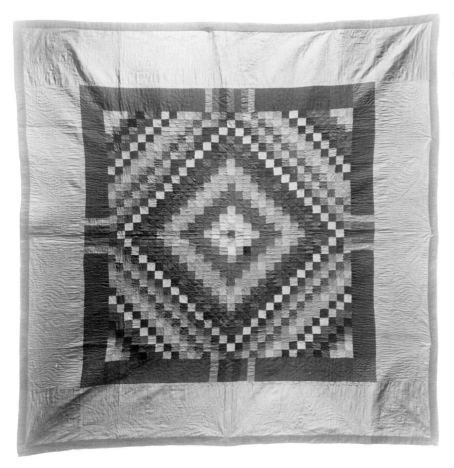

67. Unidentified artist: Sunshine and Shadow quilt. Pennsylvania? c. 1900. Wool, 82″ x 82″. A favorite pattern of the Amish Sunshine and Shadow quilts is composed of small patches of perhaps ten to fifteen colors arranged in alternating light and dark rows. (Collection of Phyllis Haders)

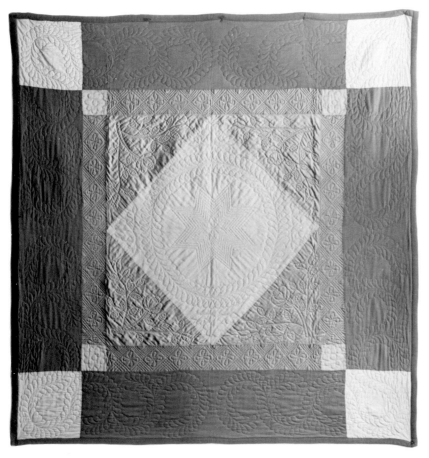

68. Unidentified artist: Center Diamond quilt. Lancaster County, Pennsylvania. 1915–1925. Pieced wool, 80″ x 80″. It has been suggested that because an excess of pride in worldly possessions is considered sinful in Amish society, the early quilts produced by Amish are almost uniformly constructed of large simple pieces. (Collection of Bryce and Donna Hamilton)

69. Mennonite Relief Sale. Mio, Michigan. 1980. Women in Mennonite churches across the country continue to quilt for the church by donating at least one and sometimes many quilts to the quilt auctions held by the Mennonite Relief Fund committees. (Photograph: Folk Arts Division, The Museum, Michigan State University)

70. Unidentified artist: Portable altar. St. Lawrence River region. c. 1890. Carved wood, 60¾" x 42⅛" x 15¾". Thought to have been made by an Indian for a Jesuit priest, this portable altar was found in the St. Lawrence River region. (Collection of Tom and Barbara Witte)

71. Unidentified artist: Detail from a double-weave Jacquard coverlet. Provenance unknown. c. 1840. Blue wool on white cotton warp, 91" x 75". The combination of the Oriental village with the New England town provides the source for the common title of this coverlet pattern: "Christian and Heathen." (Henry Ford Museum)

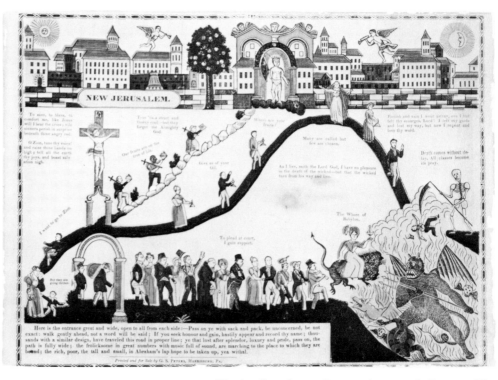

72. Attributed to Gustav Sigismund Peters: *The Roads to Hell and to Heaven*. Harrisburg, Pennsylvania. c. 1827–1847. Stencil, colored woodcut, 9⅝" x 13⅛". Both English- and German-language versions of this mortality print were printed in Pennsylvania. (Photograph: Folk Arts Division, The Museum, Michigan State University; private collection)

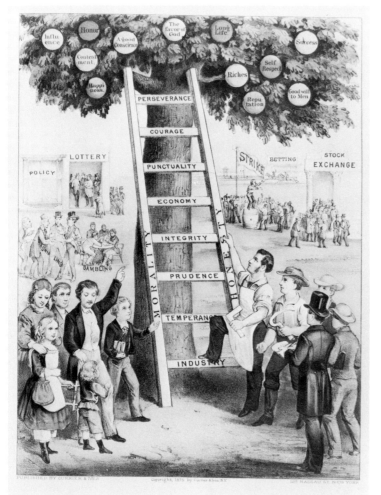

73. *The Ladder of Fortune*. Currier & Ives lithograph. 1875. This print is similar to Currier & Ives's *Tree of Life* print, but incorporates virtues particularly geared to the aspiring businessman. Prints such as this one were used to decorate the walls of a family's home or to instruct children in Sunday schools. (Museum of the City of New York; The Harry T. Peters Collection)

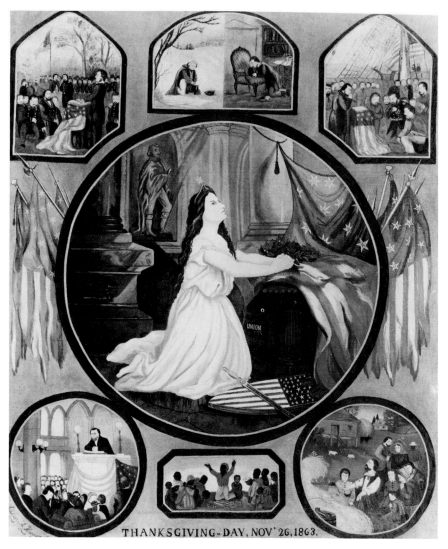

THANKSGIVING-DAY, NOV. 26, 1863.

74. Addie A. Harrington: *Thanksgiving Day, Nov. 26, 1863.* Provenance unknown. 1863. Oil on canvas, 27½" x 22½". As was the case with schoolgirl artists, widely circulated religious prints of the mid- to late nineteenth century served as inspirational sources for other artists. Harrington copied this scene from an illustration that appeared in *Harper's Weekly* (Photograph: Helga Photo Studio, Inc.; Hirschl & Adler Galleries)

75. Carl Christian Anton Christensen: *Emigration of the Saints.* Utah. 1878. Oil on canvas, 35" x 46¹³⁄₁₆". C. C. A. Christensen, a Mormon, traveled to Mormon communities, where, aided by his lamplit paintings, he would lecture on Mormon Church history. (Collection of Daughters of Utah Pioneers)

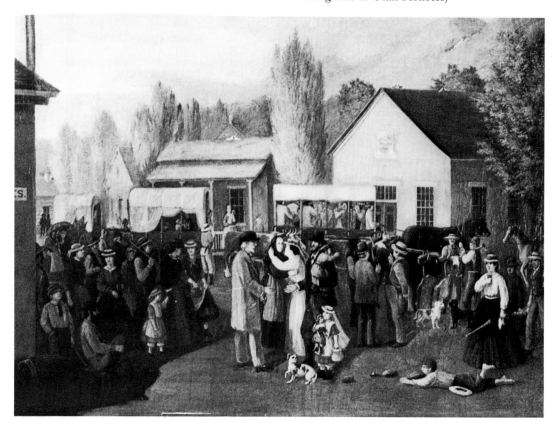

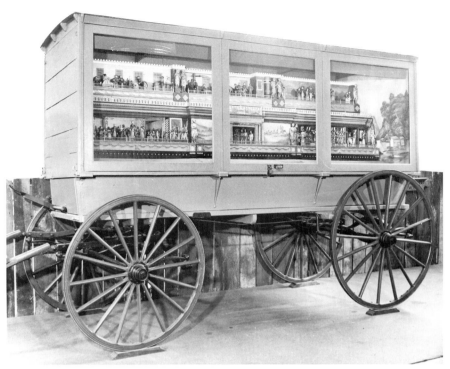

76 and 76a. David Hoy: "The Busy World" show wagon, and detail. Walton, New York. c. 1840. Carved and polychromed wood, L. 11′ 4″ (wagon). Biblical scenes are included in this grouping of carvings, which was pulled by horse-drawn wagon throughout upper New York State until the early twentieth century. (Greenfield Village and Henry Ford Museum)

77. Unidentified artist: Panorama (detail). Midwest area. Nineteenth century. Painted canvas, approx. 8′ x 400′. This panoramic painting was recently found in Illinois and is thought to have been used in outdoor or in-church revival meetings. (Photograph courtesy Susan Martens; private collection)

78. *The Aim of Pope Pius IX*. Cartoon. 1855. "Shall It Come to This?" and "Danger in the Dark" headline this flyer, which was circulated under the misguided impression that Roman Catholicism was an international threat to American democracy. (Collections of The Library of Congress)

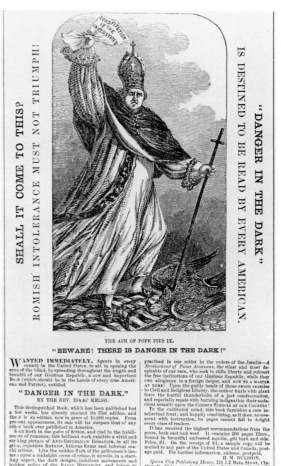

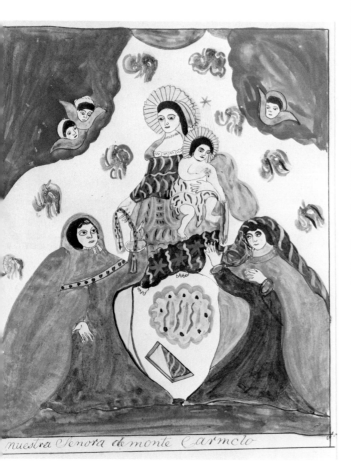

9. Mary Ann Willson: *Nuestra Señora de Monte Carmelo*. probably New England. Nineteenth century. Ink and watercolor on paper, 12⅛" x 9¹¹⁄₁₆". The importance placed on e role of women and the Spanish inscription in this picture splay an awareness of popular Catholic prints. (Museum of ine Arts, Boston; M. and M. Karolik Collection)

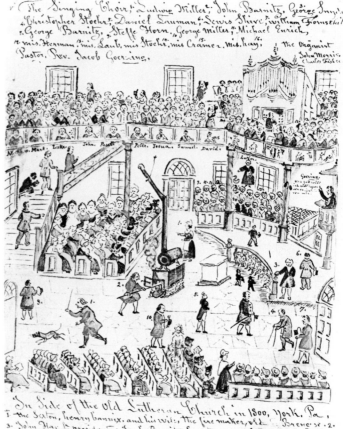

80. Lewis Miller: *Inside of the Old Lutheran Church in 1800, York, Pa.* York, Pennsylvania. c. 1820. Ink and watercolor on paper, 9¾" x 7½". As a self-appointed chronicler of Pennsylvania life, Miller has left us an important written and drawn description of religious customs in this region. (The Historical Society of York County)

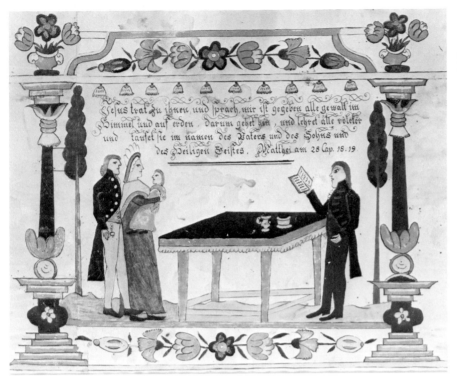

81. Attributed to Durs Rudy: *A Baptism.* Brodheadsville, Pennsylvania. c. 1825. Ink and watercolor on paper, 7⅞" x 9¹³⁄₁₆". A view of a baptism has been framed by the artist with unmistakably Germanic decorative motifs. (Museum of Fine Arts, Boston; M. and M. Karolik Collection)

82. Unidentified artist: *Cana Plate of 1742.* Pennsylvania. c. 1742. Cast iron, 27" x 22½". This stoveplate is based on the story of the miracle of Christ changing water into wine at a marriage celebration in Cana. The bride, bridegroom, and two guests can be seen to the right while Christ is seen entering at the left of the plate. (The Bucks County Historical Society)

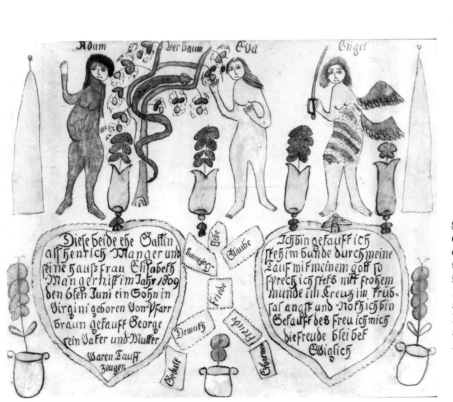

83. Unidentified artist: *Birth Certificate for George Manger.* Possibly Virginia. 1809. Watercolor on paper, 12⅝" x 15½". The German text on the left side of the Fraktur translates as follows: "On the sixth day of June in the year 1809 a son, George was born to Henrich Manger and his housewife Elizabeth Manger in Virginia. He was baptized by Reverend Brown. His father and mother were godparents." (Courtesy Abby Aldrich Rockefeller Folk Art Center)

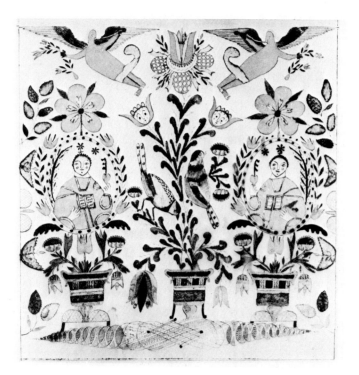

84. Unidentified artist: *Mennonite Spiritual Illumination*. Montgomery County, Pennsylvania. 1790–1810. Watercolor and ink on paper, 8½" x 7⅝". Germanic folk images were popularly employed in art by numerous Pennsylvania religious sects, including the Mennonites. (Collection of Peter Tillou)

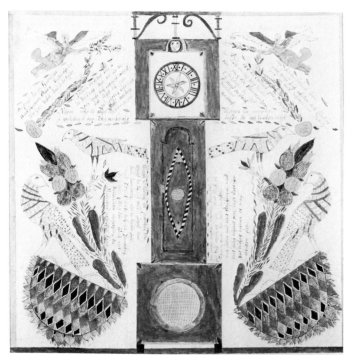

85. Unidentified artist: *Spiritual Chimes Drawing*. Pennsylvania. Early nineteenth century. Watercolor on paper, 12¼" x 12½". Only two examples of drawings using the "grandfather clock," or "spiritual chimes," motif have been identified by scholars. Fraktur artists freely blended folk motifs, religious symbols, and secular images in their work. (Collection of William E. Wiltshire III)

86. Unidentified artist: *Schwenkfelder Illumination*. Pennsylvania. c. 1835. Watercolor on paper, 12½" x 7⅞". The persistence of folk traditions from their German background permeated all facets of Pennsylvania German culture. Art, dress, food, dialect, religion, architecture, and literature all embodied elements of Old World customs. (Collection of Peter Tillou)

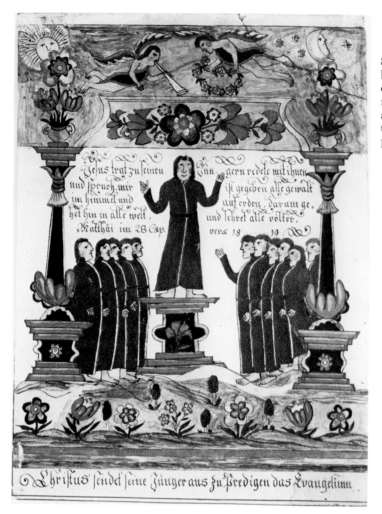

87. Durs Rudy: *Jesus and the Disciples*. Probably Pennsylvania. c. 1810. Drawn and colored on woven paper, 8¹³/₁₆″ x 6½″. Outfitted in nineteenth-century dress and hairstyles, Jesus and his disciples are framed by folk art motifs in this illuminated manuscript. (Rare Book Department, Free Library of Philadelphia)

88. Unidentified artist: Dower chest. Berks County, Pennsylvania. c. 1780. Painted softwood, W. 52½″. The decorative unicorn motif sometimes found on young women's dower chests hints at the medieval fable of unicorns as the guardians of maidenhood. (The Metropolitan Museum of Art; Rogers Fund, 1923)

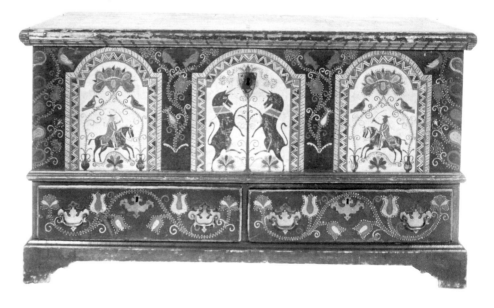

89. Johann Georg Nuechterlein: *Confirmation Certificate*. Frankenmuth, Michigan. March 21, 1869. Watercolor and pinpricks on paper, 12″ x 18″. German-American settlements in other parts of the country also were centers for the continuation of religious folk art practices. (Photograph: Folk Arts Division, The Museum, Michigan State University; Frankenmuth Historical Museum and St. Lorenz Church)

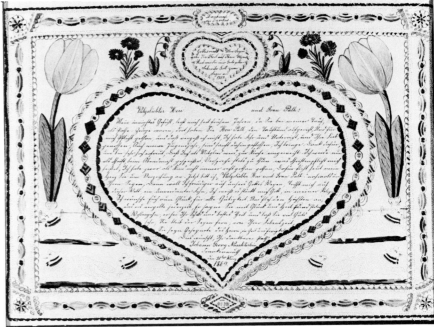

90. Barbara Becker: *Birth and Baptismal Certificate for Johannes Hamman*. Shenandoah County, Virginia. 1806. Watercolor on paper, 15″ x 12½″. Barbara Becker, the mother of Johannes, received her training in calligraphy in the Strasburg, Virginia, German School. (Photograph: Ronald H. Jennings; collection of William E. Wiltshire III)

91. George Geistweite: *Psalm 34*. Pennsylvania. August 19, 1801. Fraktur, pen and ink over watercolor on paper, 12½″ x 15⅛″. Geistweite, a circuit-riding minister of the Reformed Church, found time to produce this extraordinary example of Fraktur work. (Philadelphia Museum of Art; Titus C. Geesey Collection)

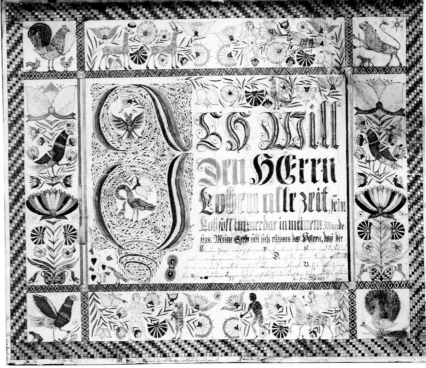

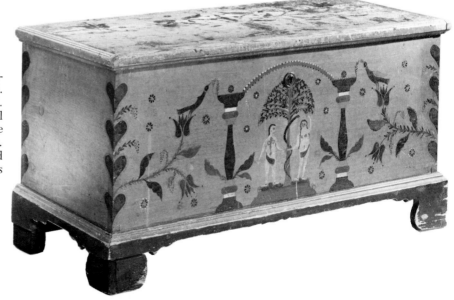

92. Attributed to (Johann) Heinrich Otto: *Spiritual Garden-Maze.* Near Ephrata, Lancaster County, Pennsylvania. 1788. Watercolor and ink on paper, 16" x 12¾". Labyrinths or spiritual garden-mazes were puzzles designed to explicate the Scriptures. Some were even mass-produced by Pennsylvania printers. (Courtesy, The Henry Francis du Pont Winterthur Museum)

93. Unidentified artist: Dower chest. Lebanon County, Pennsylvania. 1765–1800. Painted white pine, 24¾" x 50" x 21½". Dower chests, given to young girls to fill before their marriage, were one of the most popular of the Pennsylvania folk arts. Numerous Christian symbols adorned each chest. (Courtesy, The Henry Francis du Pont Winterthur Museum)

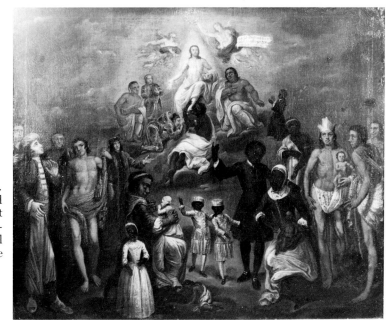

94. John Valentine Haidt: *The First Fruits*. Bethlehem, Pennsylvania. c. 1755–1782. Oil on canvas, 41½″ x 50½″. One of the most significant paintings in the history of the Moravian Church, this work was one of several versions painted by Haidt. (The Archives of the Moravian Church)

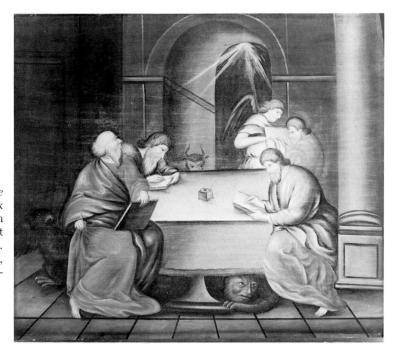

95. Attributed to Gerardus Duyckinck: *The Four Evangelists Writing the Gospels*. New York City or Albany, New York. c. 1715–1720. Oil on wood panel, 29¼″ x 35⅞″. Each evangelist is depicted with his traditional attribute: St. John, the eagle; St. Luke, the ox; St. Matthew, the winged man; and St. Mark, the lion. (Collection Albany Institute of History and Art)

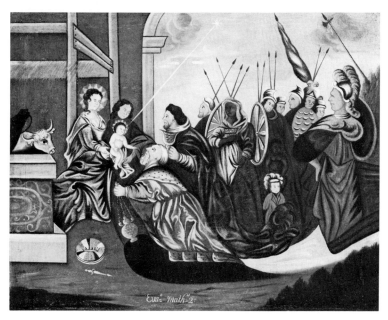

96. C2 Limner: *Adoration of the Magi*. Probably Schenectady, New York. c. 1740. Oil on canvas, 29½″ x 36⅝″. Several other Scripture paintings have been attributed to this artist by recent scholarship. Scripture paintings were popular among the eighteenth-century Dutch in New York State. (Abby Aldrich Rockefeller Folk Art Center)

97. Unidentified artist: *Black Girl with Flowers and Devil*. Provenance unknown. Nineteenth century. Watercolor on paper, 6⅝″ x 4¼″. The revivalism of the Great Awakening raised a strong interest in evangelizing among the growing American black population. (Photograph: Old Sturbridge Village)

98. Richard Norris Brooke: *A Pastoral Visit*. Virginia. 1881. Oil on canvas. Blacks found a certain measure of both personal and racial freedom in religious expression. Black preachers led plantation services, and occasionally an entirely black church was formed. (Collection of The Corcoran Gallery of Art)

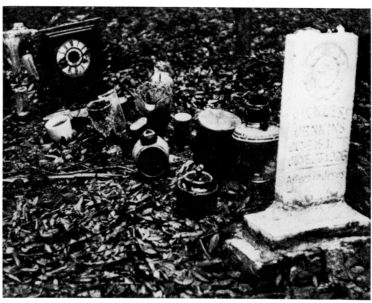

99. Lanier Meaders: Face or Devil Jug. Georgia. 1971. Stoneware, ash glaze with white ceramic clay, 9¾" x 7". The face jug has its precursors in African and Caribbean pottery forms. This jug, with its protruding horns, has been called a devil jug. (Photograph: Jerome Drown; Museum of Georgia Folk Culture, Georgia State University)

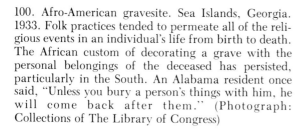

100. Afro-American gravesite. Sea Islands, Georgia. 1933. Folk practices tended to permeate all of the religious events in an individual's life from birth to death. The African custom of decorating a grave with the personal belongings of the deceased has persisted, particularly in the South. An Alabama resident once said, "Unless you bury a person's things with him, he will come back after them." (Photograph: Collections of The Library of Congress)

101. Unidentified artist: *Preacher Man*. Possibly eastern Alabama. Late nineteenth century. Redware, iron oxide, slip glaze, 16½". Scholars have suggested that the bell shape of this piece of pottery may indicate that its intended use was as a graveyard decoration. (Collection of John Gordon Gallery)

102. Cyrus Bowens: Graveyard sculpture. Sunbury, North Carolina. c. 1920. Carved wood, tallest piece approx. 12½". All that remains of this mortuary environment is the simple pole with rounded head. Since Bowens died in 1961, little is known about this wood graveyard assemblage. (Photograph from *Drums and Shadows*, courtesy Muriel and Malcolm Bell, Jr.)

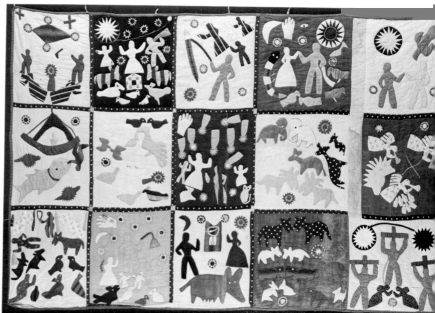

103. Harriet Powers: Appliqué quilt. Athens, Georgia. 1895–1898. Dyed and printed cotton fabrics pieced and appliquéd on cotton, with touches of gilt embroidery yarns, 105" x 69". Born a slave, Powers is known for two magnificent appliquéd and pieced quilts that combine Bible stories with astronomical events and local legends. Recently, another quilt similar to hers has sufaced in Tennessee. (Museum of Fine Arts, Boston; M. and M. Karolik Collection)

104. Slave's apron. Yalobusha County, Mississippi. Like the engravings and lithographs popular in the nineteenth century, this slave's apron depicts souls en route to Heaven or Hell. (Photograph: Eudora Welty; reprinted by permission of Eudora Welty and Mississippi Department of Archives and History)

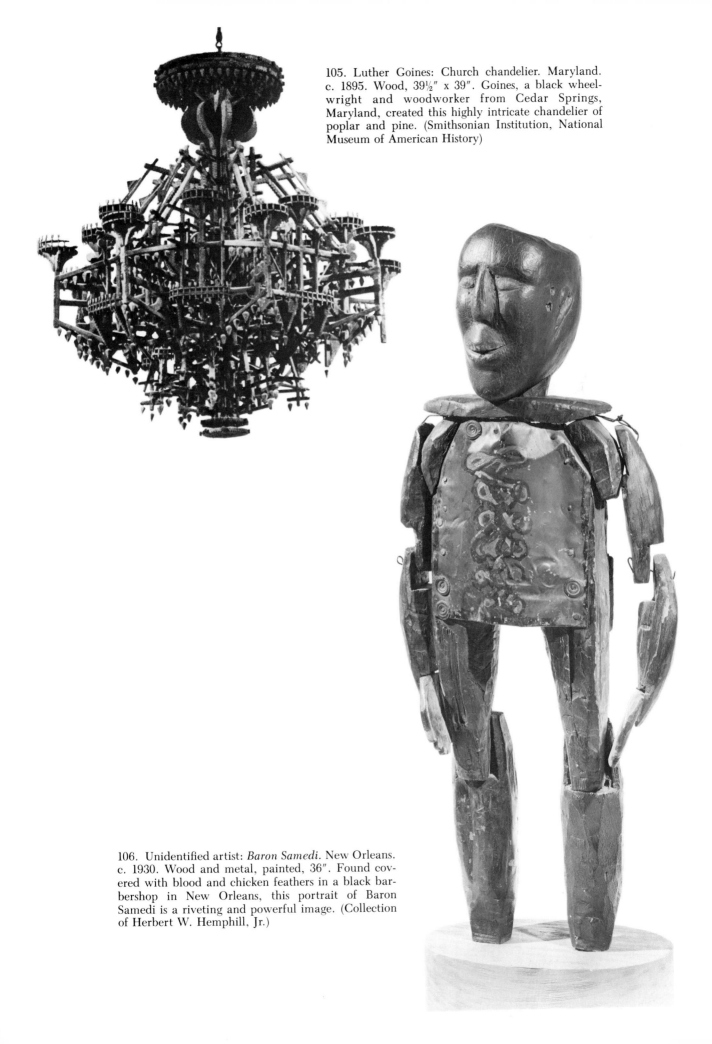

105. Luther Goines: Church chandelier. Maryland. c. 1895. Wood, 39½" x 39". Goines, a black wheelwright and woodworker from Cedar Springs, Maryland, created this highly intricate chandelier of poplar and pine. (Smithsonian Institution, National Museum of American History)

106. Unidentified artist: *Baron Samedi*. New Orleans. c. 1930. Wood and metal, painted, 36". Found covered with blood and chicken feathers in a black barbershop in New Orleans, this portrait of Baron Samedi is a riveting and powerful image. (Collection of Herbert W. Hemphill, Jr.)

107. Unidentified artist: *King Strang and His Harem on Beaver Island*. Probably Michigan. c. 1850. Oil on canvas, 28⅝″ x 41⁹⁄₁₆″. King Strang was the self-proclaimed King of Beaver Island (Michigan). He led a faction of Mormon followers to the island to serve as their refuge. Eventually he was killed and all that is left of the colony is its original print shop. (Greenfield Village and Henry Ford Museum)

108. *Shakers*. D. W. Kellogg & Co. lithograph. One of the religious sects formed during the nineteenth century, the Shakers gained their name from a dance that was incorporated into their worship service. (Courtesy The Shaker Museum)

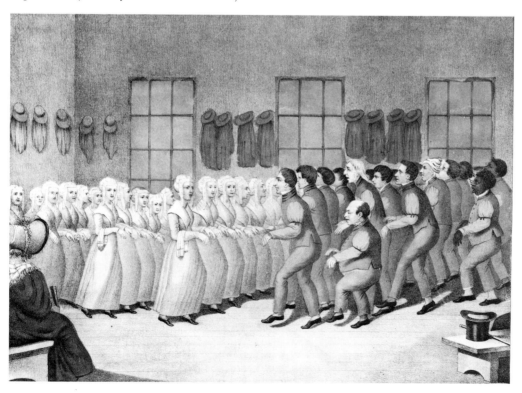

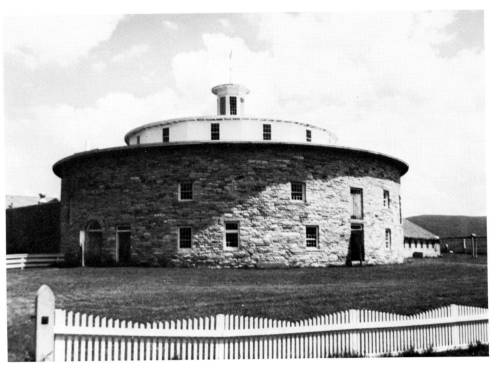

109. The Round Barn at Hancock Shaker Village, Hancock, Massachusetts. The Shakers stressed an orderliness and usefulness that infused every aspect of their built environment. A church elder, Frederick Evans, once told historian Charles Nordhoff, "The divine man has no right to waste money upon what you would call beauty, in his house or daily life, while there are people living in misery." (Photograph: Folk Arts Division, The Museum, Michigan State University)

110. Hannah Cohoon: *The Tree of Life*. New Lebanon, New York. 1854. Ink and watercolor on paper, 18⅛″ x 23⁵⁄₁₆″. After the artist recorded her vision of a spiritual experience, the spirit of Mother Ann told her, "Your tree is the tree of life." (Hancock Shaker Community, Inc.)

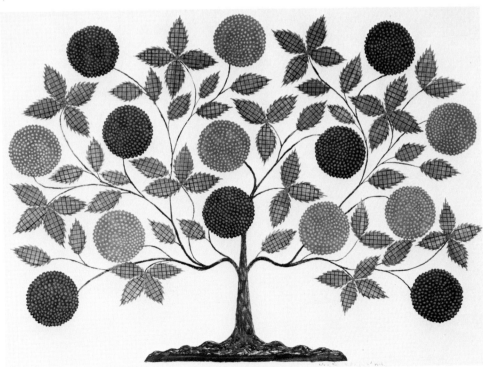

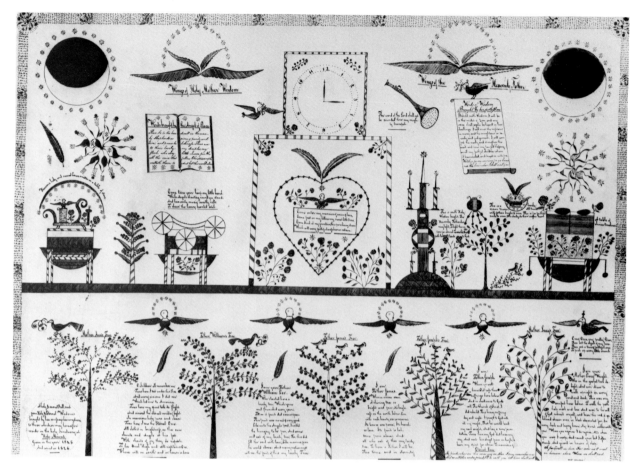

111. Unidentified artist: *Wings of Holy Mother Wisdom, Wings of the Heavenly Father.* Probably New England. 1846. Blue ink and watercolor on paper, 19¾" x 27¼". Brightly colored and highly decorated clothes, foods, ornaments, flowers, and musical instruments were usually rendered by Shaker artists in ink and watercolor on paper. (Photograph: George M. Cushing; Fruitlands Museums)

112. Unidentified artist: *Star of Bethlehem.* Zoar, Ohio. c. 1830. Watercolor and ink on paper, 16½" x 16". This drawing made by a German Separatist incorporates a variation of the official Zoar seven-pointed star. (Photograph: Robert and Joan Doty; Western Reserve Historical Society)

113. Anders Jensen: Gravestone. Ephraim, Utah. 1872. Tan sandstone, 41½″. Clasped hands, the all-seeing eye, the horn of plenty, and the beehive were all motifs adopted as institutional symbols of the Church of Jesus Christ of Latter-Day Saints in the mid-nineteenth century. The beehive was, however, by far the most popular symbol. (Photograph: Brent Herridge)

114. Babnik Family, Palm Sunday. Saint Marks Place, New York City. April 1976. For members of the Babnik family, the wearing of traditional Slovenian costumes and the fabrication of decorative palms are evidence of the maintenance of folk religious customs even in an urban setting. (Photograph: Katrina Thomas)

115. Feast of San Gennaro. Little Italy, New York City. September 1982. The celebration of saints' days often provides the setting for an outpouring of folk religious traditions including special foods, dress, songs, and art. (Folk Arts Division, The Museum, Michigan State University)

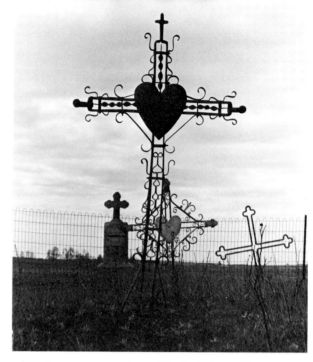

117. Iron grave markers. North Dakota. Late nineteenth and early twentieth centuries. Wrought iron. German-Russian graveyards in some counties of North Dakota are well known for their beautiful handwrought or cast-iron crosses, which have been found in many nineteenth-century graveyards associated with strong Catholic ethnic communities. (Photograph: Nicholas Vrooman and Patrice Marvin)

116. Unidentified artist: Iron cross. Southern Louisiana. 1790–1850. Wrought iron, 43½″ x 30¼″. Iron crosses are used to mark graves throughout southern Louisiana and are considered a part of the Franco-Spanish Roman Catholic influence on that region. (Louisiana State University Rural Life Museum)

118. Unidentified artist: Grave marker. Ceres, Virginia. Nineteenth century. Carved limestone, H. 30″. In the hills of southwestern Virginia, gravestones in the burial yards of German settlers' churches are mute reminders of the persistence of Old World folk art motifs. (Folk Arts Division, The Museum, Michigan State University)

119. Votive offerings before the Icon of the Panaghia. St. Nicholas Greek Church, Detroit. Some immigrants have maintained folk and official religious practices in private spaces. Such is the case with the prevalent use of *eikonostasi* (sacred corners containing icons) in the homes of Greek Americans. Votive offerings are found there as well as in Greek American churches. (Photograph: Ed Hernandez; courtesy Bob Teske)

120. Sikh family Christmas Day. Queens, New York. December 1975. It is not uncommon to see the material aspects of the prevailing religious beliefs of a community incorporated into the customs of families who practice alternative beliefs. (Photograph: Katrina Thomas)

Chapter 3

IN THEIR CRAFT IS THEIR PRAYER

But they shall maintain the fabric of the world; and in the
handiwork of their craft is their prayer.

—Ecclesiasticus 38:39

RELIGIOUS ICONOGRAPHY IN AMERICAN FOLK ART

The religious material culture produced by American folk
artists during the past three centuries has spanned a broad
range of subject matter. The following discussion examines
the iconographical content of the works of art in this book,
focusing especially on twentieth-century material, as
well as on the work of certain independent nineteenth-
century artists whose output was not governed by the aes-
thetic traditions of any particular religious or ethnic group.
References are also made to examples of the traditional,
group-oriented art discussed in the two preceding chapters.

The variety of subjects and themes treated by American
folk artists from the seventeenth to the twentieth centu-
ry can generally be grouped into three major categories:
(1) scriptural or traditional, (2) documentary, and (3)
visionary or symbolic. The first of these categories, the
scriptural or traditional, covers all material based on reli-
gious texts and traditions: stories and figures drawn from
the Old and New Testaments of the Bible, the Talmud,
Hasidism, Hebrew and Yiddish literature, and native
American legends. The second category, the documen-
tary, comprises all representations of religious life, such as
prayer meetings, baptisms, weddings, funeral rites, and
depictions of churches and the clergy. The final category,
the visionary or symbolic, includes those works of art that
were inspired by the artists' private visions or personal
concepts of spiritual truth as well as those works based on
traditional symbolic imagery.

This system of classification has been applied in exam-
ining the material folk culture included in this book. Be-
cause many of these works of art combine elements from
more than one category, classification according to subject
matter was determined by the dominance of certain im-
ages or themes. By grouping the works of art under sepa-
rate headings, it is possible to discern patterns of continuity
or change from one period to another through the persis-
tence of some themes and the modification, disappear-
ance, or appearance of others. Such persisting or changing
patterns in iconography often reflect stable or shifting
values within society itself. An iconographical analysis of
this material may also disclose relationships between cer-
tain subjects and the cultural or personal contexts in which
they appear, in addition to possible correlations of conti-
nuity or change in subject matter to religious or social de-
velopments. Many such relationships have already been
noted in the two previous chapters.

To be sure, definitive conclusions concerning continuity,
change, and cultural context of religious iconography are
not possible, inasmuch as the works of art selected for this
study compose a limited sample of the entire output of re-
ligious material folk culture produced during the past
three centuries and, as such, may not exactly reflect the
range and relative predominance of subjects treated in that
total production. A precise interpretation of the mean-
ing of iconographical stability or change in American reli-
gious folk art would require an even more comprehensive
survey of works of art, historical background, and reli-
gious developments than is possible within the limits of this
investigation. Nevertheless, an attempt was made to select

a group of works that would approximate the iconographical range of all such material so that tentative observations might be made concerning possible correlations between subject matter and social context, for religious folk art reflects not only the presence of faith but also, like all art, the cultural climate within which it is created. The discussion that follows will consider the ways in which America's religious material folk culture, particularly the art of nineteenth-century independent artists and those of the twentieth century, has revealed various facets of its environment as well as the spiritual devotion of its creators.

1. SCENES BASED ON SCRIPTURAL OR TRADITIONAL SOURCES

The Old Testament: The Garden of Eden

Man was by Heaven made to govern all/But how unfit, demonstrates in his fall.
—Verse from *The Fall of Man*,
an early nineteenth-century print

If the Garden of Eden is not right, Moses is to blame. He wrote it up and I built it.
—S. P. Dinsmoor, c. 1930

The Old Testament subject most frequently found in American folk art of the nineteenth and twentieth centuries is the Garden of Eden with its celebrated inhabitants, Adam and Eve, as described in the Book of Genesis. The theme of Adam and Eve in the garden has long been popular in both folk art and fine art. Earlier depictions from the seventeenth and eighteenth centuries include stitched or carved versions found on samplers and gravestones (see figs. 28, 30, and 35). The theme's continued popularity in nineteenth-century America may well have been a reflection of the new nation's view of itself as a divinely chosen land and people. In *The Hand and the Spirit* Jane Dillenberger has suggested that the numerous later representations of the Garden of Eden "seem to bear analogy to the many references in nineteenth-century literature to America as the New World Garden."[1] The nineteenth-century popularity of Adam and Eve in the garden has also been attributed to spreading urbanization, growing materialism, and a heightened sense of lost innocence among Americans:

People in the 19th century worried about the loss of the simple agricultural "good" life of such classical and biblical heroes as Cincinnatus, David, and Jesus. The "good" life in

the young republic was threatened by the continued quest for individual rights, which, paradoxically, weakened the primacy of community, and by the parallel quest for material riches and the subsequent growth of "evil" cities. The innocent ways of Americans were dwindling, while the wish for innocence accelerated. . . . Sin fascinated the popular American reading public. Home libraries, school reading lists, and popular magazines referred their readers to illustrated stories of "Eve and the Serpent," "Temptation," "The Fall," and "The Expulsion." Inexpensive reprints of *Paradise Lost*, illustrated by Richard Westall and John Martin, were said by publisher Prowett to have sold better in the United States than in Britain. Their illustrations from the *Imperial Family Bible* and *Illustrations of the Bible* also flooded the market. . . . The popularity in America of Milton's great epic led directly to an outpouring of contemporary art on the Fall.[2]

The late eighteenth-century dower chest, with its painted scene of Adam and Eve, has been noted in the preceding chapter (see fig. 93). In addition to the figures, the chest includes decorative symbolic motifs, such as the lily, a symbol of hope, and hearts, symbolizing love and joy. Among nineteenth-century depictions of the Garden of Eden are a watercolor Fraktur, *Adam und Eva* (fig. 121), a popular print, *The Fall of Man* (fig. 122), and the *Garden of Eden* quilt (fig. 123). Like the painted dower chest, the first two were produced within Pennsylvania German communities as part of the traditional material culture associated with such groups. *Adam und Eva*, painted between 1790 and 1825 by Durs Rudy, bears the inscription "Adam and Eve were led astray by the snake in Paradise," written in German. The early nineteenth-century print *The Fall of Man* expands on the transgression in verse:

Man was by Heaven made to govern all,
But how unfit, demonstrates in his fall,
Created pure, and with strength endu'd
Of grace divine, sufficient to have stood,
But alienate from God he soon became
The child of wrath, pride, misery and shame.

Prints such as *The Fall of Man* were among the flood of broadsides published by Pennsylvania German printers before the mid-nineteenth century. *Adam and Eve in Paradise*, or *The Fall of Man*, was perhaps the most popular of these prints, some of which contained numerous stanzas of ballads or poems describing the unfortunate results of man's disobedience to God. Walter E. Boyer has attributed the widespread popularity of *The Fall of Man* print to its expression of commonly held values:

"In Adam's fall we sinned all" was part of the "Christian nurture" of children and accepted by adults as being a description of man's status. In his creation, in his damnation and redemption, and in the sense of the eternal, man could still evaluate his lot from day to day. Thus the song of Adam and Eve in Paradise provided him with a dramatic rehearsal of man's creation, temptation, and fall—all elements of the religious symbolical value of the time.[3]

Unlike *Adam und Eva* and *The Fall of Man*, the *Garden of Eden* quilt, made in 1874 by Abby F. Bell Ross of Irvington, New Jersey, omits any direct reference to human transgression, concentrating instead on a profusion of plant and animal life to create a colorful and complex pattern in which Adam and Eve are but minor motifs.

Other interpretations of the earthly paradise were painted around 1865 by Erastus Salisbury Field (1805–1900), an itinerant Massachusetts portrait artist. Field, who began painting landscapes, historical, and biblical scenes in 1847 after photography had usurped his portraiture market, produced two similar versions of the Garden of Eden. He may have based his interpretations of the scene on an engraving of the English artist John Martin's painting *The Temptation*, which was found in many illustrated Bibles of the period. Field may also have been indebted to prints of Thomas Cole's painting of the same subject. Field's version shows a lush landscape in the foreground, where Adam and Eve reside peacefully amid animals, birds, and fruit-laden trees (fig. 124). Eve reaches to pluck the forbidden fruit but there is no hint of the terrible events that will follow. Only our own familiarity with the story imparts a sense of foreboding.

A century later, around 1969, Andrea Badami (b. 1913) of Omaha, Nebraska, painted a far different version of the scene, *Adam and Eve in the Sight of God* (fig. 125). In Badami's interpretation tranquillity and innocence have been replaced by guilt and condemnation as God literally strikes the disobedient Eve with the lightning of his wrath. Badami's painting is unusual in that it depicts the face of God, an image rarely found in American art.[4] Another guilt-ridden version of the Garden appears in John ("Uncle Jack") Dey's *Adam and Eve Leave Eden*, painted in Richmond, Virginia, in 1973 (fig. 126). In this expulsion scene the officiating angel delivers an "eviction notice" from God, while another sign announces "Gravy train gone."

Carved renderings of the same subject include those made by the German-born itinerant woodcarver Wilhelm Schimmel (1817–1890) during the late nineteenth century after his immigration to America. "Old Schimmel," as he was known to the Carlisle, Pennsylvania, area, used a jackknife to whittle decorative pieces and toys, which he sold or exchanged for lodging and rum as he roamed the countryside.[5] Before his death in the Carlisle poorhouse, Schimmel had produced countless carved animals as well as some scenes of Adam and Eve within a fenced Eden (fig. 127). The Garden of Eden also inspired twentieth-century carvers José Dolores Lopez (fig. 21) and Edgar Tolson (b. 1904) of Campton, Kentucky. Tolson's eight-part series, *The Fall of Man*, includes *Paradise*, *Temptation*, *Original Sin*, *Expulsion*, *Paradise Barred*, *Birth of Cain*, *Cain Slays Abel*, and *Cain Goes into the World* (fig. 128). The murder of Abel by his brother Cain was a popular subject in previous centuries as well, frequently appearing in the work of both folk artists, such as Mrs. H. Weed (fig. 129), and trained artists, such as Thomas Cole, William Rimmer, and Horatio Greenough. Dillenberger has offered a possible explanation for the attraction of this theme:

These [works of art] may all be related to Salomon Gessner's book, *The Dead Abel*, a bathetic eighteenth-century German elaboration of the Biblical event, which was translated into English and widely read. By 1762 a third English edition was published in London. William Blake did a drawing of the subject of Abel and Byron wrote a poem on it. Indeed, this preoccupation with the Biblical episode may indicate not only the theme of human sin and the sons of Cain as the inheritors of bestiality but also a general fascination with the theme of fratricide during the eighteenth and nineteenth centuries.[6]

An unusual variation on the Garden of Eden scene is the relief carving made in 1979 by Ned Cartledge (b. 1917) of Atlanta, Georgia (fig. 130). As a member of the Unitarian Church, which emphasizes intellectual freedom in pursuit of social justice, political equality, and spiritual truth, Cartledge has used his carving ability to criticize the Vietnam war, flag-waving patriotism, and other similar targets. "My work has social and historic significance," says Cartledge. "I really wanted to say something in protest and my art allowed me to have more influence than if I had just sounded off."[7] In his version Cartledge has invested the traditional scene with contemporary details and satirical overtones. Twentieth-century aspects include a "rabbit-eared" television set advertising Coca-Cola, while Adam and Eve are driven from the garden by a black woman as the angel of expulsion (or perhaps as God).

Other twentieth-century interpretations of the Garden of Eden introduce new media and scale as well as new images into the biblical scene. Among the total environments based on the theme is the work of S. P. (Samuel Perry) Dinsmoor (1843–1932). Between 1907 and 1927 Dinsmoor constructed his two-part environment, the *Garden of Eden* and *Modern Civilization*, around his Rock Log Cabin home at Lucas, Kansas (figs. 131 and 132). Built of

cement and limestone, the dual environment includes not only the familiar figures of Adam and Eve, Cain and Abel, and a hovering angel but also the Devil, God's all-seeing eye, concrete trees and flags, and *The Crucifixion of Labor* by members of the professions: a doctor, a lawyer, a preacher, and a banker. Moreover, Dinsmoor and his first wife are interred in the limestone mausoleum that he built within the garden. It has been observed that Dinsmoor's cement creation is a fusion of religious and political views:

> Dinsmoor's *Garden of Eden* embodies the opposing ideologies that obsessed many of the early plains settlers: a 19th century literal-moralistic view of the Bible, and a 20th century social-political liberalism. Two-thirds of his life were in the 19th century, one-third in the 20th, and his art perceptively spans these periods. The first sculptures for the *Garden of Eden* were Adam and Eve, the last the "crucifixion of labor" group. In the *Garden* these figures and the branch-like forms that support them unite distant myth with the contemporary world.[8]

Dinsmoor once remarked, "If the Garden of Eden is not right, Moses is to blame. He wrote it up and I built it."[9] The artist also outlined his plans for the Day of Judgment:

> Some people know they are going to heaven and those they do not like are going to hell. I am going where the Boss puts me. . . . If I get to go up I have a cement angel outside, above the door of the mausoleum, to take me up. . . . In the resurrection morn, if I have to go below, I'll grab my jug [a two-gallon cement jug next to his coffin] and fill it with water on the road below. . . . I think I am well prepared for the good old orthodox future.[10]

Other twentieth-century environmental artists have created their own gardens, using the biblical Eden as a model. The Reverend Howard Finster (b. 1916) has constructed a two-acre *Paradise Garden* in his backyard at Summerville, Georgia, incorporating innumerable found objects into its concrete walls (fig. 133). Biblical inscriptions composed of mirror fragments are embedded in the *Garden*'s concrete walks. Finster, who operates a lawn mower and bicycle repair business, built his garden at God's bidding:

> I preached about 40 years. All the time I was preachin' . . . my mind was on building something. . . . I retired from pastoring due to my health. Just something I told the Lord, is there anything else you want me to do besides pastoring? Well, just show me. So it come to me to build a paradise and decorate it with the Bible. I went to the dump and started picking up glass and molding bricks. . . . I just saved everything but money. The Lord'd give me a picture of a

night what to do the next day. . . . When I started on it, I wasn't expecting to excite the whole world. . . . I wanted to put every verse in the Bible in this part. . . . I write what I feel like God's word says. . . . If I have to write it on a refrigerator or down on the walk out of marbles, I write it.[11]

This twentieth-century environmental artist continues to commune with God in his concrete paradise: "It's nice to walk of a night in the Garden when everybody's gone, in the cool of the evening. Just you and the Lord. And you can talk and He can tell you things to do. And when He does, there's just something about it that makes us understand real well."[12] Finster's words are reminiscent of the popular gospel hymn "In the Garden," which may have been an additional source of inspiration in the building of his environmental paradise.[13]

Numerous other folk art environments inspired by the Garden of Eden are scattered across America. Each is an unusual personal interpretation of its biblical prototype. Many such gardens combine the concept of the Old Testament paradise with imagery derived from the New Testament. Noteworthy examples include *Lund's Scenic Garden* near Maple City, Michigan; Paul Domke's *Prehistoric Dinosaur Garden* at Ossineke, Michigan; and Father Mathias Wernerus's *Holy Ghost Park* at Dickeyville, Wisconsin. *Lund's Scenic Garden* was opened in 1948 by two United Brethren of Christ ministers, E. K. and Orpha Lund, who were inspired to create their garden while painting scenery for a church play. Their thirty-six life-size tableaux depicting the entire life of Christ are placed along a path that winds through sixteen wooded acres[14] (fig. 134). Visitors to Domke's *Dinosaur Garden* may climb into the ribcage of a life-size cement brontosaurus, where the sculptor has created a shrine dedicated to "Jesus Christ, the Greatest Heart." Within the hollow beast, a portrait of Jesus occupies the neck cavity, and, in the tail, sculpted figures of the three Magi appear ready to mount a ladder to the shrine. This reptilian sanctuary within its "prehistoric" Eden is surely one of Christendom's most unusual places of worship[15] (fig. 135). German-born Father Wernerus (1873–1931) built his Dickeyville grotto on the grounds of the Holy Ghost Catholic Church during the last decade of his life. *Holy Ghost Park* consists of several shrines and monuments constructed of reinforced cement embedded with broken glass, stones, tiles, shells, pottery, and other salvaged materials (fig. 136). Father Wernerus, intending that his grotto should express both religious and patriotic values, included images of Columbus, Washington, and Lincoln among the holy figures in his Park.[16] The Eden-like environments mentioned here are just a few of many such settings that have been created throughout the country.

One other remarkable twentieth-century version of

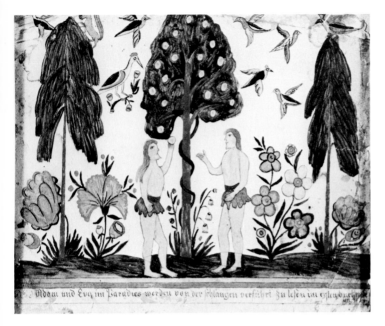

121. Durs Rudy: *Adam und Eva* Fraktur. Probably Pennsylvania. c. 1790–1825. Watercolor and ink on paper, 7¾" x 9⅝". The inscription on this Pennsylvania German Fraktur reads, "Adam and Eve were led astray by the snake in Paradise." (Courtesy, The Henry Francis du Pont Winterthur Museum)

Adam and Eve should be mentioned. Sometime before 1918 an unknown quiltmaker in the Hawaiian Islands created *The Beautiful Unequaled Gardens of Eden and Elenale* ("Na Kihapai Nani Lua 'Ole O Edena a Me Elenale"), an appliquéd cotton quilt that includes the biblical figures of Adam and Eve in the Garden as well as the literary characters of Elenale and Leinaale in a second garden setting (fig. 137). In a popular nineteenth-century Hawaiian tale, the lovely Leinaale was rescued from captivity by Elenale, who took her to live with him in his own beautiful garden. The quiltmaker has drawn parallels between the two gardens and the loves of the two couples.[17]

The Old Testament: The Finding of Moses and the Plagues of Egypt

Among other Old Testament stories that have provided subject matter for nineteenth- and twentieth-century folk artists are those that relate events in the life of Moses. The *Moses in the Bulrushes*, by an unidentified early nineteenth-century artist, is typical of many similar versions that depict Pharaoh's daughter discovering the infant Moses hidden among the bulrushes (see fig. 56). This episode in the life of Moses was especially popular as a subject for schoolgirls' stitched or painted pictures. Scenes portraying events in Moses' later life include the remarkable series

of paintings by Erastus Salisbury Field. Between 1865 and 1880 Field painted several pictures based on the Plagues of Egypt, disasters imposed by God on the Egyptians so that their Israelite captives would be allowed to return to their homeland under the leadership of Moses. Field used engravings by the English artists John Martin and Richard Westall as his guides but transformed their compositions into his own grandiose designs. One of Field's depictions of the plagues is included here: *The Burial of the First Born of Egypt* (fig. 138). *The Death of the First Born* and the *Burial* constitute the final plague that delivered the Israelites from captivity, as described in the Book of Exodus. Stories that incorporate the theme of salvation, such as Field's Plagues of Egypt, "can be seen as parables of deliverance through divine guidance, that the chosen of God might survive and live in a new land."[18] Dillenberger notes that such subjects had implications for eighteenth- and nineteenth-century America: "The theme of founding a new nation under God, which runs through political speeches, documents, sermonic interpolations, and public utterances, suggests that Americans read Biblical stories in the light of their own experiences."[19] Although Moses is seldom seen in the Plagues of Egypt series, he appears, together with his brother, Aaron, at the far right of *He Turned Their Waters into Blood*. Dillenberger suggests that the seated figure at the far right of *The Death of the First Born* may also be Moses.[20] The Plagues of Egypt was painted by Field in the years immediately following the catastrophic experience of the Civil War. Perhaps the concept of deliverance had implications that extended far beyond its biblical context to the freeing of America's slaves from bondage, the nation from the grip of an evil institution, and the Union from certain destruction.

The Old Testament: The Peaceable Kingdom

The wolf also shall dwell with the lamb, and the leopard shall lie down with the kid; and the calf and the young lion and the fatling together; and a little child shall lead them.
—Isaiah 11:6

Another Old Testament subject popular with nineteenth- and twentieth-century folk artists is one based on the words above from the Book of Isaiah. The greatest number and most celebrated Peaceable Kingdom paintings inspired by this text were produced by the Quaker preacher of Bucks County, Pennsylvania, Edward Hicks (1780–1849). Raised in the Quaker household of David and Elizabeth Twining, Hicks received a thorough religious education. One of his most fmous paintings, *The Residence of David Twining 1787*, includes the figure of Elizabeth Twining reading the Bible to young Edward. Hicks became a

coachmaker's apprentice at an early age and later learned the art of sign painting. His youthful excesses led to illness, repentance, and conversion to the Quaker faith. Eventually he was called to the ministry and for thirty years he traveled over 3,000 miles on horseback as an itinerant preacher, serving as a channel for the "Light Within" at meetings of the Society of Friends. Around 1820 Hicks painted the first of more than eighty versions of *The Peaceable Kingdom*, loosely patterning his composition after an engraved illustration of a painting by Richard Westall and adding a scene of William Penn's Treaty that showed the Quaker founder of Pennsylvania paying Indians for the land in 1682. This additional scene was based on a popular 1775 engraving of Benjamin West's earlier painting, *Penn's Treaty with the Indians.*

Religious and civil events during those decades when Hicks was painting his many versions of the Peaceable Kingdom were anything but harmonious. Anti-Catholicism was spreading, erupting from time to time in acts of violence, as in 1834 when an Ursuline convent was burned in Charlestown, Massachusetts. In 1833 the formation of the American Anti-Slavery Society in Philadelphia gave official status to the movement for emancipation of slaves and drove a divisive wedge between church people on both sides of the controversy. The Virginia slave revolt led by Nat Turner in 1831 and the 1837 murder of the abolitionist printer Elijah P. Lovejoy at Alton, Illinois, intensified the bitter debate that would ultimately end in the terrible bloodshed of a civil war. The assassination of Mormon prophet Joseph Smith in 1844 at Carthage, Illinois, gave further evidence of nineteenth-century America's intolerance of religious beliefs that differed too sharply from established forms of Protestantism. The doctrine of separation of church and state, which had been formulated earlier by Jefferson, was severely tested during the nineteenth century, as various religious groups sought to claim political advantage. A Thomas Nast cartoon of 1871 summarizes the controversial issue that has continued to be a source of political debate (fig. 139). Through such religious discord and social strife, Hicks held to his vision of eventual world peace when all people would live together in harmony in a messianic kingdom. In his *Memoirs* Hicks expressed his own generous spirit of religious tolerance that enabled him to identify with all seekers of spiritual truth:

My soul feels a sweet union and communion with all God's children in their devotional exercise, whether it is performed in a Protestant meeting house, a Roman cathedral, a Jewish synagogue, a Hindoo temple, an Indian wigwam, or by the wild Arab of the great desert with his face turned towards Mecca.[21]

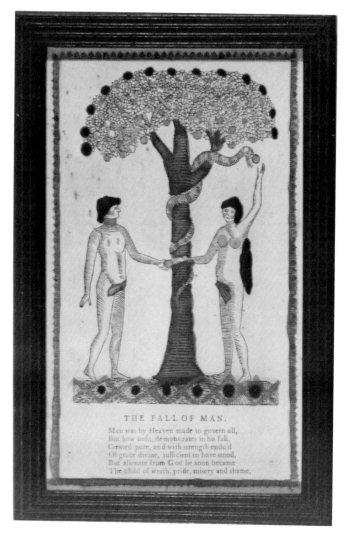

122. Unidentified artist: *The Fall of Man.* Pennsylvania. Early nineteenth century. Hand-colored woodcut, 10¼″ x 6¼″. Perhaps the most popular religious broadside published by Pennsylvania German printers was this version of Adam and Eve in the Garden. The verse opens with these lines: "Man was by Heaven made to govern all/But how unfit, demonstrates in his fall." (Private collection; Folk Arts Division, The Museum, Michigan State University)

Over the years Hicks's Peaceable Kingdom paintings underwent several changes in composition, with children, animals, and other figures added and rearranged. The version included here is sometimes referred to as the *Kingdom of Conflict* because it reflects discord within the Society of Friends, the so-called Hicksite-Orthodox schism. The bitter struggle was between two factions, one led by Edward's own cousin Elias Hicks and the other composed of urban Friends under the influence of revivalism. The former em-

phasized the mystical aspects of faith, the "Light Within," while the latter stressed the Orthodox tenets of scriptural authority and the atonement of Christ. In 1827 a great separation split the Society of Friends. In *The Peaceable Kingdom with Quakers Bearing Banners* (or *Kingdom of Conflict*) Hicks replaced the usual scene of Penn's Treaty with a pyramid of Quakers holding a banner inscribed, "Behold I bring you glad tidings of great joy. Peace on earth and good-will to men" (fig. 140). The group of figures includes the foreground profile of Elias Hicks, hatless and in riding boots, together with George Washington in a powdered wig. At the top of the pyramid are early Quakers Robert Barclay, William Penn, and George Fox.[22] The banner, representing Christian liberty and supported by Protestant reformers, extends through the distance to Christ and the twelve apostles, who are barely visible on the mountaintop. The painting clearly reflects Hicks's distress over the Separation of 1827, through its divided composition, foreground erosions, cleft tree trunk, and hostile expressions.[23]

Another nineteenth-century depiction of the Peaceable Kingdom was executed in 1865 by Dr. William Hallowell (1801–1890), also a Quaker minister as well as a physician and dentist at Norristown, Pennsylvania.[24] Hallowell, who probably knew Hicks's work, inscribed the text from Isaiah around the oval edge of his pen-and-ink version of the scene (fig. 141). Still another nineteenth-century artist, working in a different medium, carved a Peaceable Kingdom scene at the center of his walnut bench, which was made in 1853, either as a presentation piece for the Reverend W. Granville, rector of St. Paul's Episcopal Church at Medina, Ohio, or it was carved by the rector himself (fig. 142). The central figure of the child with his animals is surrounded by the inscription, "A little . . . shall lead them." The child's image completes the verse.

The best-known twentieth-century representations of the Peaceable Kingdom theme are those painted by Horace Pippin (1888–1946). Born at West Chester, Pennsylvania, Pippin spent his early years at Goshen, New York, where he worked at various jobs before joining the army in 1917. While serving in France during World War I, he was wounded and paralyzed in his right arm, an injury that gradually healed over the years. Pippin's earliest artistic efforts were crayon and watercolor sketches depicting scenes from the Bible. Selden Rodman notes that "the choice of biblical subjects reflects a lifelong piety and a familiarity with Scripture that often astonished his friends."[25] Pippin's first oil painting, based on his memories of war, was made in 1930. His Holy Mountain series of four paintings was produced between 1944 and 1946, the year of his death (fig. 143). The subject was drawn from his knowl-

edge of the Bible as well as his acquaintance with Hicks's Peaceable Kingdom paintings. Pippin has left us his own explanation of the Holy Mountain pictures:

> To my dear friends:
> To tell you why I painted the picture. It is the holy mountain my Holy mountain.
> Now my dear friends.
> The world is in a bad way at this time. I mean war. And men have never loved one another. There is trouble every place you Go today. Then one thinks of peace, yes there will be—peace, so I look at Isaiah xi-6-10—there I found that there will be peace. I went over it 4 or 5 times in my mind. Every time I read it I got a new thought on it. So I went to work. Isaiah xi the 6v to the 10v gave me the picture, and to think that all the animals that kill the weak ones will Dwell together like the wolf will Dwell with the lamb, and the leopard shall lie down with the kid and the calf and the young lion and the fatling together. . . .
> Now my picture would not be complete of today if the little ghostlike memory did not appear in the left of the picture. As men are dying, today the little crosses tell us of them in the first world war and what is doing in the south today—all of that we are going through now. But there will be peace.[26]

As Pippin's words indicate, his Holy Mountain pictures were based not only on the same biblical text that had inspired Hicks but also on his own wartime experiences and the civil rights struggles of the 1940s. In addition to the peaceful assemblage of wild animals tended by a white-robed shepherd and two children, shadows of warring soldiers and rows of white crosses are visible within the distant woods. Pippin died of a stroke in 1946 while still working on his fourth and final version of the *Holy Mountain*.

The Old Testament: Other Stories

A preacher don't hardly get up in the pulpit without preaching some picture I got carved.

—Elijah Pierce

The Old Testament story of Noah and the Ark was another subject popular with nineteenth-century folk artists. Like the Plagues of Egypt, it was viewed as a parable of divine deliverance with implications for the new nation. In 1846, basing his composition on an 1844 lithograph by Nathaniel Currier, the Quaker minister-artist Edward Hicks painted a memorable version of *Noah's Ark* (fig. 144). On the reverse side of his painting Hicks inscribed words from Genesis (7:15): "And they went in unto Noah in the ark,

two and two of all flesh, wherein is the breath of life." The imagery of Noah and the Ark, symbolizing salvation, was especially meaningful for Hicks, who painted the scene while grieving over the death of a beloved granddaughter, Phoebe Ann Carle. In spite of his sorrow Hicks was able to declare facetiously in his journal that he was smarter than Noah because he could build an ark faster than the biblical patriarch.[27]

Additional Old Testament subjects found in American folk art include Mary Williams's *The Queen of Sheba Admiring the Wisdom of Solomon* (see fig. 27), *Joab Slaying Absalom* (see fig. 29), *Solomon's Temple* (see fig. 50), *Ruth and Naomi* (see fig. 58), *Joseph Interpreting Pharaoh's Dream* (see fig. 60), Field's *Ark of the Covenant* (fig. 145), and Henry Couse's *Samson Table* (fig. 146). The subjects of Absalom, Joseph, and Ruth and Naomi seemed to be especially popular among schoolgirl artists. The story of Samson was chosen by furniture maker and carver Henry Washington Couse as the subject of his unusual *Samson Table*, which was presented as a birthday gift to Mrs. Levi Nichols of Waverly, Iowa. Inscribed on the table are these words of the blinded Samson, as they are recorded in the Book of Judges (16:28): "And Samson called unto the Lord and said, 'O Lord God remember me I pray Thee, and strengthen me I pray Thee, only this once, O God, that I may be at once avenged of the Philistines for my two eyes.'" Samson, whose celebrated strength had vanished with his shorn hair, had been placed by his Philistine captors between the pillars of their temple, so that they might mock him. His appeal to God brought renewed power, enabling him to seize the pillars and topple the building, thus slaying all who were present, including himself. Henry Couse's carved figure of Samson stands within the table legs, which he grasps as though they were the pillars in the biblical tale.

Other Old Testament figures seen in twentieth-century folk art are Job, Daniel, Moses, and Aaron. The story of Job has been depicted by woodcarver Elijah Pierce (b. 1892) (fig. 147). Born into an intensely religious Mississippi family, Pierce became a barber and settled in Columbus, Ohio, where he still resides. During slack moments in his barbershop, Pierce, an active member of the Gay Tabernacle Baptist Church, has carved numerous relief plaques based on biblical stories. For many years Pierce and his wife took his carvings to county fairs and church bazaars, where he preached on the scenes portrayed in the plaques, which would then be sold or given away. Pierce, whose *Story of Job* was carved in 1938, once claimed that a preacher could scarcely "get up in the pulpit without preaching some picture I got carved."[28]

Twentieth-century representations of Daniel, Moses, and Aaron were painted by Morris Hirshfield (1872–1946), who was born in the Russian part of Poland and came to the United States in 1890, settling in Brooklyn. Hirshfield was part of the vast migration of east European Jews that came to America from Russia, Poland, and the Austro-Hungarian Empire between 1870 and 1924.[29] Like many in that group, he entered the garment industry. Hirshfield began to paint in 1937 after illness forced his retirement. He once recalled his early efforts in creating religious images:

> At the age of fourteen, I undertook the sculpturing in wood of a piece of work almost six feet high for our local synagogue. It formed the prayer stand in front of the scroll on which the Cantor's prayer-books rested. It consisted of two huge lions holding books lying flat, and on top of the holy volumes were two birds, one holding in his beak a pear, the other a leaf. Everything was carved in full life-like figures and embossed with a good many more ornamental designs which I do not remember in detail and the whole gilded with gold and other colors of paint. . . .[30]

Hirshfield's painting *Daniel in the Lion's Den* depicts the Old Testament hero among beasts that have miraculously become docile (fig. 148). His portrayal of Moses and Aaron shows the two patriarchs holding the symbols of their authority as lawgiver and high priest (fig. 149). In both scenes, Hirshfield's years of experience in the garment industry are reflected in his treatment of textures, pattern, and line. It seems significant that Hirshfield, a Jewish artist, chose to portray Moses in his role as the empowered leader of the Israelites, rather than as the helpless foundling so frequently seen in early nineteenth-century schoolgirl art.

Depictions of the devil are not often found in American folk art, although devilish serpents abound in versions of the Garden of Eden. Some exceptions include the unusual nineteenth-century image of Satan in the watercolor painting *Black Girl with Flowers and Devil* (see fig. 97) and the more recent Satanic representation in Lanier Meaders's *Face* or *Devil Jug* (see fig. 99). S. P. Dinsmoor's environmental garden includes a concrete devil figure as well as the more usual serpent. Another twentieth-century depiction of Satan has been carved by Miles Carpenter (b. 1889) of Waverly, Virginia (fig. 150). Carpenter, who operates an icehouse and watermelon stand, has been carving for forty years. His *Wages of Sin* shows the devil consigning a sinner to the torments of hell. The small figure at the end of the devil's pitchfork holds a drink in one hand and a cigar in the other, expressing the fundamentalist view of alcohol and tobacco as evils leading to eternal damnation.

Some works of art that fall into the scriptural category

derive their subject matter from both the Old and the New Testaments of the Bible. Among these more comprehensive pieces are two superb late nineteenth-century quilts mentioned earlier. Harriet Powers's appliqué quilt features the great heroes of the Old Testament—Job, Jonah, Noah, and Moses—as well as scenes from the New Testament life of Christ (see fig. 103). Susan Arrowood's *Sacret bibel* quilt contains such Old Testament scenes as the Garden of Eden and Noah's Ark in addition to Jesus' Baptism and the Crucifixion from the New Testament (see fig. 65). Both quilts give eloquent witness to their makers' faith.

The New Testament: The Life of Christ

My carvings are all preaching one important message. It's what Jesus taught us when he was here on earth: Love one another.

—Elijah Pierce

Jesus has planted the seed of carving in me.

—William Edmondson

Events from the life of Christ have inspired many American folk artists. One of the most remarkable works, incorporating several scenes from the New Testament account of Jesus' life, is the *Altarpiece* carved by Lars Christenson (1839–1910) between 1897 and 1904 for the local church at Benson, Minnesota (fig. 151). Christenson, born in Sogndal, Norway, came to Benson in 1866 as a typical pioneer settler who cleared his land and built his dwelling. He also "helped organize a Lutheran congregation, which often met in his house during the ten years before there was a church.[31] Trained as a carpenter, Christenson carved furniture before beginning his altarpiece. The scenes carved on the altarpiece are based on illustrations in a large Doré Bible printed in America in the 1890s and include the Nativity, Christ Among the Elders, the Last Supper, the Crucifixion, the Road to Emmaus, the Transfiguration, the Ascension, and two Angels Among Flowers. The altarpiece's main inscription, written in Norwegian, translates, "But, behold, the hand of him that betrayeth me is with me on the table." Marion Nelson notes that the altarpiece reflects the "pietistic spirit which prevailed in the early Norwegian-American church."[32] Before its completion, the altarpiece was exhibited at the Minnesota State Fair in 1904. When it was spurned by the church for which it was intended, Christenson became disheartened and never finished carving the base of his great work. Housed today in the Norwegian-American Museum at Decorah, Iowa, Christenson's altarpiece is considered one of the truly powerful expressions of religious conviction in American folk art.

Scenes of the Nativity are seldom found in American folk art. Jane Dillenberger has observed the absence of Nativity scenes in both fine art and folk art: "New Testament events which are not depicted, or depicted rarely, are of interest, since they evidently indicate themes in which the artists and their patrons were not interested. The Nativity as such, and the Adoration of the Shepherds, is replaced by the Adoration of the Magi."[33] Some exceptions to the apparent lack of scenes of Christ's birth may be found in *The Adoration of the Christ Child*, which shows shepherds paying homage to the infant Jesus (fig. 152) and in the Nativity panel of Christenson's altarpiece. Another example is the native American Nativity group discussed earlier (see fig. 7). The painting *Christ in the Manger* by Samuel Colwell Baker (1874–1964) of Shenandoah, Iowa, represents the visit of the Wise Men rather than the Nativity itself (fig. 153). However, countless handmade Nativity scenes, carved and painted, have long been used by both Catholic and Protestant churches as central features of annual Christmas celebrations. These, too, should be considered part of the religious material folk culture of America. As such, they substantially increase the frequency of Nativity scene appearances.

Folk artists' depictions of the ministry of the mature Jesus include Ann Johnson's *Baptisam of Our Savour* (see fig. 55), Elijah Pierce's carving of Jesus' miracle, *The Man That Was Born Blind Restored to Sight* (fig. 154), Howard Finster's figure of Jesus titled "*I Preach 24 Hours a Day from Hearts Without Any Charge*" (fig. 155), and paintings that represent the parables told by Jesus in his sermons. Pierce, whose scene of the miraculous healing was carved in 1938, has this to say of his work:

My carvings look nice, but if they don't have a story behind them, what's the use of them. Every piece of work I carve is a message, a sermon. My carvings are all preaching one important message. It's what Jesus taught us when he was here on earth: Love ye one another. If I love you and you love me, I won't do you any harm and you won't do me any harm.[34]

The environmental artist Finster, who began painting pictures in 1976, portrays Jesus covered with hearts that are inscribed with Jesus' sayings. In his sermons, Jesus frequently used parables to explain spiritual truths. The parables of the Good Samaritan and the Prodigal Son have been favorite subjects for many folk artists. *The Good Samaritan*, painted by an unidentified artist in the early nineteenth century, is one of a series depicting the familiar story of the traveler who befriended an injured stranger (fig. 156). *The Prodigal Son Reveling with Harlots* (fig. 157), the series on the Prodigal Son painted by Friedrich Krebs (figs. 158–160), the sequence produced by Mary Ann

Willson (fig. 161), and the comic-strip version by Ruby Devol Finch (fig. 162) illustrate some of the varied interpretations of another parable told by Jesus as a means of explaining God's forgiving nature.

The disciples of Jesus have also been subjects for the religious material culture produced by American folk artists during the past three centuries. The stitched portraits of the disciples, created by Prudence Punderson in the late eighteenth century, have already been noted (see fig. 32). Another early example is *Jesus and the Disciples*, painted around 1810 by Durs Rudy (see fig. 87). Portrayals of the disciples by twentieth-century folk artists include the carved icons of John Perates (1894–1970) and the three-dimensional life-size figures made by Joseph Barta (1904–1972). Perates, born in Amphikleia, Greece, came to this country in the early twentieth century and settled at Portland, Maine, where he worked as a furniture finisher, upholsterer, and cabinetmaker. A devout member of the Greek Orthodox Church in Portland, Perates began "building furniture for the house of the Lord" during slack periods of the 1930s.[35] His carved and painted icons depict figures and events from the New Testament and Christian tradition (figs. 163 and 164). In Perates's own words, "they represent the life of Christ from His baptism or spiritual birth to His death on the cross, those who wrote what He taught and those who carried on His teachings."[36] Perates's icons are related to the great Byzantine icons of Eastern Christianity in their monumentality, simplified forms, frontality, rich color, use of symbolism, and spiritual intensity:

In the developed doctrine of Eastern Orthodoxy icons are seen as sacred manifestations pointing beyond themselves to the eternal archetype who is unseen in heaven. The icon should not therefore be realistic; anything in the nature of statues or three-dimensional images is prohibited, with tests and limits specified on reliefs to ensure their flatness; likewise natural light and shadow are omitted from paintings. The icon is regarded instead as a window or mirror reflecting supernatural light and enabling the viewer to experience the power of the Holy from beyond.[37]

Joseph Barta's portrayal of Judas, the betrayer, is one of eighty-five life-size figures that comprise the Carved by Prayer series at Barta's private museum in Spooner, Wisconsin (fig. 165). The series depicts the entire life of Christ as well as some scenes from the Old Testament. Throughout the sixteen years required to complete the series, Barta relied on God's direction through dreams in which he was told what he must do. His constant prayer became, "Dear God, please guide my hand."[38]

The subject of Christ's Crucifixion has been treated by many American folk artists. An early example appeared as part of the Pennsylvania German Fraktur tradition (fig. 166). A less stylized version was produced by an unidentified nineteenth-century artist who applied oil paint to bed ticking in executing *The True Cross* (fig. 167). Around 1870 the Reverend William Gale (1814–1880), a former slave from Ark, Virginia, carved three cross-hung figures for his Crucifixion group (fig. 168). Mention should also be made of the native American *Crucifix* (see fig. 6) and the New Mexican bulto by Ortega (see fig. 16), both of which have been noted in chapter 1 of this book.

Among twentieth-century representations of the Crucifixion is *The Stone Cross*, carved between 1930 and 1940 by William Edmondson (c. 1883–1951) of Nashville, Tennessee (fig. 169). The son of former slaves, Edmondson began carving stone in 1934, having received instructions from God: "I was out in the driveway with some old pieces of stone when I heard a voice telling me to pick up my tools and start to work on a tombstone. I looked up in the sky and right there in the noon daylight He hung a tombstone out for me to make."[39] As the instructions continued to be given, they became more explicit: "I knowed it was God telling me what to do. God was telling me to cut figures. First He told me to make tombstones; then He told me to cut the figures. He gave me them two things."[40]

Edmondson, who attended the United Primitive Baptist Church, had such divine encounters throughout his life. His visions suggested many subjects for the tombstones that he carved for black cemeteries: crucifixes, angels, preachers, doves, "courtin' gals," and "uplifted ladies"—women who had been good members of his church and were uplifted to heaven.[41] Another of Edmondson's carvings included here is his double portrait of *Mary and Martha*, sisters who were followers of Jesus (fig. 170). Edmondson's deep faith was expressed through his carving:

This here stone and all those out there in the yard come from God. It's the work in Jesus speaking His mind in my mind. I must be one of his disciples. These here is miracles I can do. Can't nobody do these but me. I can't help carving. I just does it. It's like when you're leaving here you're going home. Well, I know I'm going to carve. Jesus has planted the seed of carving in me.[42]

Other Crucifixion scenes have been painted by Frank Baldwin of Pittsburg, New Hampshire (fig. 171), and by Horace Pippin (fig. 172). Pippin's painting is a simple but powerful interpretation of the suffering of Christ. Elijah Pierce's carved and painted *Crucifixion*, although much more complex, is equally strong in its impact (fig. 173).

Events following the Resurrection have also furnished subject matter for some folk artists, including John Landis

123. Abby F. Bell Ross: *Garden of Eden* quilt. Irvington, New Jersey. 1874. Appliquéd cottons, 87″ x 87″. The central characters of Adam and Eve are easily overlooked in this teeming Paradise. (Mr. and Mrs. Ben Mildwoff; photograph courtesy John Gordon)

and Eunice Pinney. Many New Testament scenes were painted by Landis (1805–after 1857), a self-styled "Anointed of God" eccentric, whose unusual appearance and behavior earned him notoriety if not acclaim. Born at Hummelstown, Pennsylvania, into a devout Lutheran family, Landis joined the Lutheran Church at the age of fifteen. "His faith was so vivid that he said he could almost see with natural eyes, the Saviour and His disciples passing by."[43] Landis became a painter in 1830, after learning the rudiments of the trade from a traveling limner. His *Jesus in the Upper Room*, painted in 1836, shows the resurrected Christ surrounded by his disciples, while the doubting Thomas, finally convinced by his Master's wounds, kneels in awe (fig. 174). A much larger version of this scene was among the ten paintings offered by Landis in 1845 to the Pennsylvania Academy of Fine Arts for the "low price" of $16,000, after a major fire had destroyed many works of art at that institution. (The offer was declined.) A writer as well as a painter, Landis produced a number of books, including *Discourses on the Depravity of the Human Family*, published in 1839.

The New Testament relates that the final departure of Jesus from his disciples occurred when he ascended to heaven. According to the Book of Acts (1:9), "As they were looking on, he was lifted up, and a cloud took him out of their sight." Few versions of this dramatic event appear to have been painted by American folk artists. The one example included here is the watercolor painting by Eunice Pinney (1770–1849) of Simsbury, Connecticut (fig. 175). Pinney often based her paintings on published engravings, but the possible print source for her *Christ's Ascension* is not yet known. Another portrayal of this episode may be found in the previously mentioned *Lund's Scenic Garden*, which depicts the entire life of Christ from his birth to his ascension into heaven.

The final book of the New Testament, the Book of Revelation, has provided inspiration for a number of twentieth-century folk artists, whose work could also have been included in this scriptural category of iconography. However, because of the unusual personal imagery and the important visionary element in their art, these artists have been placed instead in the third iconographical category, the visionary or symbolic, and will be discussed under that heading.

Folk Tales

Among twentieth-century folk artists who have found their subject matter in stories other than those of the Bible was the centenarian Harry Lieberman (1877–1983) of Great Neck, New York. Born in the Polish town of Gnieveshev, where his uncle was the Hasidic rabbi, Lieberman studied for the rabbinate. Persecution of the Jewish community caused Lieberman and others to leave their homeland. After immigrating to the United States in 1906, Lieberman settled in New York where he established a successful confectionery business. Upon his retirement, Lieberman and his wife moved to Great Neck where he became an active member of the Great Neck synagogue. Lieberman began painting at the age of eighty, taking his subjects from the Torah, the Talmud, Hasidism, and Hebrew and Yiddish literature. *The Driver's Promotion* is based on a Jewish folk tale that has appeared in several variations (fig. 176). Lieberman's version relates the tale of Chaim, a horse-cart driver who offered a ride to the rabbi. When the driver grew tired, he asked the rabbi to take the reins while he slept. So the rabbi put on his tefillin and prayed while holding the reins. The horse, knowing the way, went in the right direction. When the cart reached town, everyone marveled that the rabbi drove while the real driver lay in the back of the cart. The people began to think how much more important must be the cartman, if the rabbi now drove, and they concluded that he must surely be one of the Lamed Vov, the Thirty-six Just Men who hold up the world.[44]

2. SCENES THAT DOCUMENT RELIGIOUS LIFE

Nineteenth- and twentieth-century folk artists in America have documented the religious life of their contemporaries with far greater frequency than did artists of earlier periods. Whereas many depictions of religious activity, structures, and leaders are found in folk art of the past two hundred years, relatively few examples were produced during the seventeenth and eighteenth centuries. The paucity of early scenes of contemporary religious life may stem from the fact that self-trained artists relied heavily, for guidance in subject matter and composition, on the prints found in illustrated Bibles. Documentation of their own religious activities might have been thought to require more technical mastery of perspective, proportion, and modeling than such artists possessed. Moreover, biblical subjects were perceived as having greater value than familiar religious events. This last factor applied to academic artists as well, even into the nineteenth-century, as Joshua Taylor has observed:

> The piety expressed in art itself extended in a curious way to make acceptable the religious practices of "artistic" countries abroad, notably Italy. . . . Yet for all their interest in religious practices abroad, American artists seem rarely to have turned their attention to depicting religious happenings at home except for an occasional family scene with a Bible or a former slave reading the Bible to a child. A special kind of pietistic sentiment allowed art to bridge sectarian gaps, but not to ally itself with local religious activity. Elevation could be achieved through remoteness of style or remoteness of place; there seemed to be little concern for direct spiritual transport.[45]

Even so, depictions of contemporary religious activity were produced by more folk artists of the nineteenth century than by earlier artists. In this century, scenes that document religious life in America have appeared in even greater number. In the following discussion, these documentary works of art have been divided into three groups: those that record prayer and praise, both public and private; those that depict religious rites for special occasions or provide ephemeral material for such events; and those that portray religious leaders: preachers, priests, and rabbis.

124. Erastus Salisbury Field: *The Garden of Eden.* Sunderland, Massachusetts. c. 1860. Oil on canvas, 35″ x 41¼″. Field added a handsome trompe-l'oeil border to his view of a lush and peaceful Eden. (Courtesy Shelburne Museum)

Public Prayer and Praise; Private Piety

Remember the sabbath day, to keep it holy.

—Exodus 20:8

We are going to attend Sunday School and shun bad company today.

—Inscription on a watercolor drawing of 1810–1825

Getting to know and love thy neighbor as well as thyself was more or less a religious picknick all the time for everybody.

—Fannie Lou Spelce, 1968

Going to meetinghouse, church, camp meeting, or synagogue to join in congregational worship has long been an important feature of American life. Numerous folk artists of this and previous centuries have drawn on their own experiences to depict such activity. Some artists have focused on the teaching of the Fourth Commandment as given in the Book of Exodus (20:8): "Remember the Sabbath day, to keep it holy." A drawing by an unidentified artist of the early nineteenth century is inscribed, "We are going to attend Sunday School and shun bad company today" (see fig. 61). The watercolor painting made by native American artist Dennis Cusick in 1821 also advises, "Keep the Sabbath" (see fig. 9). Other early representations of religious practice include Lewis Miller's lively rendering of a Lutheran church service in 1820 (see fig. 80), a view of Shakers performing a ritual dance (see fig. 108), a depiction of a camp revival meeting (see fig. 41), and a scene that records the arrival of worshipers at church, *Winter Sunday in Norway, Maine* (fig. 177). Additional portraits of houses of worship include those on early samplers (see fig. 33).

Religious services within church, tent, or synagogue

have been documented by several twentieth-century folk artists. In 1974 Ethel Wright Mohamed (b. 1907) of Belzoni, Mississippi, based her embroidered view of the *Double Springs Baptist Church Sacred Harp Singing, 1874* on harp sings still held at the same place of worship (fig. 178). Mohamed has included many activities taking place outside the church as the singing proceeds within. Her comments point out the persistence and strength of worship customs in our national life:

This church is more than a hundred years old. The most beautiful songs are still sung there. Once a year, on their memorial day, they honor their forefathers who are buried there. Things haven't changed that much except that they park their cars under the trees now instead of their horses and wagons. The memorial has an atmosphere of a family reunion more than anything else. These families have been coming to this church to worship for more than a hundred years, and early American traditions are still carried on among the people there.[46]

Fannie Lou Spelce (b. 1908) of Austin, Texas, recalls religious experiences of her childhood in *Camp Meeting at Maple Shade*, painted in 1968 (fig. 179). Each summer her family spent a week camped by a stream near Maple Shade, Arkansas, where they attended revival meetings:

The camp meeting at Maple Shade was a summer event that included the entire family. The planning and preparation for these camp meetings was quite an occasion including an all day travel by wagon to arrive at their destination. The entire time was spent around church activities, preaching services early each morning and night, with singing and prayer meetings at mid-morning and mid-afternoon. Getting to know and love thy neighbor as well as thy self was more or less a religious picknick all the time for everybody.[47]

Another twentieth-century version of a religious gathering is Harriet French Turner's view of a Dunkard meeting in Roanoke, Virginia (fig. 180). One of the most unusual representations of public worship is the motor-driven church meeting made by the Reverend Carlton Elonzo Garrett (b. 1900) of Flowery Branch, Georgia (fig. 181). Garrett, who has been an ordained Baptist minister since 1931, began making wooden toys and whimsical figures powered by windmills, while working in local furniture factories. His "dream church," *Mount Opel—Holy Children of Israel*, depicts a Southern "old-time" church service, activated by a motor in the box below. When the motor is turned on, the bellringer starts ringing and the organist begins to play. The latter's husband directs the sing-

ing while their little daughter sits beside the organ where she will behave properly. Another switch activates the phonograph, which plays a recording of the gospel hymn "Perfect Joy." Members of the congregation twist their heads, sway with the music, fan themselves, shake hands, or simply wait for the preacher, who represents Garrett himself, to begin his sermon. The artist recalls, "I used to preach real smart. A good gospel record makes me feel so good."[48] Garrett's mechanical church is reminiscent of "The Busy World" show wagon, created by a mid-nineteenth-century carver, David Hoy of Walton, New York (see figs. 76 and 76a). Hoy's horse-drawn wagon contained more than 350 figures, many of which depicted biblical scenes. As in Garrett's church, Hoy's figures could also be activated, but through hand-cranked gears and pulleys rather than motor-driven parts.[49] In each case, however, the maker bestowed kinetic "life" upon his miniature religious world.

Some scenes of religious activity represent services of prayer and praise in less public situations. Eunice Pinney's watercolor version of *The Cotters Saturday Night*, painted around 1815, was inspired by Robert Burns's poem describing a family's evening devotions (see fig. 47). *Cottage Meeting 1914*, painted around 1976 by Emily Lunde of North Dakota, depicts a similar prayer meeting within the home (fig. 182). Lunde's scene is based on memories of her childhood among Swedish immigrants in northern Minnesota. Harry Lieberman has also recorded a religious gathering in his painting *The Divine Spirit Dwells Among Us*, inspired by an old saying, "When ten people sit together and occupy themselves with the Torah, the Divine Presence dwells among them" (fig. 183). A scene of completely private piety is found in Horace Pippin's painting *John Brown Reading His Bible*, produced in 1942 as one of three pictures dealing with the trial and execution of the fiery abolitionist (fig. 184). Pippin's grandmother, a slave, had witnessed the hanging of the Bible-reading agitator, condemned to the gallows for fomenting the slave insurrection of 1859 at Harpers Ferry, West Virginia. Pippin's painting reveals a quiet moment in Brown's turbulent life and the central role played by religious convictions in the abolitionist movement.

Religious Rituals and Ephemera for Special Occasions

Religious ceremonies for special events and celebrations also have furnished subject matter for folk artists in the twentieth century. Queena Dillard Stovall (1887–1980) of Lynchburg, Viriginia, recorded significant occasions in the lives of her neighbors by painting funeral (fig. 185) and baptism scenes. The figures are rendered with affection and such careful attention to likeness and detail that many are

recognizable members of the community. Another funeral scene, carved by an unidentified early twentieth-century artist, captures the solemnity of a Catholic funeral procession (fig. 186). Malcah Zeldis (b. 1931) has documented more joyous occasions in her paintings *My Wedding* (fig. 187) and *Family Seder* (fig. 188). Zeldis's scenes of Jewish religious observances are drawn from her own early years in Detroit, her experiences on an Israeli kibbutz, and her more recent life in Brooklyn. "Her Jewishness was then, as it is now, part of the general stream of her experience and it colors her extraordinary sensitivity," notes Julia Weissman.[50]

In addition to depictions *of* special religious observances, an extensive body of material culture made for use *on* such occasions should also be noted. Ephemeral in nature, this traditional material is created and used for particular festivals or ceremonies, after which it is discarded or dismantled. Some examples of these impermanent forms are the "succoth" made for the Feast of Tabernacles and the items created to honor St. Gerard Maiella (see fig. 115). Each of these symbolic objects is fabricated to function as a significant element in special religious rituals. The succoth, a temporary shelter constructed of tree branches, is created as part of the observance of the Feast of Tabernacles or Booths, an autumnal festival that commemorates both the harvest season and the temporary shelters made of boughs by the Israelites during their wandering in the wilderness.[51] The instructions for observing the Feast of Tabernacles, given by God to Moses, are recorded in the Book of Leviticus (23:39–43):

On the fifteenth day of the seventh month, when you have gathered in the produce of the land, you shall keep the feast of the Lord seven days; . . . And you shall take on the first day the fruit of goodly trees, branches of palm trees, and boughs of leafy trees, and willows of the brook; and you shall rejoice before the Lord your God seven days. . . . You shall dwell in booths for seven days. . . . that your generations may know that I made the people of Israel dwell in booths when I brought them out of the land of Egypt.

Today the booths, or succoths, are built even on the sidewalks of busy urban communities.

Among other examples of ephemeral material created specially for specific religious celebrations are the items made in the Italian-American community of Newark, New Jersey, to observe October 16, the feast day of St. Gerard Maiella, the patron saint of motherhood, the poor, and the sick. As the saint's image is carried through the streets, robes and bouquets fashioned of dollar bills by women of the neighborhood are presented and fastened to the figure in gratitude for the many miracles attributed to the saint.

This particular feast is considered to be the oldest continual celebration of its kind on the East Coast. The succoth made for the Feast of Tabernacles and the robes and bouquets fabricated for the Feast of St. Gerard Maiella typify many such ephemeral forms that are central to the spiritual life of various ethnic and religious communities throughout America.

Preachers, Priests, and Rabbis

Images of religious leaders have been popular with American folk artists since the Colonial era. In fact, the first known portrait made in their new land by early settlers was a woodcut likeness of the Reverend Richard Mather produced in 1670 by John Foster (see fig. 26). Other very early portraits of Puritan clergymen were carved on gravestones (see fig. 37). Portraits of preachers continued to be popular throughout the nineteenth century. As the foremost members of the intellectual class, ministers were frequently the community leaders in educational, political, and cultural affairs, in addition to being moral and spiritual advisers. The clergy played leading roles in many of the humanitarian reforms that marked the first half of the nineteenth century, a period when numerous long-standing institutions and practices came under review. As instigators and agitators, ministers led several crusades that were aimed at the perfecting of American society, so that the new nation would be worthy of its divinely ordained role as a beacon to the world. During the 1820s and 1830s men like the Unitarian ministers Joseph Tuckerman and Orestes Brownson were among the first advocates of the "social gospel" that recognized the needs of the poor, while the Reverend Louis Dwight pressed for reforms in the prison system. Although the major supporters of the peace crusade were members of the Society of Friends, by 1820 other religious leaders such as the Rev. Noah Worcester had joined in the struggle to avert war.

Slavery, the most controversial issue, involved clergymen in a number of abolitionist movements, as well as in efforts to justify slavery's existence. When war began, ministers on both sides of the conflict provided leadership. After the outbreak of hostilities in April 1861, both sides claimed the blessing and guidance of God for their cause. Throughout the long and bitter conflict, Northern and Southern clergy alike prayed for victory, called for enlistments, and affirmed the righteousness of their stands. Northern and Southern churches also sent chaplains to the troops. In addition to giving comfort to the sick, wounded, and dying, chaplains conducted highly successful religious revivals in the army camps, resulting in thousands of conversions among officers and enlisted men. When the Civil War

97

125. Andrea Badami: *Adam and Eve in the Sight of God.* Omaha, Nebraska. c. 1969. Oil on canvas, 44″ x 34″. Badami's painting is unusual in that it depicts the face of God, an image seldom seen in American art. (Courtesy Mr. Elias Getz; photograph: Eeva-Inkeri)

marionette (fig. 193), a priest at the altar, made by John Wasilewski (fig. 194), and a portrait of a rabbi, painted by Malcah Zeldis (fig. 195).

The carving of a black preacher (fig. 192) records the central role played by black clergymen in the life of the black community. W. E. B. DuBois once noted the significant contribution of black ministers: "The Preacher is the most unique personality developed by the Negro on American soil. A leader, a politician, a 'boss,' an intriguer, an idealist—all of these he is, and ever, too, the center of a group of men, now twenty now a thousand."[53] Most important, perhaps, the black minister was the spiritual head of his people, during periods in American history when their lives were filled with fear and uncertainty. As the leader of his flock, the black preacher comforted the afflicted and encouraged hope for the future (see fig. 98). Sydney Ahlstrom points out that "long before Emancipation, black Christians had found strength and hope through their own identification of themselves as God's Israel, as a chosen people being led out of bondage."[54]

3. VISIONARY AND SYMBOLIC SUBJECTS

The third iconographical category used for examining the religious folk art in this survey consists of expressions of personal visions as well as works of art that incorporate traditional religious symbolism.

Personal Visions of Spiritual Truth

Where there is NO vision, the People Perish.
—James Hampton

My whole life has been dreams.
—Minnie Evans

One of the most remarkable visionary images ever produced by an American artist is the *Historical Monument of the American Republic*, painted by Erastus Salisbury Field in 1876 to commemorate the nation's first centennial (fig. 196). A small photoengraving of Field's great painting may have been displayed at the Centennial Exposition in Philadelphia. In his "Remarks" included in the *Descriptive Catalogue* for the painting, Field explained that "My aim has been to get up a brief history of our country, or epitome, in monumental form."[55] The scheme of the painting is a complex architectural design composed of numerous colonnaded towers that rest upon an elaborate substructure. Each level of every tower depicts an event in American history. The central tower portrays Lincoln and the Civil War. Included are angels pleading for abolition. As a member of the Congregational church in Palmer, Massachu-

ended, many religious leaders began to search for some meaning in the terrible conflict. A few saw the war as a purging experience. Horace Bushnell viewed the struggle as a cleansing of corporate sin and guilt that would permit national unity. Philip Schaff interpreted the war as a redemptive event, a judgment on the sin of slavery and a preparation for American world leadership.[52]

The extensive involvement of clergymen in the many crusades were typical of the nineteenth century and the conflict caused by slavery. The significance of these spiritual leaders was reflected in countless portraits done in a variety of media. In addition to the woodcut portrait of the Reverend Mather and those found on early tombstones, other depictions include the *Rev. Ebenezer Gay, Sr.*, painted by Winthrop Chandler (fig. 189), *The Preacher* by an unidentified artist (fig. 190), the *Portrait of a Clergyman* by another unidentified artist (fig. 191), the carved figure of a black preacher (fig. 192), a preacher

126. John ("Uncle Jack") Dey: *Adam and Eve Leave Eden*. Richmond, Virginia. 1973. Airplane model paint on board, 23″ x 47″. Dey's colorful interpretation of the expulsion includes an eviction notice and a sign announcing "Gravy train gone." (Collection of Herbert W. Hemphill, Jr.; photograph: Helga Photo Studio, Inc.)

setts, Field was reflecting the abolitionist sentiment of his denomination. Although most of the major denominations had been divided, North from South, over the issue of slavery, the Congregationalists, who had no Southern churches, had remained unified and had played a major role in the antislavery movement.[56]

The top level of each tower in Field's grandiose design rests on a base inscribed "T. T. B." for "The True Base." Columns, representing the States of the Union, stand on the several True Bases. Field's catalogue description explains that "the towers are connected with suspension bridges, and cars are going to and fro from the Centennial Exhibition, which is on the top of the central tower. The troops are marching around the monument which illuminates the Centennial anniversary of the American Independence."[57]

Field's religious convictions, having guided his choice of Old Testament imagery for his other paintings, now led him to include an essay on the Bible in the *Historical Monument*. His observations, inscribed on the facade of the building at the right of the painting, give evidence of his faith:

THE BIBLE is a brief recital of all that is past and a certain prediction of all that is to come. . . . It reveals the only living and true God, and points the unerring way to Him. . . .THE BIBLE is a book of . . . wisdom which condemns all foolishness and vice . . . It is a book of truth that detects all lies, and confutes all error; and a book of life, which

leads in the sure way from eternal death. THE BIBLE is the most compendious work in the world. . . . It contains the earliest antiquities, the strangest events, the most wonderful occurrences, heroic deeds, and unparalleled wars; it describes the celestial, terrestrial, and infernal worlds; the origin of the angelic host, the human tribes, and hellish legions. . . . This book is the king's best copy, the magistrate's best rule, the parent's best guide, the servant's infallible directory, and the young man's best companion. It is the schoolboy's spelling book and the learned man's masterpiece. It contains a choice grammar for the novice, and deep sayings for the sage. . . . Inexcusable is he who does not read, and unwise is he who gains no instruction; for to guilty man it is a savor of life unto life, or of death unto death.[58]

The originality, scale, and power of Erastus Field's unusual personal vision are rarely found combined in single works of art. Perhaps the nearest twentieth-century equivalent of Field's nineteenth-century painting is James Hampton's *Throne of the Third Heaven of the Nations Millennium General Assembly*, constructed between 1950 and 1964 (fig. 197). Hampton (1909–1964) was born in Elloree, South Carolina, the son of a black gospel singer and Baptist preacher. He settled in Washington, D.C., in the 1930s and, after three years of army service, became a janitor for the General Services Administration. Throughout his adult life Hampton experienced visions of divine beings such as God, angels, Moses, Adam, and the Virgin

99

Mary. These visions inspired Hampton to begin the construction of his masterwork. For fourteen years he labored five or six hours every night in a rented garage, assembling his great throne out of old furniture, insulation board, cardboard, glass jars, and light bulbs, all of it covered with gold and silver foil. The assemblage, thirty-two feet long and nine feet high, includes fifty thrones, altars, pulpits, plaques, and crowns. The various parts of the throne complex were labeled by the artist in both English and an invented cryptic script. On the viewer's left, the pieces represent the New Testament: Jesus and Grace. On the right, the parts refer to the Old Testament: Moses and the Law. Labels on many of the objects refer to the millennium and to the Book of Revelation, chapters 20 and 21, which describe the resurrection of the dead, the Day of Judgment, and the new heaven and earth. On one label Hampton wrote: "The word Millennium means 'the return of Christ and a part of the Kingdom of God on earth.'"[59]

The Book of Revelation may have inspired the artist to develop his own mysterious script, just as Saint John, the author of Revelation, was instructed by God to use a cryptic language to record his visions. Hampton used his own enigmatic hieroglyphics to fill a small notebook, marking each page with the word *Revelation*. The same curious script appears on the labels along with English translations. In his written notations, Hampton referred to himself as "St. James, Director of Special Projects for the State of Eternity."

Hampton was convinced that God came regularly to his garage-workshop to guide him in his ambitious undertaking. Inscriptions on the *Throne* record other visions and visitations:

> This is true, that the Great Moses, the giver of the 10th Commandment, appeared in Washington, D.C., April 11, 1931.

> On October 21, 1946, the Star of Bethlehem appeared over our nation's capitol. This is also true.

> This is true, that Adam, the first man God created, appeared in Person on January 20, 1949. This was on the first day of President Truman's inauguration.[60]

The existence of James Hampton's great work went virtually unnoticed until after his death. Following its discovery in the garage, many visitors speculated on its true purpose. Hampton had told acquaintances of his wish to become a minister after his retirement. Possibly he intended to convert the garage into a church. Written on a bulletin board in Hampton's workshop were these words from the Book of Proverbs (29:18): "Where there is NO vision, the People Perish." James Hampton's majestic *Throne of the Third Heaven*, inspired by an intense private vision, has preserved the name of this unusual artist as part of our cultural heritage.

Other twentieth-century folk artists have also been guided by private visions in their creation of spirit-filled images. Some of these, such as William Edmondson, Horace Pippin, Elijah Pierce, and Joseph Barta, have been included in the category based upon scriptural subjects because of their use of traditional biblical imagery. Additional artists, whose works feature highly original images, include Sister Gertrude Morgan, Minnie Evans, and Patrick J. Sullivan. The Book of Revelation, the source of inspiration for James Hampton, has similarly influenced these artists. Sister Gertrude Morgan (1900–1980) was an itinerant preacher and gospel singer on the street corners of Montgomery and Mobile, Alabama, and New Orleans, Louisiana, for almost forty years, after God had said to her, "Go ye in yonder's world and sing in a loud voice."[61] In 1969 her mission was changed. "Then God stopped me goin' out. He told me to stay indoors and pray and teach."[62] Attached to the porch of her small home in New Orleans was a sign that said "Everlasting Gospel Mission." Inside,

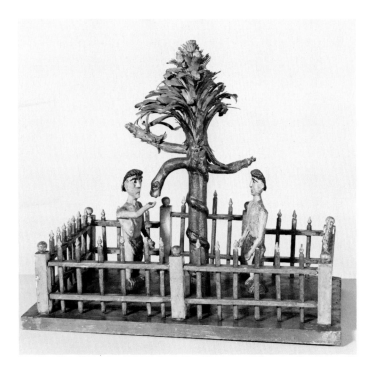

127. Attributed to Wilhelm Schimmel: *Adam and Eve*. Pennsylvania. Second half of nineteenth century. Wood, polychromed, 20″. This version of Eden places Adam and Eve and the forbidden tree within a fenced enclosure. (Philadelphia Museum of Art; The Titus C. Geesey Collection)

Gertrude Morgan gave sermons and dispensed advice while seated on a white chair behind a white-covered table. She had worn only white since becoming "the bride of the Father and the Christ," heeding the biblical admonition to "dress ye in fine white linen."

Gertrude Morgan began to paint when her street preaching came to an end, because she believed that God would use her pictures as gospel messages. She explained that "He moves my hand. Do you think I would ever know how to do a picture like this by myself?"[63] Although she painted some scenes from the Old Testament, almost all of her paintings were inspired by the Book of Revelation, especially chapter 21, which describes Saint John's vision of the New Jerusalem. Gertrude Morgan included herself as well as written texts and personal comments in these visionary scenes. Several of her paintings, titled *Jesus Is My Air Plane*, show her and her heavenly bridegroom flying above the New Jerusalem in a sky filled with rejoicing angels (fig. 198). Another painting, *Revelations*, is a composite of many images contained in the biblical text, including the Four Horsemen of the Apocalypse (fig. 199). Morgan's personal visions guided her art and her life: "When God speaks to me, He talks in family fashion as if speaking to a neighbor. His voice is loud and heavy . . . like this: 'Everyone has to stop their wickedness. Rich, poor, black, white. It's judgment day!'"[64]

Minnie Evans (b. 1892) is another twentieth-century artist whose paintings incorporate visionary images that are based on her own mystical experiences. Born at Long Creek, North Carolina, Evans has lived most of her life near Wilmington, where she worked for many years as a gatekeeper at Airlie Gardens. Her richly complex and colorful designs defy simple explanations (fig. 200). Even the artist has admitted, "My work is just as strange to me as it is to anyone else."[65] Like Gertrude Morgan, Evans is guided in her painting by a power beyond her own conscious direction. "Something had my hand" is her explanation of this outside force.[66] At other times, she has said, "My whole life has been dreams" and "I had day visions—they would take advantage of me."[67] Nina Howell Starr has noted the origins of Evans's imagery:

In what we know of her life there are two important objective sources of her art clearly established: the exuberance

of nature that she experienced closely in her twenty-seven years tending the admissions gate at Airlie Gardens in Wilmington, and the Bible, especially the book of Revelation. In it colors are named in abundance and vivid phenomena, natural, supernatural and demonic, are richly described. It was with a sign of love and wonder that Minnie Evans commented once to me "Oh Revelations, my, my!"[68]

Still another artist whose work reflects his religious and moral convictions was Patrick J. Sullivan (1894–1967). Sullivan lived most of his life in Wheeling, West Virginia, where he worked as a housepainter and a steelworker. A devout Roman Catholic, Sullivan began in the 1930s to paint pictures that expressed his spiritual philosophy. His allegorical paintings combined Christian moralizing and symbolism with highly personal imagery and ideas. Although Sullivan often provided written explanations for his paintings, he left no written theme for *The Gates of Hell Shall Not Prevail*, painted in 1959 (fig. 201). However, from statements made by the artist to his daughter, its major source and much of its meaning are known. Like Evans and Morgan, Sullivan drew on the Book of Revelation for his imagery. He also introduced other symbolic images into the scene. The Russian bear led by Satan represents Communism. The painting's message, that Christianity will triumph over the atheism of Communism, surely reflects the political climate of the decade during which it was painted.

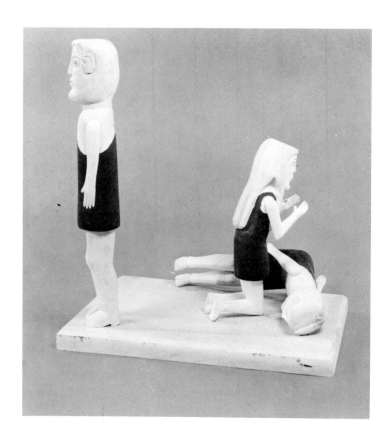

128. Edgar Tolson: *Cain Goes into the World*. Campton, Kentucky. 1969–1970. Carved and assembled wood, H. 14½". The murder of Abel by his brother Cain has been a popular subject with both folk artists and academic artists. (Mr. and Mrs. Michael D. Hall)

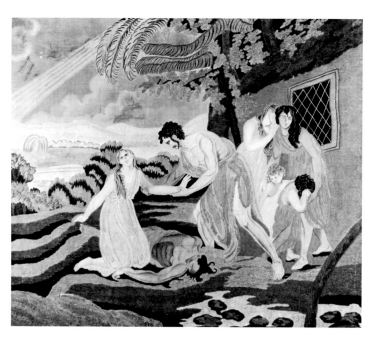

129. Mrs. H. Weed: *Death of Abel*. c. 1830. Silk and chenille threads and watercolor on satin, 28" x 32½". Adam comforts the grieving Eve in this embroidered and painted scene. (Abby Aldrich Rockefeller Folk Art Center)

In Sullivan's sky, God, not the sun, is the source of light. In the form of [the] Trinity, He is perched on a cloud representing the great white throne. The grassy plain surrounded by mountains represents the new Jerusalem with its high walls—the impregnable citadel. . . . The grassy plain is a new Eden where mankind through Christianity may be reunited with God. The stern-faced angel points Satan and his beast, atheism, off the canvas. The smiling angel guards the "gate" but in no way opposes the entrance of a priest leading a man holding a Bible.[69]

Sullivan once wrote to Sidney Janis of his aims: "If my work helps others to think . . . then I am achieving my goal. It is my intention to bring truth out in all its glory on my canvases—if you will, a sort of parable in picture form."[70]

Some paintings that belong in the visionary category have been done by artists already discussed in other contexts. Fannie Lou Spelce's painting *A Child's View of Heaven* depicts the afterlife as it might be visualized by a very young imagination (fig. 202). The same theme is expressed in Howard Finster's painting *Crossing Jordan*, which portrays the artist's personal vision of the passage from worldly sorrows to heavenly peace (fig. 203). Finster's version includes inscriptions that document the evils

of earthly existence and the blessings that await in heaven. Another unusual vision painted by Finster is his *Dog Story of the Bible*, which contrasts canine virtues with human vices. Among the many inscriptions on the painting is one that reads, "If man don't live as nice and kind as a dog, I don't think he will make it to *Heaven*."

Antoinette Schwob's painting *A Plea for Artists* shows the artist confronting God on behalf of her fellow artists. Schwob explains her work this way:

When I worked on this painting, I felt very keenly about the difficulty painters faced. Their poverty, the lack of appreciation and often ridicule they had to endure. . . . That's me up there telling God he should do something for artists and I hope you can tell how indignant I am.[71]

Among the artists seated around the table in Schwob's painting is the famous French naïve painter Henri Rousseau holding a red palette.

A much different visionary painting, done by an anonymous artist at the turn of the century, is the *Missionary Map* (fig. 204). Filled with images inspired by the Book of Revelation, this work was undoubtedly used as a teaching aid in interpreting world history and biblical prophecy. The *Missionary Map* reflects the popularity of the "dispensationalist" beliefs that were developed by fundamentalist Christian groups in the late nineteenth and early twentieth centuries. According to dispensationalist views, God's "pattern for the ages" consists of *dispensations*, or periods, marked by successive covenants between God and man. Five dispensations are represented at the top of the *Missionary Map*. Three symbolize the time of the Old Testament, the fourth represents the Christian era, and the final dispensation represents the "Divine Age" or millennium, when the returned Christ is to reign for one thousand years. Scattered throughout the map are images associated with prophecies found in the Book of Revelation. Various dispensational schemes were adopted by fundamentalist groups, who opposed theological liberalism and advocated a literal interpretation of Scripture. The most popular system, devised by Cyrus I. Scofield, was propagated through his Correspondence Bible School and Scofield Reference Bible, the latter still "a faithfully used resource of conservative Sunday School teachers, preachers, and churchgoers."[72]

Symbols of Spiritual Truth

That which remained was faith in Jesus.

—Nettie Halvorson

Several works of religious folk art have employed traditional symbols as their major motifs. Although most of the

works already discussed also use religious symbolism, the pieces included here rely on symbolism more completely for their effect. One of the most unusual examples of religious material culture that can be classified as both visionary and symbolic is the wall hanging created around 1912 by Nettie Bergland Halvorson, who lived on a farm near Houston, Minnesota (fig. 205). This large textile, seventy-six inches high and one hundred thirty-seven inches long, was made by stringing thousands of one-inch cloth squares onto horizontal strands of carpet warp that were then secured by vertical strands to form a netlike structure. With her colorful cloth squares, the artist produced a design that incorporates a rainbow overhead, a landscape below, and, in between, a sky filled with symbols and an inscription in Norwegian. The symbols include a star, a circle, a heart, and a cross. Their exact meanings in this combination are not known but they may refer to "faith, hope, and charity" as well as to Christ.[73] The inscription is translated, "The law of Moses fell to the earth and became nothing, but that which remained was faith in Jesus."[74] "Fell to the earth and became nothing" is repeated along the bottom of the hanging. Nettie Halvorson was born at Sheldon, Minnesota, to parents who had come from Telemark, Norway, in the mid-nineteenth century. An intensely religious woman, she labored for many years on the wall hanging, which became her chief interest and activity. When finally completed, the work was folded, put in a closet, and never used. Apparently, the creation of this remarkable textile was a quiet affirmation of faith, with profound personal meaning for its maker. Today the work hangs in the Norwegian-American Museum at Decorah, Iowa, where it attests to the artistry and originality of a devout woman.

There are other nineteenth- and twentieth-century examples of folk art that use symbolism to convey spiritual meanings. Edward Hicks's 1825 painting of *The Falls of Niagara* can be viewed as an expression of the religious awe inspired by the wonders of nature (fig. 206). Hicks stopped at Niagara during his travels as an itinerant Quaker preacher. His painting was based on his own observations as well as on a vignette from an 1822 map by Henry S. Tanner.[75] Around the border that frames the composition, Hicks added verses from Alexander Wilson's 1809 poem, "The Foresters":

> This great o'erwhelming work of awful time
> In all its dread magnificence sublime,
> Rises on our view, amid a crashing roar
> That bids us kneel, and Time's great God adore.

In addition to presenting natural wonders as the handiwork of the Creator, Hicks's painting also suggests the identification of the American landscape with godliness, an attitude that was prevalent during the early nineteenth century, as Joshua Taylor has observed: "It was only in the 1820s that painters and architects began to take seriously the ideas of sublimity in natural scenery and consider the relationship between landscape and mind."[76] In his *Falls of Niagara* Hicks joined Thomas Cole, Asher Brown Durand, Frederic Edwin Church, and other nineteenth-century artists whose landscapes reflected spiritual concepts.

Among other works of art that function as symbols of spiritual reality are the carved images that were created for both secular and sacred settings. Popular motifs included representations of angelic beings, such as the angel Gabriel blowing his horn. One of the finest Gabriel figures serves as the logo for the Museum of American Folk Art (fig. 208). Made around 1827 by an unidentified artist, another Gabriel figure hung for many years outside the Angel Tavern at Guilford, New York[77] (fig. 207). Another horn-blowing angel, carved around 1875, served as a weathervane on a boathouse on Old North Wharf, Nantucket, Massachusetts.[78] A late nineteenth-century example of religious symbolism in American folk art may be found in the *Hand of God*, carved by an unidentified artist around 1895 (fig. 209). Originally painted white, the long wooden arm and hand, with its forefinger pointing heavenward, was once the steeple ornament for the Midway Temple Presbyterian Church in Midway, Georgia. The church, built in 1895 by a black congregation under the

130. Ned Cartledge: *The Expulsion of Adam and Eve from the Garden of Eden.* Atlanta, Georgia. 1979. Carved and painted wood. The addition of commercial elements to the biblical setting is a satirical reflection of Madison Avenue's pervasive influence on American life. (Judith Alexander; photograph: Jay Crouse)

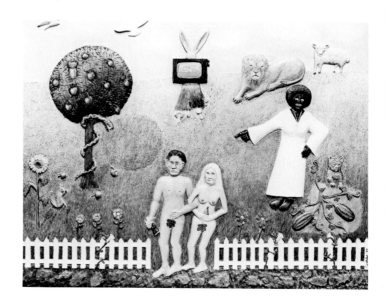

leadership of Joseph Williams of Macon, was torn down in 1963.[79] Only the *Hand of God* remains, a symbol not only of divine guidance but also of a people's faith. A twentieth-century version of the Hand of God, painted by another anonymous artist, stands beside the highway near St. Johns, Michigan (fig. 210).

Some of the religious symbols used in contemporary folk art are part of the visual vocabulary of traditional ethnic arts still being practiced. The Chippewa strawberry baskets, symbolizing the Eastern Woodlands Indian's journey to the next life, has already been mentioned in chapter 1 (see fig. 14). Another venerable folk art form, with its origins in Ukrainian religious customs, is the decoration of Easter eggs, or *pysanky*. This age-old art is based on the principles of batik printing in its use of wax to resist colored dyes, then removing the wax to produce decorative and symbolic designs on the egg's surface (fig. 211). The traditional symbols and colors used by pysanky artists, such as Gail Schmitz, have religious connotations appropriate to the holy days with which they are associated. The strawberry baskets of the Woodlands Indians and the pysanky of Ukrainian communities are just two of the many ethnic traditions that perpetuate the religious beliefs of special groups within American culture.

Closely allied to the works discussed in this and previous chapters is a vast body of religious material that should also be recognized. Among contemporary visual expressions of religious convictions are many that bridge the gap between material that has commonly been accepted as folk art and that which has been defined as popular art. Indeed, the divisions have never been clearly drawn or completely acceptable to everyone interested in all material culture that falls outside of the traditional range of so-called high or fine arts. For example, much of the nineteenth-century material that is often considered folk art today, such as the fancy pieces produced by schoolgirls or the theorem paintings of older women, was the popular art of its day. Today, the distinctions between such categories as fine arts, folk arts, popular arts, and crafts are even more difficult to determine. More important than the eroding barriers that separate such categories is the manifestation of the creative spirit that they share in common.

Numerous examples of religious expression in contemporary forms, whether considered popular or folk, may be seen in public places, especially along roadsides or even on moving vehicles. Signboards, graffiti, bumper stickers, personalized license plates, and painted messages on cars and trucks are some of the modern means through which many Americans give witness to their faith (figs. 212–214). Worship environments have also been created, both as reflections of the makers' faith and as places where the

weary motorist may find spiritual regeneration. Wayside chapels, shrines, grottoes, and religious gardens offer opportunities for private prayer or meditation. Many of the wayside chapels found throughout America were erected during the 1960s by Christian reformed churches as a ministry to travelers[80] (fig. 215). They call to mind the floating seaport churches provided by the YMCA organization as a ministry to sailors in the mid-nineteenth century[81] (fig. 216). In each case, the chapels were designed to serve the spiritual needs of those away from home. Other public manifestations of faith include such religious symbols as roadside crosses, crucifixes, and images of the saints, situated where they will offer inspiration to passersby. Whether viewed as folk art or popular art, these varied forms attest to the enduring life of the spirit in twentieth-century America.

CONTINUITY, CHANGE, AND CULTURAL CONTEXT

The works of art included in this book represent only a fraction of the religious material culture that has been created by Americans since the seventeenth century. Unfortunately, much of this material has been lost through destruction or deterioration. However, as the objects chosen for this discussion demonstrate, there is still extant a sizable body of spiritually inspired works that can exemplify the range of the original material, suggest contextual origins, and reveal iconographical trends.

Many correlations between choice of theme and cultural setting have already been noted throughout this and previous chapters. In addition to these relationships between theme and context, one can also observe the persistence of certain subjects, the modifications that occur in some, the apparent disappearance of others, and the arrival of new themes. For instance, both continuity and change can be seen in the varied interpretations of such themes as the Garden of Eden, the Peaceable Kingdom, and the life of Moses. Subjects such as the Crucifixion have continued to attract contemporary folk artists, while others, including the once-popular Old Testament stories of Jephthah, Absalom, and Joseph, no longer appear. Instead, there has been a greater emphasis on scenes of religious life drawn from the artists' own experiences. New themes and forms have also been introduced through the religious and artistic traditions brought by immigrants from diverse cultural backgrounds. The addition of Eastern Orthodox spiritual and aesthetic values and of Jewish iconographical sources has expanded and enriched the range and depth of America's religious folk material. The recent arrival of new ethnic groups, such as the Haitians and the Laotians, means that even more forms of religious material expression will become a part of our national heritage. Still another source

of iconographical change has been the rise of Protestant fundamentalism with its emphasis on the prophetic Book of Revelation, which has become a rich source of imagery for many twentieth-century visionary artists.

A careful examination of iconographical patterns in America's religious material folk culture clearly reveals both continuity and change in choice and treatment of theme. The modifications, deletions, and additions that characterize these patterns have stemmed from a variety of cultural factors: changing views of America's destiny; social and economic upheavals; events in political and religious history; declining reliance on print sources coupled with greater interest in religious life; the introduction of other religious traditions, aesthetic forms, iconographical sources, and viewpoints with the continuing arrival of diverse ethnic groups; and the rise of Protestant fundamentalism. Developments such as these have contributed to the fluctuating cultural context out of which have come the varied forms of visual expression that testify to the rich spiritual life of the American people.

Notes

1. Jane Dillenberger, "Catalogue to the Exhibition," in Jane Dillenberger and Joshua C. Taylor, *The Hand and the Spirit: Religious Art in America 1700–1900* (Berkeley, Calif.: University Art Museum, 1972), p. 25.

2. Anita Schorsch and Martin Greif, *The Morning Stars Sang: The Bible in Popular and Folk Art* (New York: The Main Street Press, 1978), pp. 25–27.

3. Walter E. Boyer, "Adam und Eva in Paradies," *The Pennsylvania Dutchman* 8, no. 2 (Fall–Winter 1956–1957), p. 15.

4. Dillenberger notes that representations of God are seldom seen in American art, whether academic or naïve, *The Hand and the Spirit*, p. 25.

5. Robert Bishop, *American Folk Sculpture* (New York: Dutton Paperbacks, 1983), p. 204.

6. Dillenberger, *The Hand and the Spirit*, p. 28.

7. Quoted by Michael Haggerty in "Art and Soul," *Atlanta Weekly*, June 29, 1980, p. 28.

8. Gregg Blasdel and Philip Larson, "S. P. Dinsmoor's Garden of Eden," *Naïves and Visionaries* (exhibition catalogue) (New York: Dutton Paperbacks, 1974), p. 33.

9. *Ibid.*

10. *Ibid.*, p. 41.

11. Quoted in Anna Wadsworth, ed., *Missing Pieces: Georgia Folk Art 1770–1976* (exhibition catalogue) (Atlanta, Ga.: Georgia Council for the Arts, 1976), p. 106.

12. *Ibid.*

13. The words to the chorus of this well-known early twentieth-century hymn by C. Austin Miles describe divine encounters in a garden setting: "And He walks with me, and He talks with me/And He tells me I am His own; And the joy we share as we tarry there/None other has ever known."

14. C. Kurt Dewhurst and Marsha MacDowell, *Rainbows in the Sky: The Folk Art of Michigan in the Twentieth Century* (exhibition catalogue) (East Lansing, Mich.: Michigan State University Press, 1978), pp. 115–118.

15. Betty MacDowell, "Religion on the Road: Highway Evangelism and Worship Environments for the Traveler in America," *The Journal of American Culture* 5, no. 4 (Winter 1982), p. 72.

16. *Grotto and Shrines* (Dickeyville, Wisc.: Dickeyville Grotto, n.d.).

17. Thomas K. Woodard and Blanche Greenstein, "Hawaiian Quilts: Treasures of an Island Folk Art," *The Clarion* (Summer 1979), pp. 24–25.

18. Dillenberger, *The Hand and the Spirit*, p. 29.

19. *Ibid.*, p. 28.

20. *Ibid.*, p. 118.

21. Edward Hicks, *Memoirs*, quoted by Eleanore Price Mather in *Edward Hicks: A Gentle Spirit* (exhibition catalogue) (New York: Andrew Crispo Gallery, 1975), unpaged.

22. These figures have been identified by Frederick B. Tolles in "The Primitive Painter as Poet," *Bulletin of the Friends Historical Association* 50, no. 1 (Spring 1961), pp. 12–30.

23. Mather credits Mary Black with having first noted the reflections of the Quaker schism in this type of composition. See Mary C. Black, *Edward Hicks 1780–1849, a Special Exhibition Devoted to His Life and Work* (Williamsburg, Va.: Abby Aldrich Rockefeller Folk Art Collection, 1960). Also, Mary C. Black, "& a Little Child Shall Lead Them," *Arts in Virginia* 1, no. 1 (Autumn 1960), pp. 22–29.

24. N. F. Karlins, "The Peaceable Kingdom Theme in American Folk Painting," *Antiques* (April 1976), p. 739.

25. Selden Rodman, "Horace Pippin," *American Folk Painters of Three Centuries* (exhibition catalogue) (New York: Hudson Hills Press, in association with the Whitney Museum of American Art, 1980), p. 213.

26. Quoted in "Chronology of Horace Pippin's Life and Work," *Horace Pippin* (exhibition catalogue) (Washington, D.C.: The Phillips Collection, 1977).

27. Edward Hicks, *Memoirs*, entry for April 18, 1846; quoted in Dillenberger, *The Hand and the Spirit*, p. 88.

28. Quoted by Elinor Lander Horwitz, *Contemporary American Folk Artists* (Philadelphia and New York: J. B. Lippincott, 1975), p. 88.

29. Will Herberg, "Judaism in America," in John M. Mulder and

John F. Wilson, eds., *Religion in American History: Interpretive Essays* (Englewood Cliffs, N.J.: Prentice-Hall, 1978), p. 383.

30. Morris Hirshfield, "My Life Biography," in Sidney Janis, *They Taught Themselves: American Primitive Painters in the 20th Century* (New York: The Dial Press, 1942), p. 17.

31. Marion John Nelson, *Lars Christensen: A Pioneer Artist and His Masterpiece* (Decorah, Iowa: A Vesterheim Publication, 1976), p. 5.

32. *Ibid.*, p. 11.

33. Dillenberger, *The Hand and the Spirit*, p. 29.

34. Quoted by Gaylen Moore in "The Vision of Elijah Pierce," *The New York Times Magazine*, August 26, 1979, p. 30.

35. *John Perates: Twentieth-Century American Icons* (exhibition catalogue) (Cincinnati, Ohio: Cincinnati Art Museum, 1974), unpaged.

36. *Ibid.*

37. Albert C. Moore, *Iconography of Religions* (Philadelphia: Fortress Press, 1977), p. 247.

38. *Carved by Prayer* (Spooner, Wisc.: Museum of Woodcarving, n.d.), back cover.

39. Quoted by Edmund L. Fuller in *Visions in Stone: The Sculpture of William Edmondson* (Pittsburgh, Pa.: University of Pittsburgh Press, 1973), p. 8.

40. *Ibid.*

41. Herbert W. Hemphill, Jr., and Julia Weissman, *Twentieth-Century American Folk Art and Artists* (New York: E. P. Dutton, 1974), p. 94.

42. Fuller, *Visions in Stone*, p. 3.

43. Frances Lichten, "John Landis: 'Author and Artist and Oriental Tourist,'" *Pennsylvania Folklife* 9, no. 3 (Summer 1958), p. 10.

44. The tale on which *The Driver's Promotion* was based was sent to the authors by Mr. Morris Weisenthal of Morris Gallery, New York City. Other variations involving the exchange of the driver and the rabbi may be found in collections of Jewish folklore.

45. Taylor, "The Hand and The Spirit," *The Hand and the Spirit*," p. 12.

46. Ethel Wright Mohamed, *My Life in Pictures*, ed. Charlotte Capers and Olivia P. Collins (Jackson, Miss.: Mississippi Department of Archives and History, 1976), p. 17.

47. *Fannie Lou Spelce* (Austin, Tex.: Fannie Lou Spelce Associates, 1972).

48. Haggerty, "Art and Soul," p. 34.

49. Bishop, *American Folk Sculpture*, pp. 276–277.

50. Julia Weissman, "Malcah Zeldis: A Jewish Folk Artist in the American Tradition," *The National Jewish Monthly* 90, no. 1 (September 1975), p. 4.

51. E. O. James, *Seasonal Feasts and Festivals* (New York: Barnes & Noble, 1961), pp. 113–115.

52. Sydney E. Ahlstrom, *A Religious History of the American People* (Garden City, N.Y.: Image Books, Doubleday & Co., 1975), vol. 2, p. 135.

53. W. E. B. Dubois, *The Souls of Black Folk* (1903; reprint ed., New York: Fawcett World Library, 1961), p. 190.

54. Ahlstrom, *A Religious History of the American People*, vol. 2, p. 168.

55. Erastus Salisbury Field, "Remarks," *A Descriptive Catalogue of the Historical Monument of the American Republic* (Amherst, Mass.: H. H. McCloud, 1876).

56. Ahlstrom, *A Religious History of the American People*, vol. 2, pp. 112–113.

57. Quoted by Dillenberger, *The Hand and the Spirit*, p. 120.

58. *Ibid.*

59. Lynda Roscoe, "James Hampton's Throne," *Naives and Visionaries* (New York: Dutton Paperbacks, 1974), pp. 16, 19.

60. *Ibid.*, p. 15.

61. Horwitz, *Contemporary American Folk Artists*, p. 27.

62. *Ibid.*

63. *Ibid.*

64. *Ibid.*, p. 30.

65. Nina Howell Starr, *Minnie Evans* (exhibition brochure) (New York: Whitney Museum of American Art, 1975), unpaged.

66. *Ibid.*

67. *Ibid.*

68. *Ibid.*

69. Gary E. Baker, *Sullivan's Universe: The Art of Patrick J. Sullivan, Self-Taught West Virginia Painter* (Wheeling, W. Va.: Oglebay Institute, 1979), p. 38.

70. Janis, *They Taught Themselves*, p. 58.

71. Statement by the artist given to Jay Johnson, New York City.

72. Ahlstrom, *A Religious History of the American People*, vol. 2, pp. 279–280.

73. This interpretation was given to the authors by Dr. Marion John Nelson, Director of the Norwegian-American Museum, which owns the wall hanging.

74. The translation of the inscription was also supplied by Dr. Nelson.

75. Eleanore Price Mather, "Edward Hicks," *American Folk Painters of Three Centuries*, p. 92.

76. Taylor, *The Hand and the Spirit*, p. 17.

77. Bishop, *American Folk Sculpture*, p. 392.

78. Jean Lipman and Alice Winchester, *The Flowering of American Folk Art, 1776–1876* (exhibition catalogue) (New York: The Viking Press, 1974), p. 139.

79. Wadsworth, ed., *Missing Pieces*, p. 59.

80. Betty MacDowell, "Religion on the Road," pp. 69–70.

81. Calder Loth and Julius Trousdale Sadler, Jr., *The Only Proper Style: Gothic Architecture in America* (Boston: New York Graphic Society, 1975), p. 84.

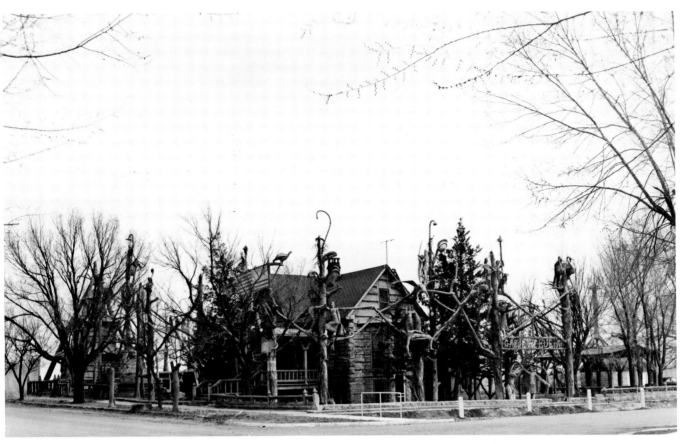

131. S. P. Dinsmoor: Overall view of the Rock Log Cabin with the *Garden of Eden* and *Modern Civilization*. Lucas, Kansas. 1907–1927. Cement and limestone. Dinsmoor once remarked, "If the Garden of Eden is not right, Moses is to blame. He wrote it up and I built it." (Photograph courtesy Mr. and Mrs. Wayne Naegele)

132. S. P. Dinsmoor: *The Crucifixion of Labor*. Lucas, Kansas. 1907–1927. Cement and limestone. This allegorical group, part of Dinsmoor's *Modern Civilization* environment, depicts Labor being crucified by professional-class "grafters": Doctor, Lawyer, Preacher, and Banker. (Photograph courtesy Roger Brown)

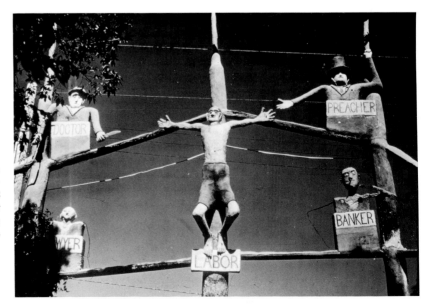

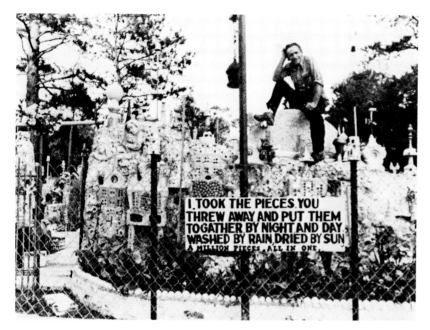

133. Reverend Howard Finster: *Paradise Garden*. Summerville, Georgia. Twentieth century. Cement, glass, brick, mirrors, and various found materials. Finster's Eden-like environment is filled with biblical inscriptions composed of mirror fragments that are embedded into its cement walls and walks. (Photograph: Bud Lee)

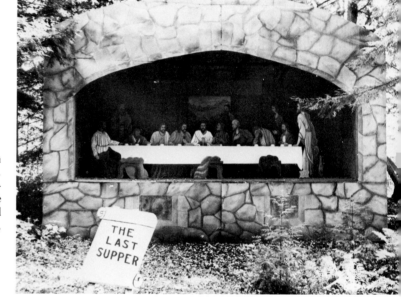

134. E. K. and Orpha Lund: *The Last Supper* from *Lund's Scenic Garden*. Maple City, Michigan. 1948. Painted plywood, H. approx. 15′. This religious setting is one of thirty-six painted tableaux depicting the entire life of Christ that spreads over sixteen wooded acres. (Photograph: Folk Arts Division, The Museum, Michigan State University)

135. Paul Domke: *Prehistoric Dinosaur Garden*. Ossineke, Michigan. Early twentieth century. Cement, H. approx. 18′. The hollow cement brontosaurus in Domke's "prehistoric" Eden contains a religious shrine dedicated to "Jesus Christ, the Greatest Heart." Gardens such as Domke's and the Lunds' combine the concept of the Old Testament paradise with imagery derived from the New Testament. (Photograph: Folk Arts Division, The Museum, Michigan State University)

136. Father Mathias Wernerus: *Holy Ghost Park*. Dickeyville, Wisconsin. c. 1921–1931. Mixed media. Images of Columbus, Washington, and Lincoln are included among the holy figures in this garden inspired by both religious and patriotic fervor. (Photograph: Betty Mac-Dowell)

137. Unidentified artist: *The Beautiful Unequaled Gardens of Eden and Elenale* ("Na Kihapai Nani Lua 'Ole O Edena a Me Elenale"). Hawaiian Islands. Before 1918. Cotton, 78½" x 92". This appliquéd quilt includes the lovers Elenale and Leinaale, characters from a popular nineteenth-century Hawaiian tale, in addition to images of Adam and Eve. (Honolulu Academy of Arts; Gift of Mrs. C. M. Cooke, 1929)

138. Erastus Salisbury Field: *Burial of the First Born of Egypt*. Massachusetts. c. 1880. Oil on canvas, 33¼″ x 39¼″. (Museum of Fine Arts, Springfield, Massachusetts; The Morgan Wesson Memorial Collection)

139. Thomas Nast: *Church and State—No Union Upon Any Terms*. 1871. This cartoon, representing the principle of separation between church and state, appeared in *Harper's Weekly*, February 25, 1871. (Courtesy Collections of The Library of Congress)

140. Edward Hicks: Detail from *The Peaceable Kingdom with Quakers Bearing Banners* (The Peaceable Kingdom No. 10). Pennsylvania. Nineteenth century. Oil on canvas, 17½" x 23½". This detail of Edward Hicks's *Peaceable Kingdom with Quakers Bearing Banners* shows the profile figure of his cousin Elias Hicks, together with George Washington and various Quaker leaders. Their banner extends to the distant figures of Christ and the twelve apostles. (Yale University Art Gallery; Bequest of Robert W. Carle, B.A. 1897)

141. Dr. William Hallowell: *Peaceable Kingdom*. Norristown, Pennsylvania. 1865. Ink on paper, 15¾" x 19¾". Hallowell, a Quaker minister as well as a physician and dentist, inscribed a text from the Book of Isaiah (11:6–9) around his interpretation of the Peaceable Kingdom theme. (New York State Historical Association, Cooperstown)

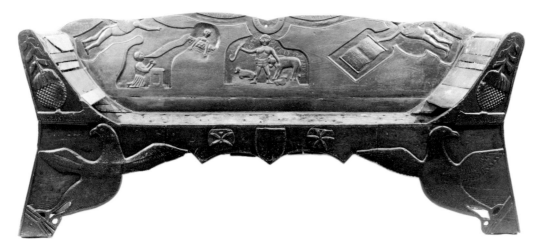

142. Carved wooden bench. Inscribed "W. Granville, January 1853." Medina, Ohio. Walnut, 30" x 78". This bench may have been made as a presentation piece for the Reverend W. Granville, rector of St. Paul's Episcopal Church at Medina, or it may have been carved by the rector himself. The central inscription, around the child, reads: "A little . . . shall lead them." (Collection of G. W. Samaha; photograph: Michael Medzweski)

143. Horace Pippin: *Holy Mountain III*. West Chester, Pennsylvania. 1945. Oil on canvas, 25" x 30". Pippin's Holy Mountain series reflects Isaiah's prophecy of peace as well as the artist's own wartime experiences and the civil rights struggles of the 1940s. (Hirshhorn Museum and Sculpture Garden, Smithsonian Institution)

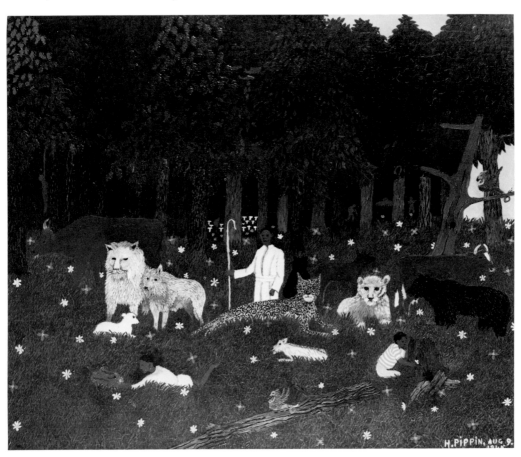

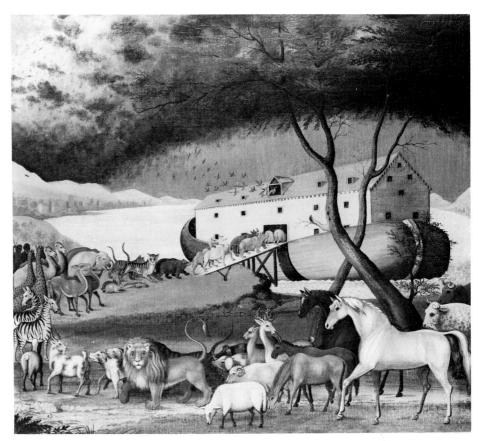

144. Edward Hicks: *Noah's Ark*. Newtown, Pennsylvania. 1846. Oil on canvas, 26½″ x 36¼″. Hicks painted this scene (a symbol of salvation) while mourning the death of his granddaughter. (Philadelphia Museum of Art; Bequest of Lisa Norris Elkins)

145. Erastus Salisbury Field: *Ark of the Covenant*. Massachusetts. c. 1865–1880. Oil on canvas, 20″ x 24⅛″. Field's painting depicts the joyful return of the sacred Ark of the Covenant to Jerusalem, as told in I Chronicles (15:3–28). (National Gallery of Art; Gift of Edgar William and Bernice Chrysler Garbisch, 1956)

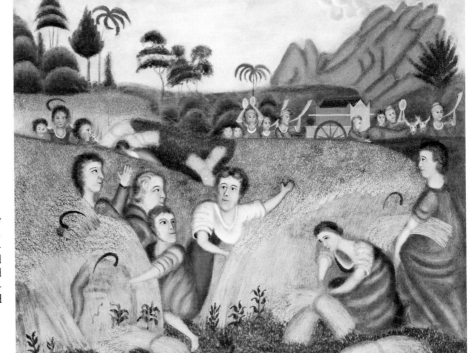

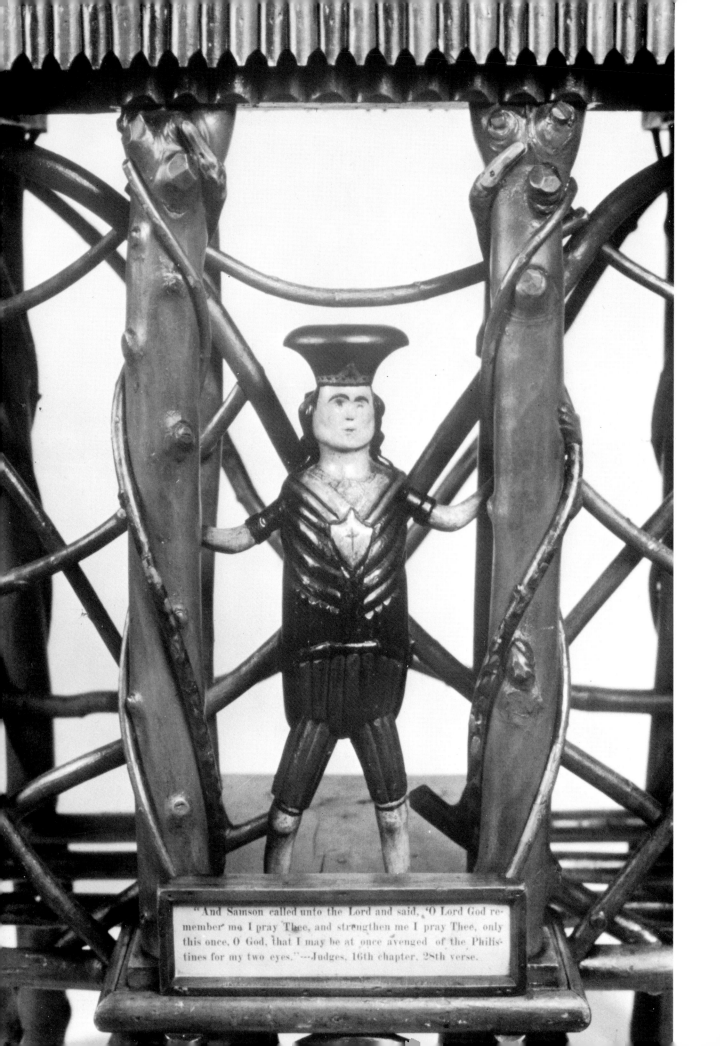

"And Samson called unto the Lord and said, 'O Lord God remember me I pray Thee, and strengthen me I pray Thee, only this once, O God, that I may be at once avenged of the Philistines for my two eyes.'"—Judges, 16th chapter, 28th verse.

146. Henry Washington Couse: Detail from *Samson Table*. Waverly, Iowa. 1879–1880. Carved and painted wood, 29″ x 22½″. Inscribed on the tablet at Samson's feet is the blinded Samson's prayer for renewed strength, so that he might seize the pillars and bring down the Philistines' temple on top of his captors. (Collection of Larry D. Whiteley)

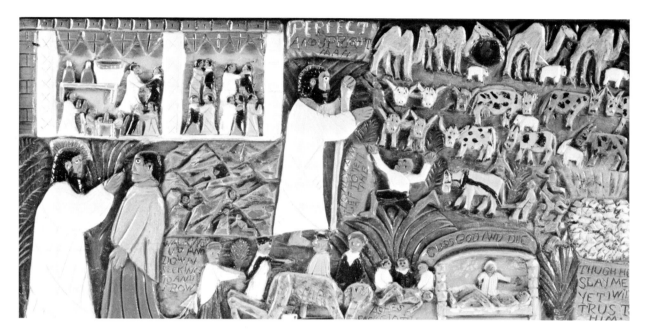

147. Elijah Pierce: *Story of Job*. Columbus, Ohio. 1938. Carved and painted wood, L. 27⅞″. Pierce once claimed that a preacher could scarcely "get up in the pulpit without preaching some picture I got carved." (Mr. and Mrs. Michael D. Hall)

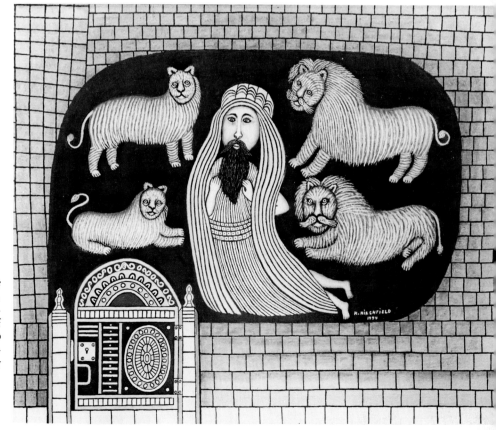

148. Morris Hirshfield: *Daniel in the Lion's Den*. Brooklyn, New York. 1944. Oil on canvas, 33″ x 39″. The Old Testament hero Daniel, thrown into a den of lions as punishment for his faithfulness to the true God, is saved through the miraculous taming of the beasts. (Courtesy Sidney Janis Gallery, N.Y.)

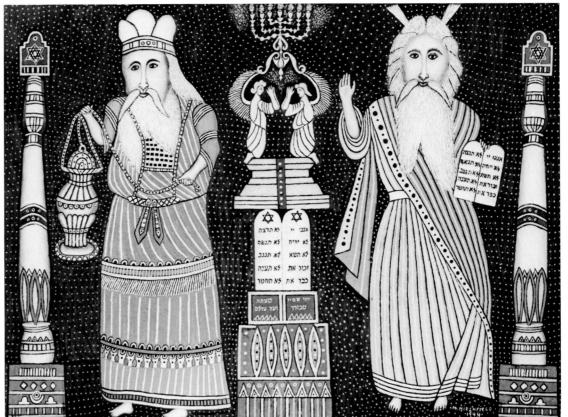

149. Morris Hirshfield: *Moses and Aaron*. Brooklyn, New York. 1944. Oil on canvas, 28″ x 40″. The two patriarchs of the Old Testament hold the symbols of their authority as lawgiver and high priest. (Courtesy Sidney Janis Gallery, N.Y.)

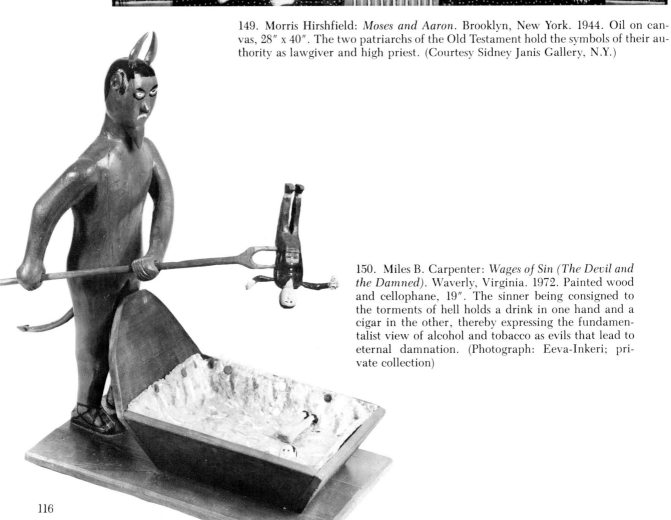

150. Miles B. Carpenter: *Wages of Sin (The Devil and the Damned)*. Waverly, Virginia. 1972. Painted wood and cellophane, 19″. The sinner being consigned to the torments of hell holds a drink in one hand and a cigar in the other, thereby expressing the fundamentalist view of alcohol and tobacco as evils that lead to eternal damnation. (Photograph: Eeva-Inkeri; private collection)

116

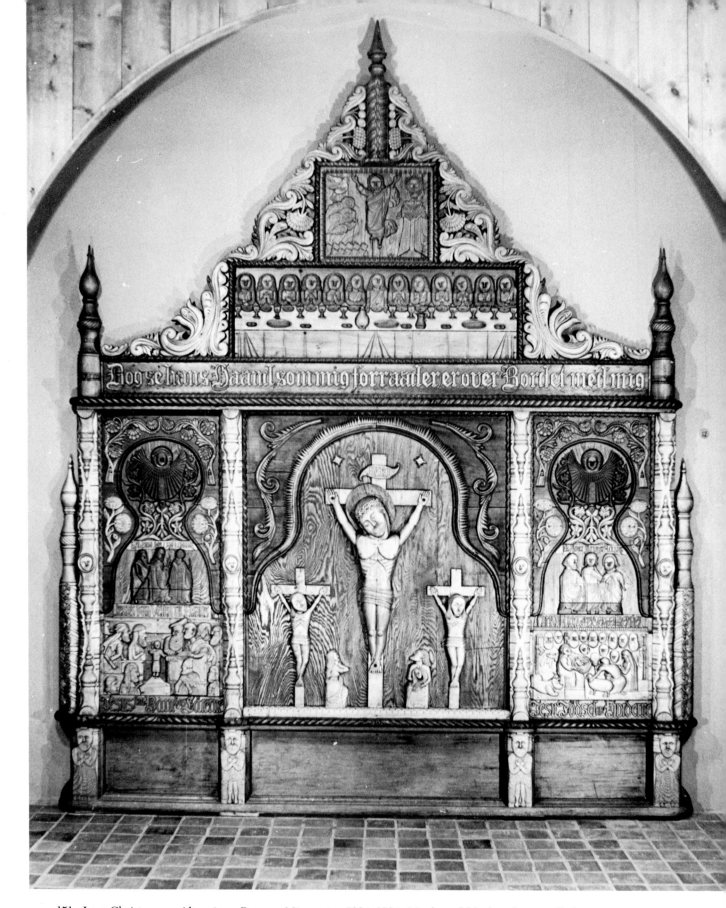

151. Lars Christenson: *Altarpiece*. Benson, Minnesota. 1894–1904. Maple and black walnut applied to veneer on pine panels, H. 148″. This superb altarpiece depicts several scenes from the life of Christ. Below the scene of the Last Supper, the Norwegian inscription translates, "But, behold, the hand of him that betrayeth me is with me on the table." (Norwegian-American Museum)

152. Unidentified artist: *The Adoration of the Christ Child*. Pennsylvania. Early nineteenth century. Silk, satin weave, with watercolor, embroidered with colored silks and chenille, 21¼″ x 26½″. This stitched and painted Nativity scene is one of the few depictions of the shepherds' visit to the infant Jesus. (The St. Louis Art Museum; Gift of Mrs. William A. McDonnell)

153. Samuel Colwell Baker: *Christ in the Manger*. Shenandoah, Iowa. c. 1950. Oil on canvas, 32¼″ x 48⅛″. The Magi bring gifts to the infant Jesus in this twentieth-century version of the Nativity. (University Collection, University of Nebraska Art Galleries; Gift of artist's estate)

154. Elijah Pierce: *The Man That Was Born Blind Restored to Sight*. Columbus, Ohio. 1938. Carved and painted wood, 23¼″. Pierce's three-part panel relates one of Christ's healing miracles. (Mr. and Mrs. Michael D. Hall)

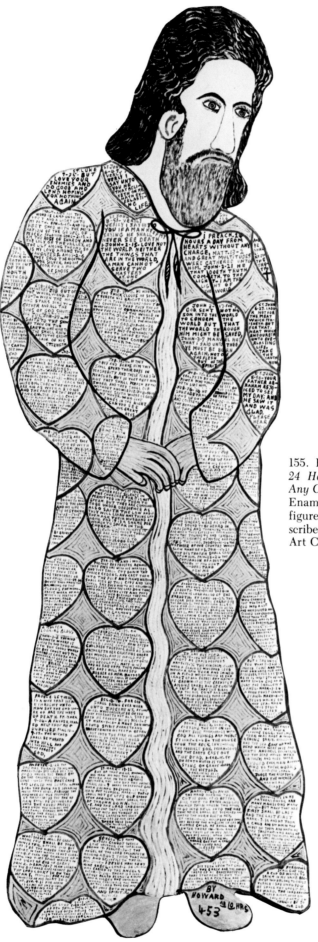

155. Reverend Howard Finster: *I Preach 24 Hours a Day from Hearts Without Any Charge.* Summerville, Georgia. 1977. Enamel on masonite, 80″ x 25″. Finster's figure of Jesus is covered with hearts inscribed with his sayings. (American Folk Art Company, Jeffrey and Jane Camp)

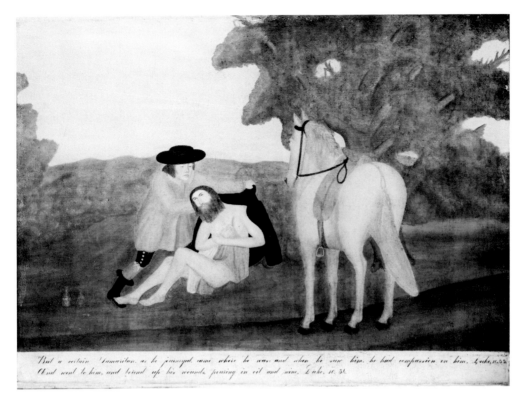

156. Unidentified artist: *The Good Samaritan*. American. 1800–1825. Oil on maple, 19⅝″ x 27″. This scene from the parable of the Good Samaritan depicts the Samaritan's rescue of a waylaid traveler. (Abby Aldrich Rockefeller Folk Art Center)

157. Unidentified artist: *The Prodigal Son Reveling with Harlots*. c. 1790. Watercolor, 5¹³⁄₁₆″ x 6¹⁵⁄₁₆″. (Abby Aldrich Rockefeller Folk Art Center)

158. Friedrich Krebs: *The Prodigal Son When He Has No More Money*. Pennsylvania. c. 1800. Watercolor and ink on paper, 8½″ x 13¼″. (The Pennsylvania Historical and Museum Commission, William Penn Memorial Museum)

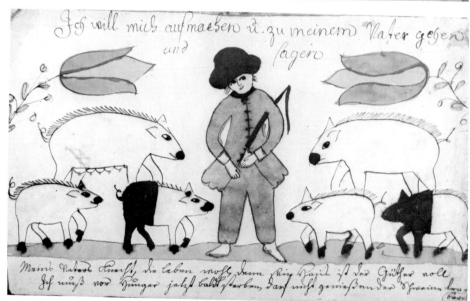

159. Friedrich Krebs: *The Prodigal Son in Misery*. Pennsylvania. c. 1800. Watercolor and ink on paper, 8½″ x 13¼″. (The Pennsylvania Historical and Museum Commission, William Penn Memorial Museum)

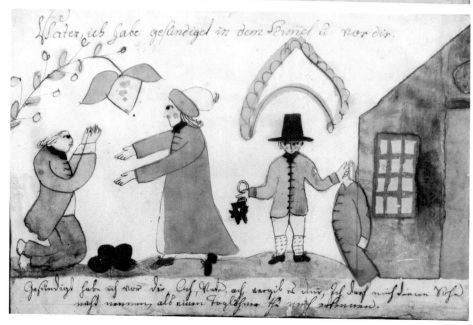

160. Friedrich Krebs: *The Prodigal Son Returns to His Father*. Pennsylvania. c. 1800. Watercolor and ink on paper, 8½″ x 13¼″. (The Pennsylvania Historical and Museum Commission, William Penn Memorial Museum)

161. Mary Ann Willson: *The Prodigal Son Reclaimed*.
Greenville, New York. Early nineteenth century. Ink
and watercolor on paper, 10″ x 12⅝″. (National Gal-
lery of Art; Gift of Edgar William and Bernice Chrys-
ler Garbisch)

162. Ruby Devol Finch: *Prodigal Son*.
Westport, Massachusetts. c. 1830. Water-
color on paper, 12¼″ x 13¾″. This version
of the popular parable presents nine
scenes in comic-strip style, with the char-
acters in nineteenth-century apparel.
(Private collection)

122

163. John W. Perates: *Saint Matthew*. Portland, Maine. Mid-twentieth century. Carved and assembled ironwood relief with enamel paint, 49″ x 27⅜″ x 6″. The attribute of the apostle, an angel, points toward the eye of God. (Private collection)

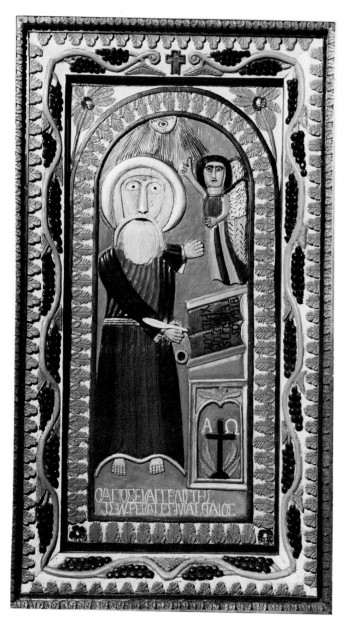

164. John W. Perates: *Icon of the Dormition of the Virgin*. Portland, Maine. Mid-twentieth century. Carved and assembled varnished wood relief, 29″ x 47″. Mary, the mother of Jesus, lies on her deathbed, surrounded by the twelve disciples and her resurrected son. (Courtesy Mr. and Mrs. Michael D. Hall; photograph: Helga Photo Studio, Inc.)

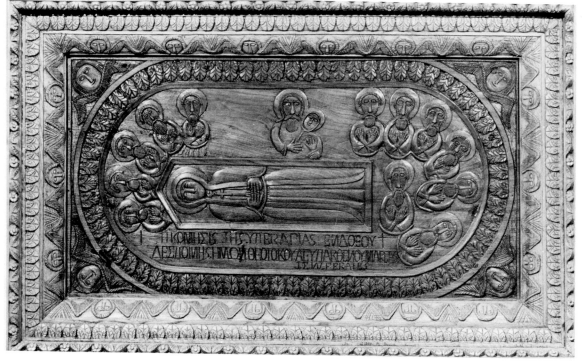

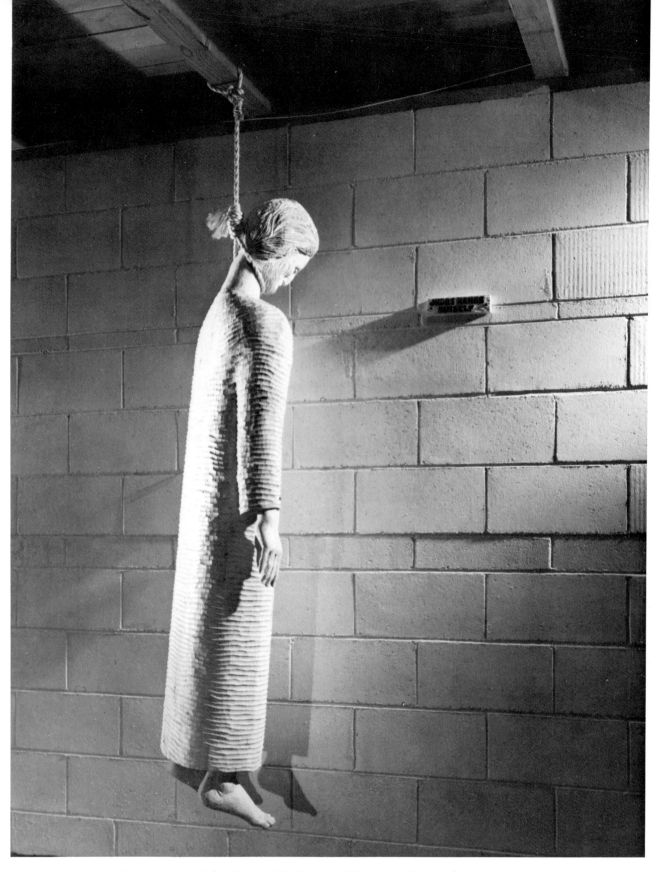

165. Joseph Thomas Barta: *Judas Hangs Self*. Spooner, Wisconsin. Twentieth century. Sugar pine, 60″. The disciple who betrayed Jesus for thirty pieces of silver hanged himself in remorse. (Museum of Woodcarving)

166. Unidentified artist: *Religious Text: The Crucifixion*. American, probably Pennsylvania. 1847. Watercolor on paper, 13½″ x 10¾″. This Fraktur includes the two thieves who were crucified with Christ. Among its many inscriptions are Jesus' words to the repentant thief: "Today you will be with me in Paradise." At the foot of the center cross, soldiers divide Christ's garments. (Abby Aldrich Rockefeller Folk Art Center)

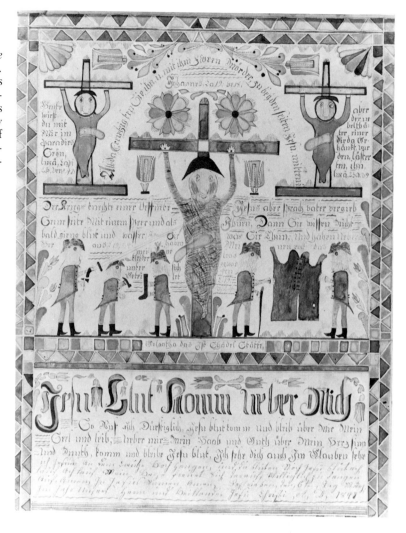

167. Unidentified artist: *The True Cross*. Found near New Hope, Pennsylvania. c. 1880–1900. Oil and resin on bed ticking, 22½″ x 32½″. Jesus hangs between the two thieves labeled "Dismas" and "Gestas." Above his head are his final words: "Father, forgive them: for they know not what they do." (Abby Aldrich Rockefeller Folk Art Center)

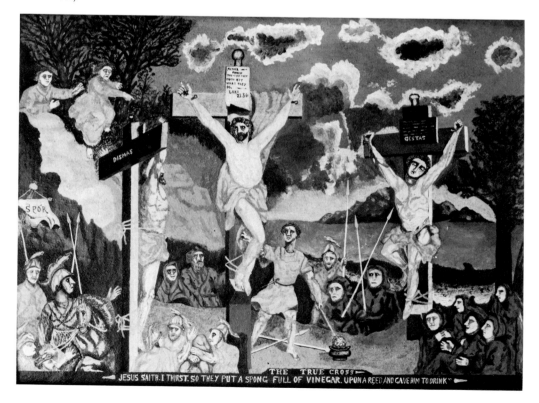

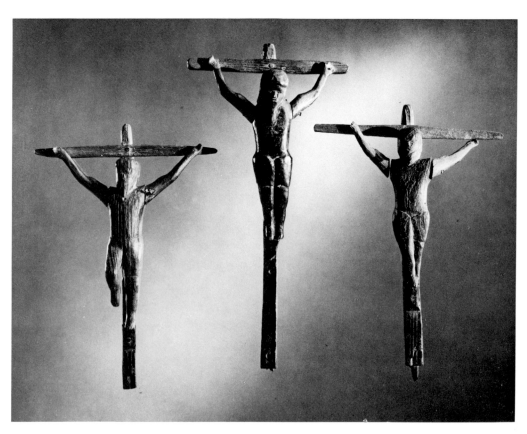

168. Reverend William Gale: *Crucifixion*. Ark, Virginia. c. 1870. Wood and paint, 19″ x 20″ x 6½″. A former slave, the Reverend Gale expressed his faith through both his ministry and his carving. (Photograph: Delmore A. Wenzel; J. Roderick Moore)

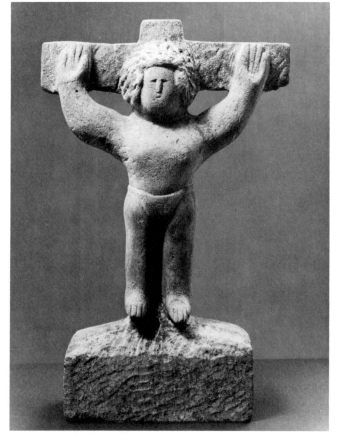

169. William Edmondson: *The Stone Cross*. Nashville, Tennessee. 1930–1940. Limestone, 47½″. Edmondson once said, "I can't help carving. . . . Jesus has planted the seed of carving in me." (Photograph: Colonial Williamsburg; Abby Aldrich Rockefeller Folk Art Center)

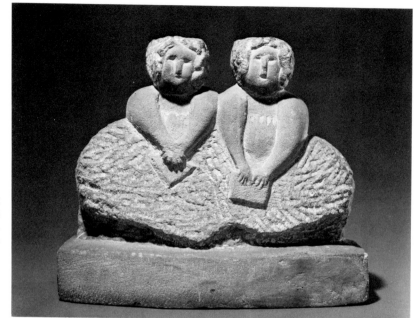

170. William Edmondson: *Mary and Martha.* Nashville, Tennessee. 1930s. Limestone, 13⅞″ x 16¾″ x 5¼″. This double portrait represents sisters who were followers of Jesus. (Hirshhorn Museum and Sculpture Garden, Smithsonian Institution)

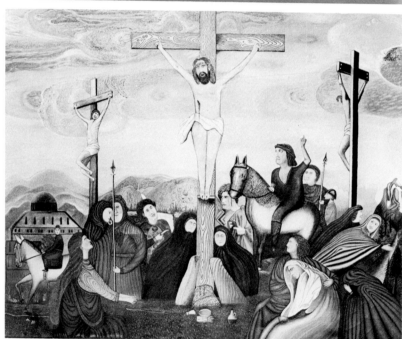

171. Frank Baldwin: *Crucifixion.* Pittsburg, New Hampshire. 1930s. Oil on canvas, 46″ x 52½″. This version of the Crucifixion scene shows the artist's interest in simplified form and curvilinear pattern. (David Wiggins)

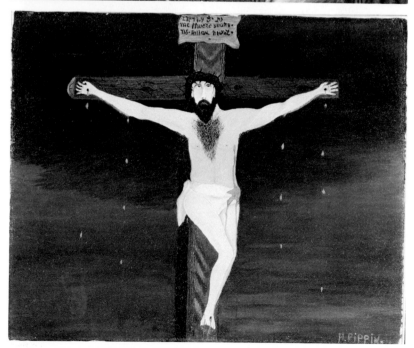

172. Horace Pippin: *The Crucifixion.* West Chester, Pennsylvania. 1943. Oil on canvas, 16″ x 20″. Pippin's stark design is a powerful interpretation of the passion of Christ. (Menil Foundation Collection Inc.)

And when he had spoken these

173. Elijah Pierce: *Crucifixion*. Columbus, Ohio. c. 1933. Polychromed wood relief, 48″ x 30½″. Pierce has included numerous figures seldom found in scenes of the Crucifixion, such as men working at an anvil and an image of the devil. (Courtesy the artist)

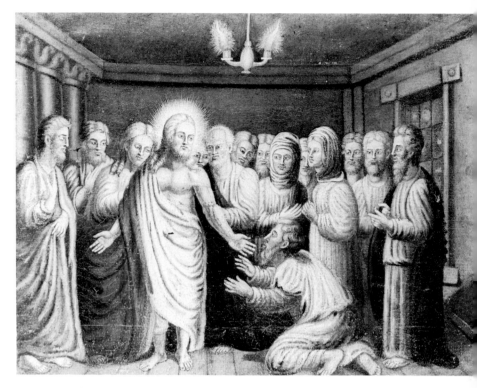

174. John Landis: *Jesus in the Upper Room*. Pennsylvania. 1836. Oil on canvas, 13⁹⁄₁₆″ x 18½″. A self-proclaimed "Anointed of God," Landis depicted the resurrected Christ with his disciples. The incredulous Thomas, seeing his Master's wounds, kneels in awe. (Philadelphia Museum of Art; The Titus C. Geesey Collection)

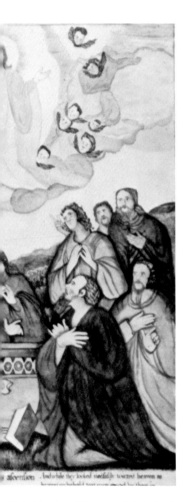

175. Eunice Pinney: *Christ's Ascension*. Simsbury, Connecticut. c. 1815. Watercolor on paper, 23″ x 19″. The final departure of Jesus from his disciples is recorded in Acts 1:9: "As they were looking on, he was lifted up, and a cloud took him out of their sight." (Photograph: Folk Arts Division, The Museum, Michigan State University; private collection)

176. Harry Lieberman: *The Driver's Promotion*. Great Neck, New York. c. 1972. Acrylic on canvas, 24″ x 30″. This depiction of a horse-cart driver who exchanged places with a rabbi is based on a familiar Jewish folk tale known through many variations. (Morris Gallery)

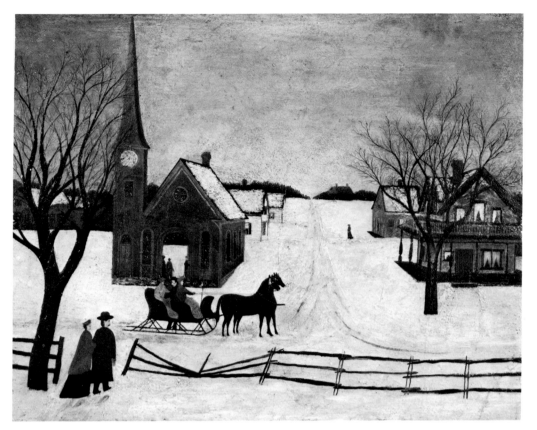

177. Unidentified artist: *Winter Sunday in Norway, Maine.* Maine. c. 1860. Oil on canvas, 21⅛″ x 27⅛″. This famous painting is remarkable for its stark beauty. (New York State Historical Association)

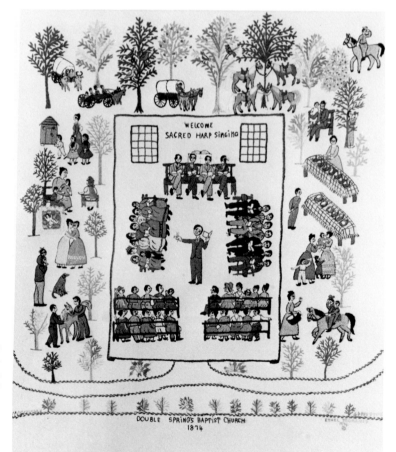

178. Ethel Mohamed: *Double Springs Baptist Church Harp Singing, 1874.* Belzoni, Mississippi. 1974. Needlework on cotton. The singing session and reunion pictured in this embroidered scene still occur annually at the same church. (Collection of the artist)

130

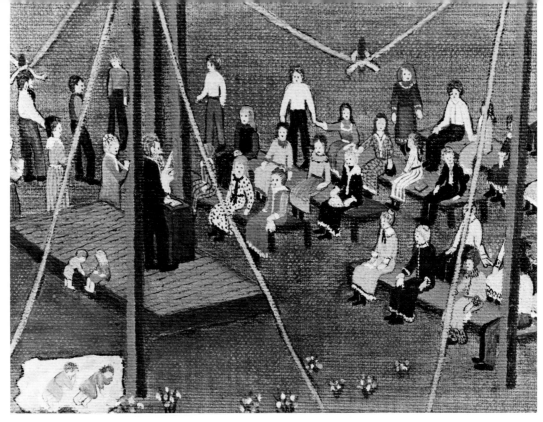

179. Fannie Lou Spelce: Detail from *Camp Meeting at Maple Shade*. Austin, Texas. 1968. Oil on canvas, 24″ x 36″. In this painting, the artist recalls her childhood experience of attending camp meetings where "getting to know and love thy neighbor as well as thyself was more or less a religious picknick for everybody." (Spelce Family Collection)

180. Harriet French Turner: *Benediction*. Virginia. 1963. Oil on presswood panel, 19½″ x 23″. This view of a Dunkard meeting in Roanoke documents the sect's customs of dress and separate seating for men and women worshipers. (Abby Aldrich Rockefeller Folk Art Center)

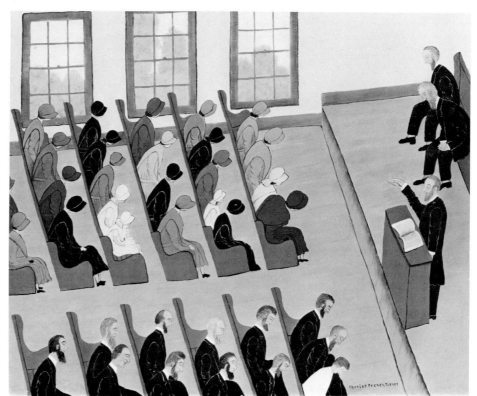

131

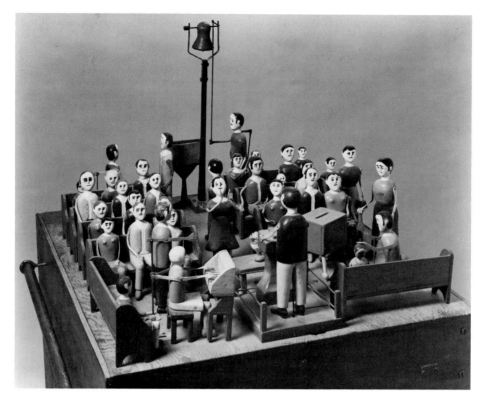

181. Carlton Elonzo Garrett: Detail from *Mount Opel—Holy Children of Israel*. Flowery Branch, Georgia. Twentieth century. Wood and metal, painted, 29" x 27½" x 31½". When the artist's "dream church" is activated by a motor, members of the congregation twist their heads, sway with the music, fan themselves, or shake hands. (Photograph: Jerome Drown; Judith Alexander)

182. Emily Lunde: *Cottage Meeting 1914*. North Dakota. c. 1976. Oil on board, 18" x 24". Memories of her childhood in northern Minnesota inspired the artist to paint this scene of Swedish immigrants gathered for a home prayer meeting. (Museum of American Folk Art; Gift of Mrs. Emily Lunde)

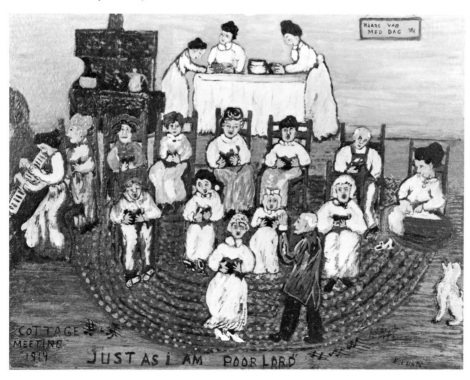

183. Harry Lieberman: *The Divine Spirit Dwells Among Us*. Great Neck, New York. 1976. Acrylic on linen paper, 15⅞″ x 19¾″. Rabbi Halatta, the son of Dosa, once said, "When ten people sit together and occupy themselves with the Torah, the Divine Spirit dwells among them." (Morris Gallery)

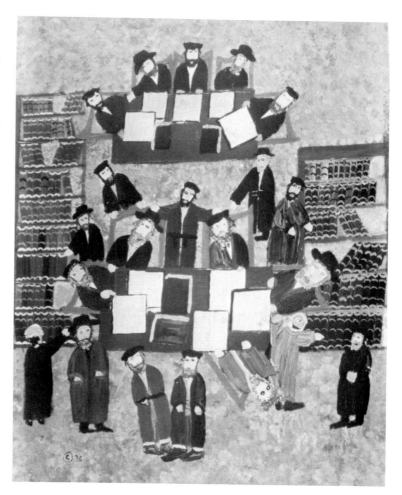

184. Horace Pippin: *John Brown Reading His Bible*. West Chester, Pennsylvania. 1942. Oil on canvas board, 16″ x 20″. This is one of three pictures painted by the artist on the subject of the fiery abolitionist who went to the gallows in 1859. (Private collection; courtesy Andrew Crispo Gallery)

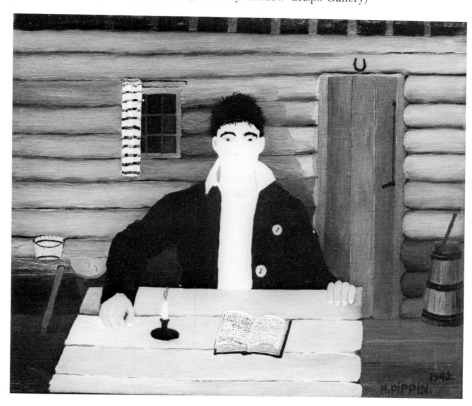

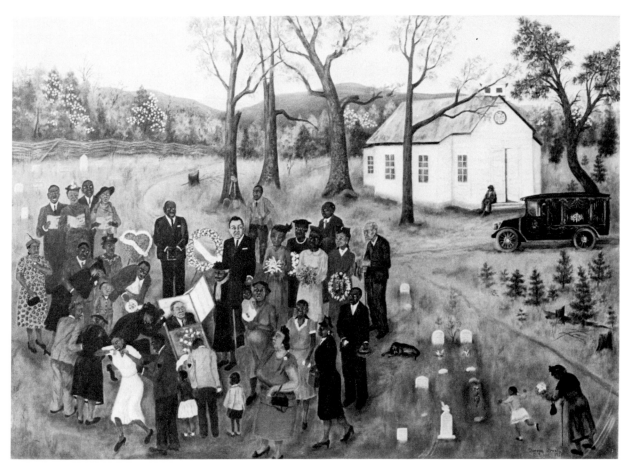

185. Queena Dillard Stovall: *Swing Low, Sweet Chariot*. Lynchburg, Virginia. 1953. Oil on canvas, 27½″ x 39½″. Many of the mourners in this funeral scene are recognizable members of the community where the artist lived. (Randolph-Macon Woman's College Art Gallery)

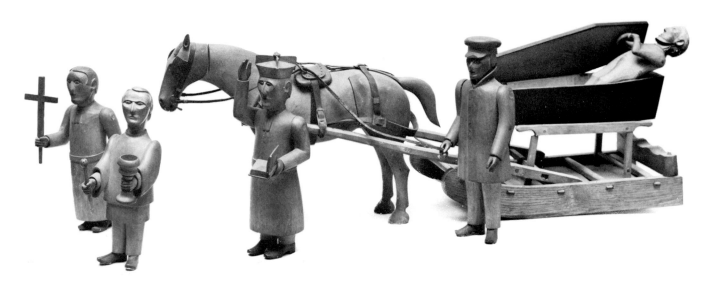

186. Unidentified artist: *Catholic Funeral Procession*. Vermont. Early twentieth century. Wood and bone, painted, L. 36″. The figure of the deceased rising from his coffin provides a startling note in an otherwise solemn scene. (Collection of Herbert W. Hemphill, Jr.)

187. Malcah Zeldis: *My Wedding*. Brooklyn, New York. 1973. Oil on masonite, 24″ x 27½″. A joyous religious event has been recorded in this colorful painting. (Jay Johnson Gallery)

188. Malcah Zeldis: *Family Seder*. Brooklyn, New York. 1980. Oil on masonite, 24″ x 36″. Members of a Jewish family join in the traditional Passover feast to commemorate the exodus of the Israelites from Egypt. (Jay Johnson Gallery)

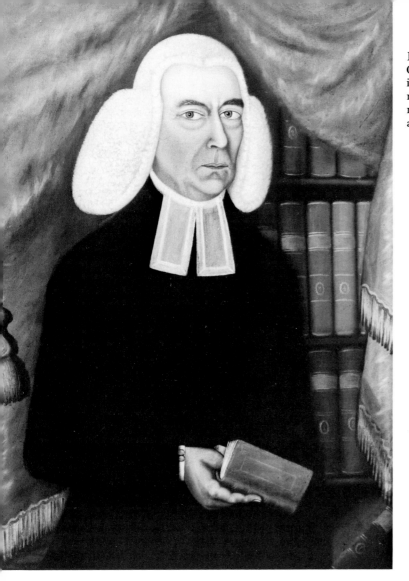

189. Winthrop Chandler: *Rev. Ebenezer Gay, Sr.* Suffield, Connecticut. 1773. Oil on canvas, 38" x 29". The significant role played by spiritual leaders in American life is reflected in countless portraits of preachers, priests, and rabbis. (Photograph: Museum of American Folk Art; Mr. and Mrs. William E. Wiltshire III)

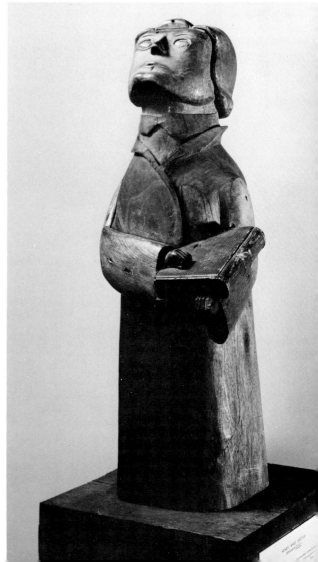

190. Unidentified artist: *The Preacher.* American. c. 1870. White pine and butternut wood, 21". Once thought to represent Henry Ward Beecher, this figure is now known to derive from a German monument to Martin Luther. The academic statue was familiar to Americans through pictures and metal replicas. (Photograph: Colonial Williamsburg; Abby Aldrich Rockefeller Folk Art Center)

136

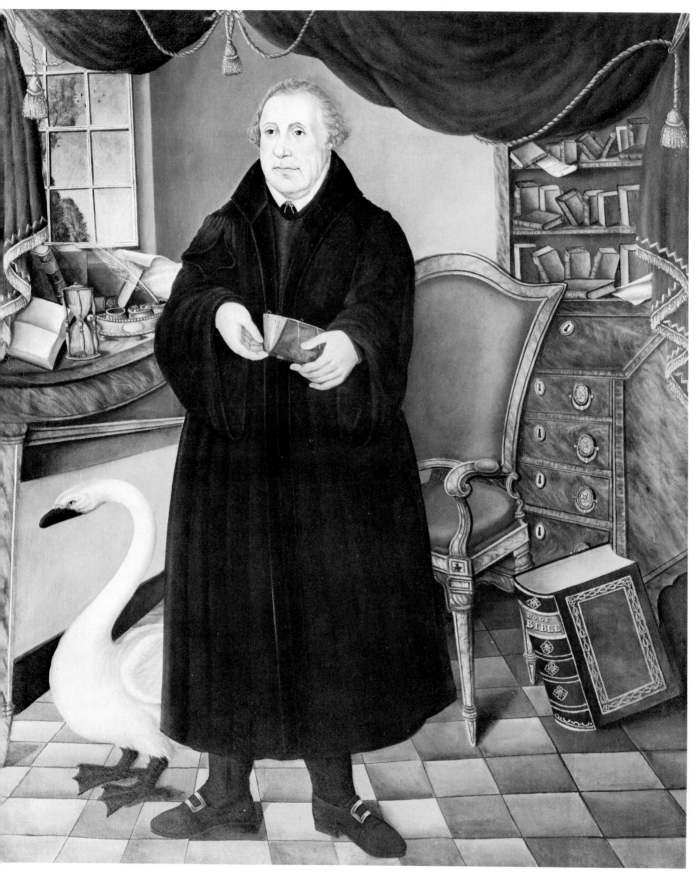

191. Unidentified artist: *Portrait of a Clergyman*. Probably Connecticut. Late eighteenth or early nineteenth century. Oil on canvas, 58⅝″ x 48¼″. (Collection of Hirschl & Adler Galleries)

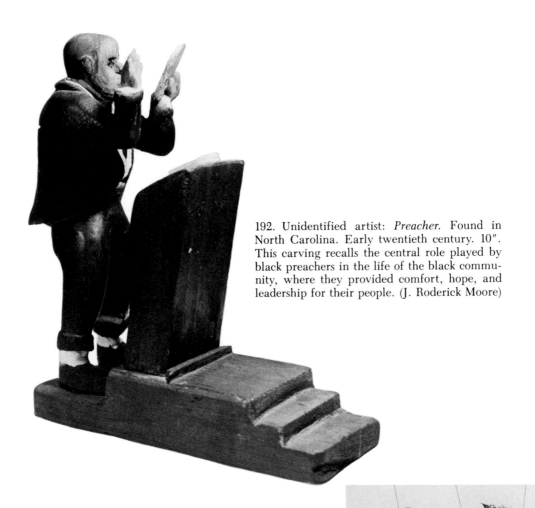

192. Unidentified artist: *Preacher.* Found in North Carolina. Early twentieth century. 10″. This carving recalls the central role played by black preachers in the life of the black community, where they provided comfort, hope, and leadership for their people. (J. Roderick Moore)

193. The Lano Family: *Preacher Marionette.* Late nineteenth century. Wood, cloth, and metal, 20½″. The "preacher" was a stock character in traveling puppet and marionette shows. (Photograph: Folk Arts Division, The Museum, Michigan State University)

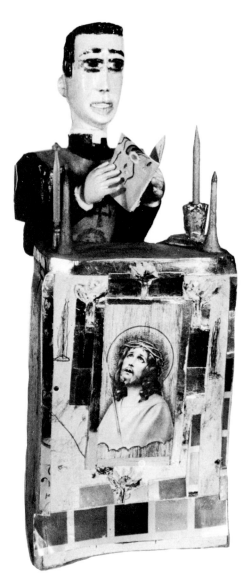

194. John Wasilewski: *Priest at Altar*. Detroit, Michigan. c. 1965–1975. Mixed media, 15″. An immigrant from Poland, Wasilewski adorned his carved and painted religious figures by adding bits of paper, plastic, printed illustrations, and other materials, all of which gave an Old World iconic character to his work. (Photograph: Folk Arts Division, The Museum, Michigan State University; John Wasilewski, Jr.)

195. Malcah Zeldis: *Rabbi*. Brooklyn, New York. 1976. Oil on masonite, 10″ x 13″. Like the preacher and priest, the rabbi has provided spiritual guidance for generations of Americans. (Jay Johnson Gallery)

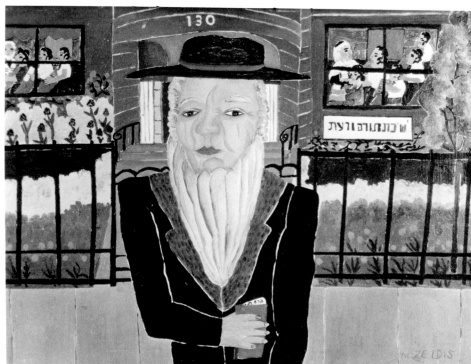

196. Erastus Salisbury Field: *Historical Monument of the American Republic*. Massachusetts. c. 1876. Oil on canvas, 9′3″ x 13′1″. Field's monumental painting created for the nation's first centennial was meant to be "a brief history of our country." At the right, Field included an essay on the Bible, calling it "a book of . . . wisdom which condemns all foolishness and vice." (Museum of Fine Arts, Springfield; The Morgan Wesson Memorial Collection)

197. James Hampton: *Throne of the Third Heaven of the Nations Millennium General Assembly.* Washington, D.C. c. 1950–1964. Gold and silver foil over 110 pieces of furniture of various sizes, 9′ x 32′. Visions of divine beings and prophecies in the Book of Revelation inspired the construction of this unfinished assemblage. The artist referred to himself as "St. James, Director of Special Projects for the State of Eternity." (National Collection of Fine Arts, Smithsonian Institution; Anonymous gift)

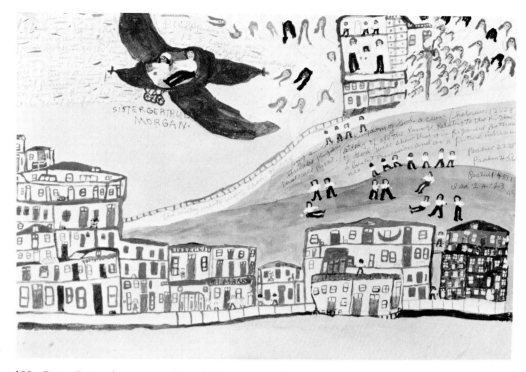

198. Sister Gertrude Morgan: *Jesus Is My Air Plane*. New Orleans, Louisiana. c. 1970. Ink and watercolor on paper, 18″ x 26⅜″. At one time an itinerant street preacher and gospel singer, the artist ministered through her Gospel Mission and her art until her death in 1980. (Photograph: Eeva-Inkeri; collection of Herbert W. Hemphill, Jr.)

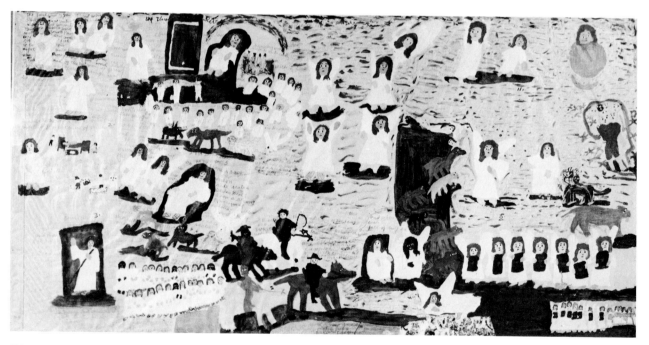

199. Sister Gertrude Morgan: *Revelations*. New Orleans, Louisiana. c. 1970. Ink and watercolor on window shade, 35¾″ x 72″. Based on the Book of Revelation, this painting is a composite of many images derived from the biblical text, including the Four Horsemen of the Apocalypse. (Collection of Herbert W. Hemphill, Jr.)

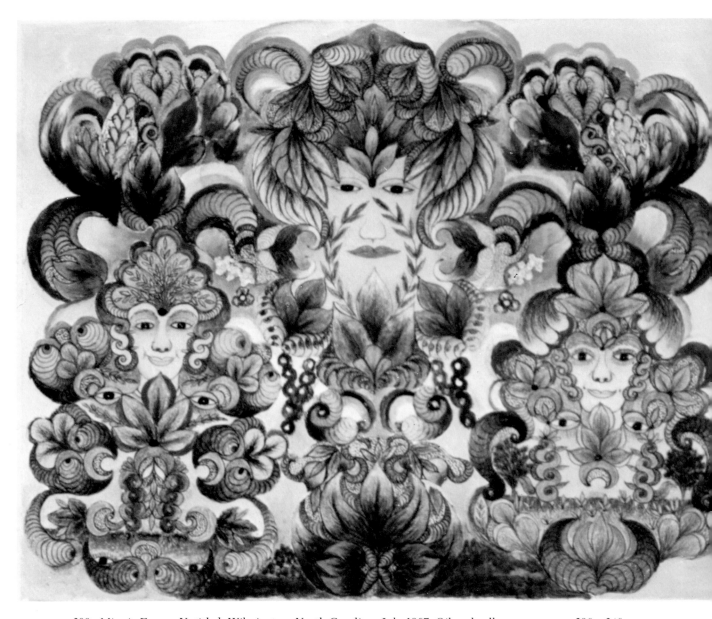

200. Minnie Evans: *Untitled*. Wilmington, North Carolina. July 1967. Oil and collage on canvas, 20″ x 24″. The artist derives her imagery from both nature and the Bible, especially the Book of Revelation. Her mystical visions have directed her work. (Photograph: Folk Arts Division, The Museum, Michigan State University; private collection)

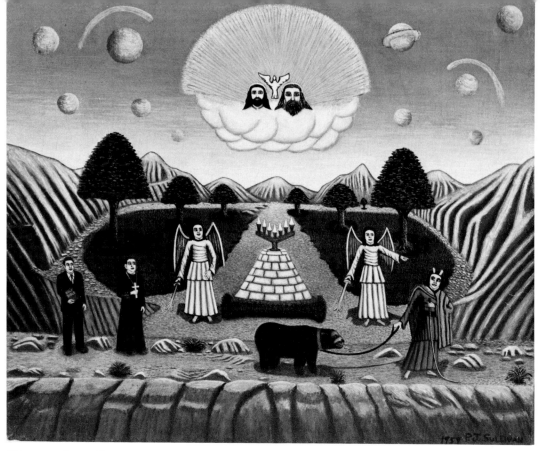

201. Patrick J. Sullivan: *The Gates of Hell Shall Not Prevail*. Wheeling, West Virginia. 1959. Oil on canvas, 22¼" x 26⅜". In this painting the artist combined images from the Book of Revelation with symbols of his own era. The Russian bear led by Satan represents the threat of communistic atheism. (Mrs. Martha Farley; photograph courtesy the artist's family and Oglebay Institute–Mansion Museum)

202. Fannie Lou Spelce: *A Child's View of Heaven*. Austin, Texas. 1971. Oil on canvas, 24" x 36". The afterlife as it might be imagined by a youngster is depicted in this painting. (Spelce Family Collection)

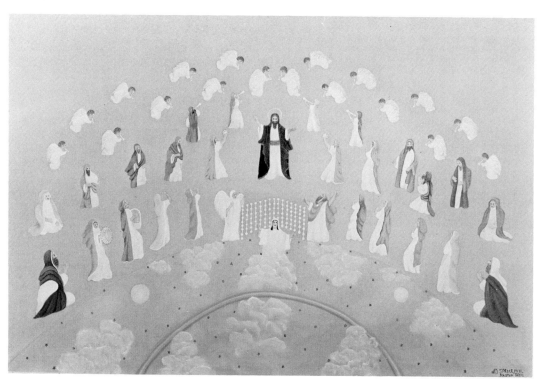

203. Reverend Howard Finster: *Crossing Jordan*. Summerville, Georgia. c. 1976. Enamel paint on board, 30″ x 29½″. Inscribed in this scene are the evils of earthly existence as opposed to the blessings of heaven. (Collection of Herbert W. Hemphill, Jr.)

204. Unidentified artist: *Missionary Map*. American. 1900. Oil on cloth, 48¾″ x 28¼″. This teaching aid reflects fundamentalist Christian views of history as divided into *dispensations*, or eras marked by successive covenants between God and man. (Collection of Herbert W. Hemphill, Jr.)

205. Nettie Bergland Halvorson: *Wall Hanging*. Houston, Minnesota. c. 1912. Cotton and wool patches on carpet warp, 76″ x 137″. Thousands of one-inch cloth squares were strung onto a netlike base to produce this design. The Norwegian inscription translates, "The law of Moses fell to the earth and became nothing, but that which remained was faith in Jesus." (Norwegian-American Museum)

206. Edward Hicks: *The Falls of Niagara*. Pennsylvania. 1825. Oil on wood panel, 31½″ x 38″. Hicks's view of Niagara and its bordering verses reflect the religious awe inspired by nature during the nineteenth century. (The Metropolitan Museum of Art; Gift of Edgar William and Bernice Chrysler Garbisch, 1962)

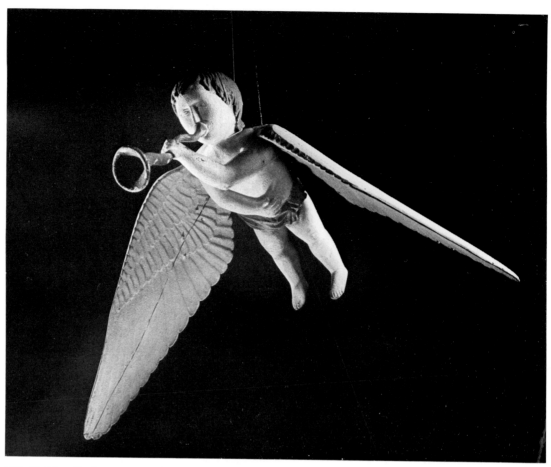

207. Unidentified artist: Angel Gabriel tavern sign. Guilford, New York. c. 1827. Painted wood, W. 46½″. This image of an angelic being served for many years as an identifying sign for the Angel Tavern at Guilford. (Photograph courtesy Gerald Kornblau Gallery; Mrs. Jacob M. Kaplan)

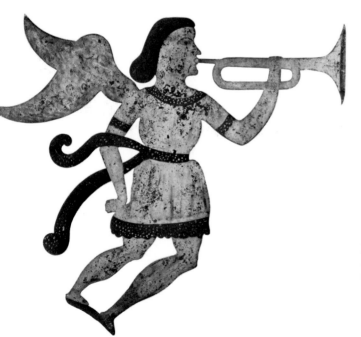

208. Unidentified artist: Angel Gabriel weathervane. New England. c. 1840. Sheet iron, polychromed, 29¼″. This wonderful Gabriel figure serves the Museum of American Folk Art as a symbol for the growth and spirit of the museum's collections and programs. (Museum of American Folk Art; Gift of Adele Earnest)

209. Unidentified artist: *Hand of God*. Midway, Georgia. c. 1895. Wood and white paint, H. 50″. Pointing heavenward, this symbol of divine guidance was originally the steeple ornament for the Midway Temple Presbyterian Church, which was built by a black congregation and razed in 1963. (Midway Museum, Inc.)

210. Highway sign. Near St. Johns, Michigan. Late twentieth century. The symbol of a hand pointed toward heaven continues to appear in contemporary versions, such as this roadside sign. (Photograph: Folk Arts Division, The Museum, Michigan State University)

211. Gail Schmitz: *Pysanky.* Lansing, Michigan. 1978. Egg, beeswax, colored dyes, approx. 2½″. Many religious symbols may be found in traditional ethnic arts. *Pysanky*, the Ukrainian art of dyeing Easter eggs, makes use of numerous motifs with spiritual significance. (Photograph: Folk Arts Division, The Museum, Michigan State University)

212. Graffiti. Detroit, Michigan. 1979. Spray paint. The religious faith of contemporary Americans is reflected in a variety of popular forms: signboards, graffiti, bumper stickers, personalized license plates, and painted vehicles, to name but a few. (Photograph: Harlan MacDowell)

213. Bumper sticker. Lansing, Michigan. 1979. (Photograph: Betty MacDowell)

214. Personalized license plate. Lansing, Michigan. 1979. (Photograph: Betty MacDowell)

215. Wayside chapel. Atwood, Michigan. 1979. Wayside chapels and shrines found across America offer today's traveler opportunities for physical and spiritual renewal. (Photograph: Betty MacDowell)

152

216. *Floating Church of Our Savior for Seamen.* New York City. Lithograph. 1844. During the nineteenth century, an unusual evangelistic ministry to sailors was provided by the YMCA (Young Men's Christian Association) through its floating seaport churches. This Gothic-style church was moored in New York's East River. A similar floating mission was operated in Philadelphia harbor. (Photograph: Collections of The Library of Congress)

EPILOGUE

This book and the exhibition it accompanies are intended as merely an overview of America's rich heritage of religious material folk culture. Together they span a broad range of visual expressions of spiritual conviction. The vast scope of material covered has prevented the examination of any particular area in depth. Fortunately, some of the folk art forms included in the foregoing discussion have been the focus of various scholarly studies, many of which are listed in the Bibliographies. However, much fieldwork and research yet remain to be done on numerous areas of religious art and individual artists. It is hoped that this survey will prompt further investigation into the varied manifestations of America's spiritual life.

The works of art illustrated within these pages have been described as "reflections of faith," because they embody personal religious beliefs or cultural values. When viewed as a whole, this material reflects a dynamic body of both continuity and fluidity. The religious experience of early Americans formed a spiritual bedrock that has remained firm, despite the tides of social, economic, and technological change. Its enduring presence continues to be demonstrated in American folk art today. At the same time, constantly shifting cultural currents have added new insights and forms to the rich pattern of our religious art heritage. Moreover, with the arrival of each fresh wave of newcomers from distant and diverse cultures, other traditions, forms, and perspectives have continued to enrich and enlarge our spiritual foundation. All of these modifications and innovations have created an increasingly intricate religious cultural life.

The Preface to this book opens with a quotation that calls attention to the still unexplored inner relationship between religion and art: "Religion and art stand beside each other like two friendly souls whose inner relationship, if they suspect it, is still unknown to them." Perhaps a similar observation might be made about the inner relationship between the diverse forms of religious art gathered together for this book and exhibition. Although differentiated by medium, style, content, and cultural origin, these works together express an awareness of the spiritual dimension of existence. In addition, they attest to the shared need of the artists to give tangible form to their inner convictions. And, as part of the complex pattern of our religious art heritage, each is linked to the others as an integral part of the whole. The realization of these relationships and the recognition of the variety of beliefs conveyed through these works of art can promote tolerance and appreciation of the complexity of religious life. With this appreciation, American folk art can become an important means of enhancing communication and understanding among all peoples.

SELECTED BIBLIOGRAPHIES

1. GENERAL REFERENCES: RELIGION IN SOCIETY

Ahlstrom, Sydney E. *A Religious History of the American People.* 2 vols. Garden City, N.Y.: Image Books, Doubleday & Co., 1975.

Banton, Michael, ed. *Anthropological Approaches to the Study of Religion.* London: Tavistock Publications, 1966.

Clements, William M. "The Physical Layout of the Methodist Camp Meeting." *Pioneer America* 5, no. 1 (January 1973).

Cross, Whitney R. *The Burned-Over District.* Ithaca, N.Y.: Cornell University Press, 1950.

Dorson, Richard M., ed. *Folklore and Folklife.* Chicago: University of Chicago Press, 1972.

Eliade, Mircea. *Patterns in Comparative Religion.* New York: Sheed & Ward, 1949.

Frazer, James G. *The Golden Bough.* 12 vols. London: The Macmillan Company, 1911–1915.

Herberg, Will. *Protestant—Catholic—Jew: An Essay in American Religious Sociology.* Garden City, N.Y.: Anchor Books, Doubleday & Co., 1960.

Hofstadter, Richard, and Smith, Wilson, eds. *American Higher Education: A Documentary History.* vol. 1. Chicago: University of Chicago Press, 1961.

Hudson, Winthrop S. *Religion in America.* 2d ed. New York: Charles Scribner's Sons, 1973.

James, E. O. *Seasonal Feasts and Festivals.* New York: Barnes & Noble, 1961.

Jamison, A. Leland, and Smith, James Ward, eds. *The Shaping of American Religion.* Princeton, N.J.: Princeton University Press, 1961.

Johnson, Charles A. *The Frontier Camp Meeting.* Dallas, Tex.: Southern Methodist University Press, 1955.

Kamarck, Edward, ed. *Religious Communities and the Arts: Arts in Society* 13, no. 1 (Spring/Summer, 1976).

Leslie, Charles, ed. *Anthropology of Folk Religion.* New York: Vintage Books, 1960.

Lessa, William A., and Vogt, Evon Z., eds. *Reader in Comparative Religion.* New York: Harper & Row, 1965.

Marty, Martin E. *Protestantism.* History of Religion Series, E. O. James, General Editor. New York: Holt, Rinehart & Winston, 1972.

Moore, Albert C. *Iconography of Religions: An Introduction.* Philadelphia: Fortress Press, 1977.

Mulder, John M., and Wilson, John F., eds. *Religion in American History: Interpretive Essays.* Englewood Cliffs, N.J.: Prentice-Hall, 1978.

Norbeck, Edward. *Religion in Primitive Society.* New York: Harper & Row, 1961.

Nye, Russel B. *The Cultural Life of the New Nation, 1776–1830.* New York: Harper & Row, 1960.

Smith, James Ward, and Jamison, A. Leland, eds. *Religion in American Life.* 4 vols. Princeton, N.J.: Princeton University Press, 1961.

Stanfield, Charles. "Pitman Grove: A Camp Meeting as Urban Nucleus." *Pioneer America* 7, no. 1 (January 1975).

Wallace, Anthony F. C. *Religion: An Anthropological View.* New York: Random House, 1966.

Weisberger, Bernard A. *They Gathered at the River: The Story of the Great Revivalists and Their Impact upon Religion in America.* Boston and Toronto: Little, Brown, 1958.

Wright, Louis B. *Culture on the Moving Frontier.* Bloomington, Ind.: Indiana University Press, 1955.

Yoder, Don, ed. *American Folklife.* Austin, Tex.: University of Texas Press, 1976.

———. "Official Religion Versus Folk Religion." *Pennsylvania Folklife* 15, no. 2 (1965–1966).

2. GENERAL REFERENCES: ART IN SOCIETY

Bishop, Robert. *American Folk Sculpture.* New York: Dutton Paperbacks, 1983.

Dewhurst, C. Kurt, and MacDowell, Marsha. *Rainbows in the Sky: The Folk Art of Michigan in the Twentieth Century.* Exhibition catalogue. East Lansing, Mich.: Michigan State University Press, 1978.

Dillenberger, Jane, and Taylor, Joshua C. *The Hand and the Spirit: Religious Art in America, 1700–1900.* Exhibition catalogue. Berkeley, Calif.: University Art Museum, 1972.

Ebert, John, and Ebert, Katherine. *American Folk Painters.* New York: Charles Scribner's Sons, 1975.

Ferris, William. *Local Color: A Sense of Place in Folk Art.* New York: McGraw-Hill Book Co., 1982.

Hemphill, Herbert W., Jr., and Weissman, Julia. *Twentieth-Century American Folk Art and Artists.* New York: E. P. Dutton, 1974.

Tyler, Moses Coit. *A History of American Literature*. New York: Putnam's Sons, 1878.

Wertenbaker, Thomas J. *The Golden Age of Colonial Culture*. New York: New York University Press, 1949.

D. The Woman's Experience

Betterton, Sheila. *The American Quilt Tradition*. Catalogue. Bath, England: The American Museum in Britain, 1976.

Bishop, Robert, and Safanda, Elizabeth. *A Gallery of Amish Quilts*. New York: Dutton Paperbacks, 1976.

Bolton, Ethel Stanwood, and Coe, Eva Johnston. *American Samplers*. New York: Dover Publications, 1973.

DePauw, Linda Grant, and Hunt, Conover. *"Remember the Ladies": Women in America, 1750–1815*. New York: The Viking Press, 1976.

Dewhurst, C. Kurt, MacDowell, Betty, and MacDowell, Marsha. *Artists in Aprons: Folk Art by American Women*. New York: Dutton Paperbacks, 1979.

Finley, Ruth E. *Old Patchwork Quilts*. Newton Centre, Mass.: Charles T. Branford Co., 1929.

Fratto, Toni Flores. *"'Remember Me': The Sources of American Sampler Verses." New York Folklore* 2, nos. 3 & 4 (Winter 1976).

Haders, Phyllis. *Sunshine and Shadow: The Amish and Their Quilts*. Clinton, N.J.: The Main Street Press, 1976.

Hall, Carrie A., and Kretsinger, Rose G. *The Romance of the Patchwork Quilt in America*. New York: Bonanza Books, 1935.

Hinson, Dolores A. "Religion in American Quilts." *The Antiques Journal* (July 1973).

Holstein, Jonathan. *The Pieced Quilt: An American Design Tradition*. New York: Galahad Books, 1973.

Kraditor, Aileen S., ed. *Up from the Pedestal: Selected Writings in the History of American Feminism*. Chicago: Quadrangle Books, 1968.

Melder, Keith. "Masks of Oppression: The Female Seminary Movement in the United States." *New York History* 55, no. 3 (July 1974).

Schorsch, Anita. "A Key to the Kingdom: The Iconography of a Mourning Picture." *Winterthur Portfolio* 14, no. 1 (Spring 1979).

——. *Mourning Becomes America*. Catalogue. Clinton, N.J.: The Main Street Press, 1976.

Stewart, Susan. "Sociological Aspects of Quilting in Three Brethren Communities in Southeastern Pennsylvania." *Pennsylvania Folklife* 23, no. 3 (Spring 1974).

Welter, Barbara. *Dimity Convictions: The American Woman in the Nineteenth Century*. Athens, Ohio: Ohio University Press, 1976.

Woodard, Thomas K., and Greenstein, Blanche. "Hawaiian Quilts: Treasures of an Island Folk Art." *The Clarion* (Summer 1979), pp. 16–27.

E. The Afro-American Experience

Clark, Erskine. *Wrestlin' Jacob*. Atlanta, Ga.: John Knox Press, 1979.

DuBois, W. E. B. *The Souls of Black Folk*. 1903. Reprint. New York: Fawcett World Library, 1961.

Fry, Gladys-Marie. "Harriet Powers: Portrait of a Black Quilter." *Missing Pieces: Georgia Folk Art, 1770–1976*. Catalogue. Atlanta, Ga.: Georgia Council for the Arts and Humanities, 1976.

Mitchell, Henry H. *Black Belief: Folk Beliefs of Blacks in America and West Africa*. New York: Harper & Row, 1975.

Raboteau, Albert J. *Slave Religion*. New York: Oxford University Press, 1978.

Vlach, John Michael. *The Afro-American Tradition in Decorative Arts*. Cleveland, Ohio: The Cleveland Museum of Art, 1978.

Washington, Joseph R., Jr. *Black Sects and Cults*. Garden City, N.Y.: Doubleday & Co., 1972.

F. The Denominational and Sectarian Experience

Andrews, Edward Deming. *The People Called Shakers*. New York: Dover Publications, 1963.

——, and Andrews, Faith. *Visions of the Heavenly Sphere*. Charlottesville, Va.: The University of Virginia Press for The Henry Francis du Pont Winterthur Museum, 1969.

——. *Work and Worship*. Greenwich, Conn.: New York Graphic Society, 1974.

Borneman, Henry C. *Pennsylvania German Illuminated Manuscripts*. New York: Dover Publications, 1973.

Boyer, Walter E. "Adam und Eva in Paradies." *The Pennsylvania Dutchman* 8, no. 2 (Fall–Winter 1956–1957).

Bronner, Simon. "'We Live What I Paint and I Paint What I See': A Mennonite Artist in Northern Indiana." *Indiana Folklore* 12, no. 1 (1979).

Cannon, Hal. *The Grand Beehive*. Catalogue. Salt Lake City, Utah: University of Utah Press, 1980.

——, ed. *Utah Folk Art*. Provo, Utah: Brigham Young University Press, 1980.

Douglas, Paul H. "The Material Culture of the Harmony Society." *Pennsylvania Folklife* 24, no. 3 (1974), p. 4.

Friesen, Steve. "Emil 'Maler' Kym, Great Plains Folk Artist." *The Clarion* (Fall 1978).

Garvan, Beatrice B., and Hummel, Charles F. *The Pennsylvania Germans: A Celebration of Their Arts, 1683–1850*. Catalogue for The Henry Francis du Pont Winterthur Museum. Philadelphia: Philadelphia Museum of Art, 1982.

Griffith, James S. "The Folk-Catholic Chapels of the Papagueria." *Pioneer America* 7, no. 2 (July 1975).

Marquardt, Lewis R. "Metal Grave Markers in German-Russian Cemeteries of Emmons County, North Dakota." *Journal of the American Historical Society of Germans from Russia* 2, no. 1 (Spring 1979).

Mercer, Henry C. *The Bible in Iron: Pictured Stoves and Stoveplates of the Pennsylvania Germans*. Narberth, Pa.: Livingston Publishing Company, 1961.

Milspaw, Yvonne. "Plain Walls and Little Angels: Pioneer Churches in Central Pennsylvania." *Pioneer America* 12, no. 2 (May 1980).

Nelson, Vernon. *John Valentine Haidt*. Catalogue. Williamsburg, Va.: Colonial Williamsburg, Inc., 1966.

Nordhoff, Charles. *The Communistic Societies of the United States*. New York: Dover Publications, 1966.

Pitzer, Donald E. "Harmonist Folk Art Discovered." *Historic Preservation* (October–December 1977).

Piwonka, Ruth, and Blackburn, Roderic H. *A Remnant in the Wilderness*. Catalogue. Albany, N.Y.: The Albany Institute of History and Art for the Bard College Center, 1980.

Rhodes, Lynette I. *American Folk Art from the Traditional to the Naive*. Cleveland, Ohio: The Cleveland Museum of Art, 1978.

Sondrup, Steven P., ed. *Arts and Inspiration*. Provo, Utah: Brigham Young University Press, 1980.

Stoudt, John Joseph. *Sunbonnets and Shoofly Pies: A Pennsylvania Dutch Cultural History*. New York: Castle Books, 1973.

Swank, George. *Painter Krans*. Galva, Ill.: Galvaland Press, 1976.

Teske, Robert Thomas. "The Eikonostasi Among Greek-Philadelphians." *Pennsylvania Folklife* 23, no. 1 (1973).

Vogeler, Ingolf. "The Roman Catholic Culture Region of Central Minnesota." *Pioneer America* 8, no. 2 (July 1976).

Weiser, Frederick S. "Piety and Protocol in Folk Art: Pennsylvania German Fraktur Birth and Baptismal Certificates." *Winterthur Portfolio* 8 (1973).

Wust, Karl. *Folk Art in Stone*. Edinburg, Va.: Shenandoah History Publishers, 1970.

G. The Experience of the Individual Artist

Arkus, Leon Anthony. *Three Self-Taught Pennsylvania Artists: Hicks, Kane, Pippin*. Exhibition catalogue. Pittsburgh, Pa.: Museum of Art, Carnegie Institute, 1966.

Baker, Gary E. "Patrick J. Sullivan, Allegorical Painter." *The Clarion* (Winter 1980), pp. 34–42.

——. *Sullivan's Universe: The Art of Patrick J. Sullivan, Self-Taught West Virginia Painter*. Exhibition catalogue. Wheeling, W. Va.: Oglebay Institute, 1979.

Black, Mary C. "& a Little Child Shall Lead Them." *Arts in Virginia* 1, no. 1 (Autumn 1960), pp. 22–29.

——. *Edward Hicks, 1780–1849, A Special Exhibition Devoted to His Life and Work*. Exhibition catalogue. Williamsburg, Va.: Abby Aldrich Rockefeller Folk Art Collection, 1960.

——. "Erastus Salisbury Field." *American Folk Painters of Three Centuries*. Edited by Jean Lipman and Tom Armstrong. Exhibition catalogue. New York: Hudson Hills Press, in association with Whitney Museum of American Art, 1980, pp. 74–81.

Blasdel, Gregg, and Larson, Philip. "S. P. Dinsmoor's Garden of Eden." *Naives and Visionaries*. Exhibition catalogue. New York: Dutton Paperbacks, 1974, pp. 32–41.

Carved by Prayer. Spooner, Wisc.: Museum of Woodcarving, n.d.

Coblentz, Patricia L. "Harry Lieberman: It Is Never Too Late to Start Painting." *The Clarion* (Winter 1978), pp. 71–72.

Dinsmoor, S. P. *Pictorial History of the Cabin Home and Garden of Eden of S. P. Dinsmoor*. Lucas, Kans.: Privately printed, n.d.

Fannie Lou Spelce. Austin, Tex.: Fannie Lou Spelce Associates, 1972.

Field, Erastus Salisbury. "Remarks." *A Descriptive Catalogue of the Historical Monument of the American Republic*. Amherst, Mass.: H. H. McCloud, 1876.

Fuller, Edmund L. *Visions in Stone: The Sculpture of William Edmondson*. Pittsburgh, Pa.: University of Pittsburgh Press, 1973.

Grotto and Shrines. Dickeyville, Wisc.: Dickeyville Grotto, n.d.

Haggerty, Michael. "Art and Soul." *Atlanta Weekly*, June 29, 1980, pp. 16–19, 28–35.

Hartigan, Linda Roscoe. *James Hampton: The Throne of the Third Heaven of the Nations General Assembly*. Boston: Museum of Fine Arts, 1976.

Hicks, Edward. *Memoirs of the Life and Religious Labors of Edward Hicks, Late of Newtown, Bucks County, Pennsylvania, Written by Himself*. Philadelphia: Merrihew & Thompson, 1851.

Horace Pippin. Exhibition catalogue, with an essay by Romare Bearden. Washington, D.C.: The Phillips Collection, 1977.

Horwitz, Elinor Lander. *Contemporary American Folk Artists*. Philadelphia and New York: J. B. Lippincott, 1975.

Janis, Sidney. "Morris Hirshfield." *American Folk Painters of Three Centuries*. Edited by Jean Lipman and Tom Armstrong. Exhibition catalogue. New York: Hudson Hills Press, in association with Whitney Museum of American Art, 1980, pp. 189–197.

——. *They Taught Themselves: American Primitive Painters of the 20th Century*. New York: The Dial Press, 1942.

Karlins, N. F. "The Peaceable Kingdom Theme in American Folk Painting." *Antiques* 109, no. 4 (April 1976), pp. 738–741.

Lichten, Frances. "John Landis: 'Author and Artist and Oriental Tourist.'" *Pennsylvania Folklife* 9, no. 3 (Summer 1958), pp. 8–17.

Lipman, Jean, and Armstrong, Tom, eds. *American Folk Painters of Three Centuries*. Exhibition catalogue. New York: Hudson Hills Press, in association with Whitney Museum of American Art, 1980.

Mather, Eleanore Price. "Edward Hicks." *American Folk Painters of Three Centuries*. Edited by Jean Lipman and Tom Armstrong. Exhibition catalogue. New York: Hudson Hills Press, in association with Whitney Museum of American Art, 1980, pp. 88–97.

——. *Edward Hicks: A Gentle Spirit*. Exhibition catalogue. New York: Andrew Crispo Gallery, 1975.

——. "In Detail: Edward Hicks's Peaceable Kingdom." *Portfolio* 2, no. 2 (April–May 1980), pp. 34–39.

Mohamed, Ethel Wright. *My Life in Pictures*. Edited by Charlotte Capers and Olivia P. Collins. Jackson, Miss.: Mississippi Department of Archives and History, 1976.

Moore, Gaylen. "The Vision of Elijah Pierce." *The New York Times Magazine*, August 26, 1979, pp. 28–34.

Nelson, Marion John. *Lars Christensen: A Pioneer Artist and His Masterpiece*. Decorah, Iowa: A Vesterheim Publication, 1976. Reprinted from *Norwegian American Studies* 22 (Northfield, Minn.: 1965).

Rodman, Selden. "Horace Pippin." *American Folk Painters of Three Centuries*. Edited by Jean Lipman and Tom Armstrong. Exhibition catalogue. New York: Hudson Hills Press, in association with Whitney Museum of American Art, 1980, pp. 213–219.

——. *Horace Pippin, A Negro Painter in America*. New York: Quadrangle Books, 1947.

——, and Cleaver, Carole. *Horace Pippin, the Artist as a Black American*. New York: Doubleday & Co., 1972.

Roscoe, Lynda. "James Hampton's Throne." *Naives and Visionaries*. Exhibition catalogue. New York: Dutton Paperbacks, 1974.

Starr, Nina Howell. *Minnie Evans*. Exhibition brochure. New York: Whitney Museum of American Art, 1975.

Tolles, Frederick B. "The Primitive Painter as Poet." *Bulletin of the Friends Historical Association* 50, no. 1 (Spring 1961), pp. 12–30.

Twentieth Century American Icons: John Perates. Exhibition catalogue. Cincinnati, Ohio: Cincinnati Art Museum, 1974.

Vlach, John Michael. "Quaker Tradition and the Paintings of Edward Hicks: A Strategy for the Study of Folk Art." *Journal of American Folklore* 94, no. 372 (April–June 1981), pp. 145–165.

Weissman, Julia. "Malcah Zeldis: A Jewish Folk Artist in the American Tradition." *The National Jewish Monthly* 90, no. 1 (September 1975), pp. 2–5.

Index

Page references for illustrations are in **boldface** type.

C. Kurt Dewhurst, Ph.D., was born in Passaic, New Jersey, and received his Ph.D. in American Studies from Michigan State University, East Lansing. He has written extensively on American folk art and is a coauthor of: *Artists in Aprons: Folk Art by American Women*, *Michigan Folk Art: Its Beginnings to 1941*, *Rainbows in the Sky: Folk Art of Michigan in the Twentieth Century*, and *Cast in Clay*. Currently he is the Director of The Museum, Michigan State University, East Lansing, Michigan, where he also serves as a curator of folk arts.

Betty MacDowell, M.A., was born in Detroit, Michigan, and received her B.A. and M.A. degrees from Wayne State University, Detroit, Michigan, where she has taught art history. Currently, she is a research specialist in the Folk Arts Division of The Museum, Michigan State University.

Marsha MacDowell, Ph.D., was born in Lansing, Michigan and received her Ph.D. from Michigan State University. A curator of folk arts at The Museum, Michigan State University, she has coauthored a number of publications on regional folk arts and initiated folk-arts-in-education projects on a local and state level.